SCULPSIT:
CONTEMPORARY ARTISTS ON SCULPTURE AND BEYOND

edited by Kerstin Mey

School of Fine Art
Duncan of Jordanstone College of Art and Design
a Faculty of the
University of Dundee
with
Manchester University Press
MANCHESTER AND NEW YORK

MANCHESTER
UNIVERSITY PRESS

D1585546

FOUNDER EDITOR
Alan Woods

EDITOR
Kerstin Mey

CONTRIBUTING EDITORS
Kevin Henderson, Tom Eccles, Dawn Gavin, Robert Thill

ADVISORY BOARD
Lynn A. Higgins, Susan Hiller, Jane Lee, Christoph Tannert

DESIGNER
Donald Addison

PUBLISHER
Manchester University Press,
Oxford Road, Manchester, M13 9NR,
and Room 400, 175 Fifth Avenue, New York, NY 10010, USA
www.manchesteruniversity press.co.uk

in association with *Transcript*,
School of Fine Art,
Duncan of Jordanstone College of Art and Design,
a Faculty of the University of Dundee

Distributed exclusively in the USA by
Palgrave, 175 Fifth Avenue, New York, NY 10010, USA

Distributed exclusively in Canada by
UBC Press, University of British Columbia, 2029 West Mall,
Vancouver, BC, Canada V6T 1Z2

British Library Cataloguing-in-Publication Data
A catalogue record for this book is available from the British Library

Library of Congress Cataloging-in-Publication Data applied for

ISBN 0 7190 6165 2 *hardback*
ISBN 0 7190 6166 0 *paperback*

COPYRIGHT © FOR TEXTS the Authors
© FOR IMAGES the Artists, Photographers and Galleries as listed
© FOR PUBLICATION the Publishers

The views and comments stated within the publication do not
necessarily represent the views of the editor, the College, the University
of Dundee, or Manchester University Press.

Contents

Introduction

Sculpsit marks a new beginning for *Transcript* with its new partner Manchester University Press. Whilst the focus of the project remains on currents and undercurrents in contemporary visual culture, and the publication continues to be a curated anthology, the format has changed from a journal into a series of books.

Transcript was first established as a journal of visual art by the late Alan Woods in December 1994. Nine issues were published until spring 1999. The venture was anchored in and supported by the School of Fine Art, Duncan of Jordanstone College of Art and Design, a Faculty of the University of Dundee. Institutional support made it possible for the publication to survive in the marketplace without advertisements. *Transcript* has aimed to document contemporary working practices including their wider cultural implications and impact on the spectators by focusing on the voice of the artist. Therefore it has been dominated by the interview format but also included artists' projects, as well as round-table discussions and critical essays. The topical profile of each individual issue was determined by Alan Woods. His enormous breadth of interests and insights into contemporary and past culture, married with intuition and a clear feel for the interconnectedness of creative production, safeguarded the journal's growth in scope and ambition. His untimely death brought the project to a temporary standstill although the contours of the next issue had already begun to emerge and thus have informed the selection of material for this book. The publication is to a considerable extent indebted to Alan's work and spirit.

Sculpsit documents contemporary modes of expression in the 'expanded field' of sculpture. Until well into the nineteenth century the Latin term *sculpsit*, which means 'he (or she) who sculptured it', frequently appeared as inscription on a sculpted object followed by the name of the artist who conceived of it. Yet, maybe in a more contemporary spirit, the title can also be read as a 'punning' abbreviation of 'sculpture's situation' with all the implications of the apparent manifold tensions between traditional and present notions of this medium.

Sculpsit points to the materiality of practice which was initially defined in terms of the constraints of *sculpere* (carving) and *plastikos* (plastic—capable of being moulded or formed/modelling). Through a historically extended use of the term sculpture, it came to be accepted to signify both ways of working. Construction as a fundamental formal principle has come into being as a definition of a new generic practice only since the early twentieth century. Due to the specific requirements of traditional sculptural practice in terms of physical labour, material, working and production conditions as well as concerning the dominant aesthetic conventions, cultural values and social functions attached to this medium in the past, it was less accessible for female artists than for instance painting.

Over the recent two to three decades the changes in society at large have opened up the arena for new forms of aesthetic interventions within and outside the gallery space. The boundaries of traditional visual media have become increasingly broader and blurred, not least through the impact of new imaging and information technologies. A diversity of new directions and concerns of creative inquiries and modes of expression have emerged. The feminist movement of the 1970s and the respective shifts in gender politics played a significant part in the development of aesthetic strategies that challenged modernist notions of the work of art, the terms of its production and consumption through the development of collaborative and participatory creative practices within and outside the established cultural institutions and dominant frameworks of reference.

A thematic anthology like this neither pretends to rehearse, sum up or rekindle a generic debate, nor to provide a *complete survey* of the present situation of sculpture, the status of the sculptural objects and its relation to the viewer, or—however tentative and fragile—formal innovations and spiritual renewals. Yet, as a kind of snapshot of present trajectories of 'sculptural imagination' in the broadest sense of the term, aspects of those issues are touched upon in different ways by the artists featured in this publication. This documentation frames diverse individual strategies of aesthetic enquiry in which the medial aspect acts as a point of reference, as a *tertium comparationis*. Rather than providing instant answers, the publication maps out a 'journey of discovery', an exploration of fruitful connections and equally productive frictions and contrasts between the artists featured, their interests and influences, concepts and positionings,

The aesthetic approaches brought together here are linked through their emphasis on the human body in a variety of ways: as the subject and/or agency of the work, as embodied experience of individual existence that (in)forms the work, and in references to body images and current body politics. Moreover, human corporeality provides a vital measure for the three-dimensional object or installation. The sensual and sensitive body lies at the heart of the dynamic and performative relationship between the viewers and the physical and spiritual presence of the work. Shared concerns as well as tensions become apparent with regard to the staging and address of the aesthetic intervention in terms of format and structure, sitedness and temporality. Scenarios introduced here bring to the fore differences between object-based and process-oriented practices, between site-specific and non-sited work, between the ambitious format of the monument and its respective public functions, appeal and valuation, and the more intimate but nevertheless challenging gallery setting. In various ways they draw on the gestural aspects of the work that span from the confrontational to the subtle, from the laconic to the elaborate, from the poetic to the dramatic, from the aesthetic to the political.

KERSTIN MEY

METAMORPHOSES

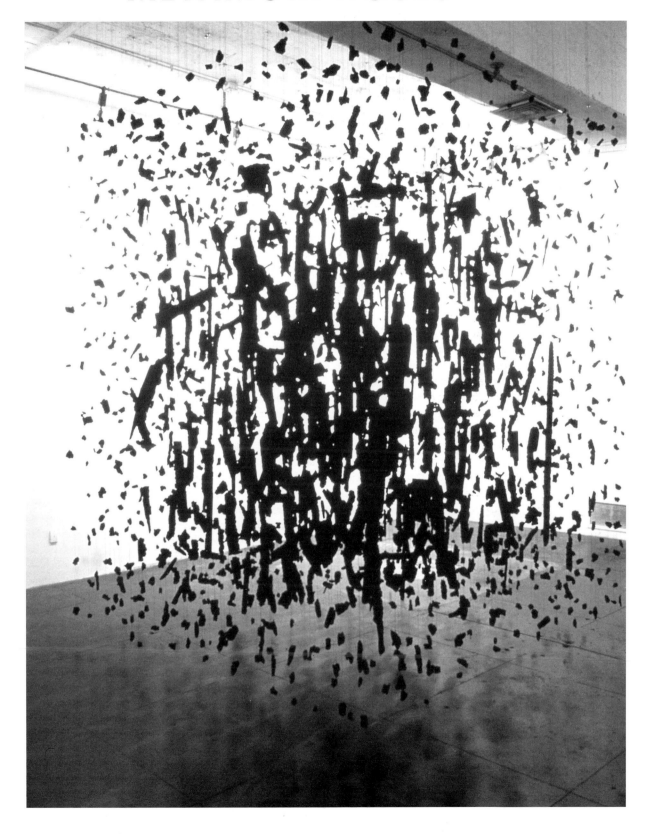

Cornelia Parker
in conversation with
Kerstin Mey

CORNELIA PARKER

Born 1956 in Cheshire, UK
Lives and works in London, UK

Photographs © Cornelia Parker
All photographs courtesy of
Frith Street Gallery, London

(Previous page)

1

Mass
Charcoal retrieved
from a church that
was struck by
lightning. 1998

KERSTIN MEY Your work *Cold Matter* was stored away for quite some time. To be honest, I've never seen it in reality before it was shown in the exhibition *Between Cinema and a Hard Place* at Tate Modern.

CORNELIA PARKER Not many people have. It was first shown here in London at the *Chisenhale Gallery*. It was exhibited in Brazil, in the 1994 São Paulo Biennial. Then it was displayed in Newcastle in 1997, in a show called *Tate on the Tyne*. This is the fourth time it has been shown, but with the biggest audience. Although, in São Paulo too, quite a few people would have seen the work. I think Tate Modern have had a million people to date, which is huge for an art exhibition. I'm not sure how many visitors that were there would actually see *Between Cinema and a Hard Place*, because it's a paying show. However, it's great to have it there.

MEY I was really struck by the presence of *Cold Matter*. The little fragments trigger lots of memories in the viewer, not least because their identity is maintained—at least in part—so that they remain recognisable.

PARKER There are lots of recognisable things in there. I chose them because they had a particular association with me, but hopefully for lots of other people too.

MEY *Cold Matter's* presence has left an imprint in my memory. Thus it overcomes the fleeting moment, the transience of life. The work's aura is unbelievably intense. One is drawn into the work, becomes part of it.

PARKER Because you step into the space between the shadow and the piece.

MEY Yes, and at the same time it keeps you at a distance.

PARKER Because it's so spiky. It's aggressive on one level, but draws you into a quiet centre. I like ambiguity when I look at art, I want to experience a whole range of emotions.

MEY That leads me to my first question with regard to your recent work in which you often transform discrete objects. How important are the objects you acquire, collect and work with?

PARKER I try to choose objects that are archetypal, universal, everyday things that everybody will recognise. They are part of the texture of our life, we surround ourselves with objects. There are certain objects I use, for example silver spoons or pearl necklaces, that reference our society, that seem almost iconic. The string of pearls is a very British way of denoting class. The silver spoon too has similar connotations. Everyone has one that might have been given as a christening present. If you try eating an egg with it the spoon tarnishes. We map out our place in society, with clothes, cars, the house we live in, etc. As we tend to define society through those objects, they seem to be a good raw material to use in sculpture. For instance, in the past I've made an installation with the burnt remains of a church that's been struck by lightening, or a house that's fallen off a cliff, or a garden shed that's been blown up. The church, the house and the shed are institutions that help define our society.

MEY Would it be right to say that in some respect the objects employed in

your work also carry certain autobiographical connotations?

PARKER The work is bound to be related to life experience, it informs every decision, but that happens on an unconscious level. I try not to make autobiographical work, but inevitably, when I was choosing the objects to go in the garden shed for example, I referred back to the contents of my childhood garden shed. However I want the work to have its own autonomy without being about my baggage particularly.

MEY You mentioned the fabric of society, the relation your work bears to society. Your work has very much to do with the destruction of objects, with their transformation.

PARKER Whether it's war or our personal life, or a relative dying, you can't avoid the fact that entropy or violence is very much part of the whole fabric of our society. I think everybody, whatever their temperament, has dramatic feelings sometimes. You may feel like throwing a glass across a room. It seems to be part of the A to Z, part of the vocabulary of life. The violence in my work is just a part of the process. In *Cold Matter* it becomes very obvious what has happened to the objects, but somehow the work is also very quiet and reflective. Despite the fact that something very violent has happened to it, the work is in stasis. It is not a kinetic Tinguely destroying-machine. The work is in repose, literally and metaphorically. It is something that is not fixed. What I like about the destruction is the fact that it unfixes things. It breaks the skin of what it was before and you have to redefine it. The object becomes much more transparent or porous, a much more movable thing. It's like a liberation, it's not killing off its character and meaning, and leaving it for dead. A teaspoon is a teaspoon—whatever its potential metaphoric value. But if you melt it down and transform it into a wire that measures Niagara Falls, you've somehow released it from its constraint—you've destroyed the spoon but you've encompassed something else with it. The spoon is there in the title *Measuring Niagara with a Teaspoon*, and in the material. My husband and I had our wedding rings made out of two-hundred-year-old silver spoon. We took the tarnish off it with a handkerchief to keep, before the spoon was melted down to make it into rings. Everything has been something else before, things are constantly in flux, and somehow I'm trying to embody that constant killing off, rebirth, generation, dying. Trying to encapsulate the life cycle in the work. It all seems too big a theme to deal with literally. I like the simple act of transforming the material, which is what sculpture has always been about. When casting metal or carving stone, the raw material has been formed over a long period of time and then, in a short period of time, the artist destroys what was there before and creates something new out of it.

MEY I am surprised that you mentioned the term sculpture because your work does not resemble traditional sculptural objects. I would like to know what you associate with the term. Do you still think of yourself as a sculptor?

PARKER I like the physicality of the term and I still think of myself as a sculptor even though I work with all kinds of media. I suppose at the beginning of the twenty-first century it seems quite antiquated as a term. When I'm making work I don't really think of it as art or sculpture, those categories I've long shed in my mind. But when I have to talk about my

2

*Tarnish from
James Bowie's
Silver Spoon*
61 x 61cm. 1997

practice, it somehow feels useful to return to where I started from in terms of trying to make art: and that was from a sculptural background.

MEY You have already mentioned the aspect of materiality. What role do the materials you employ in your practice play, and what is their significance? Does the material inspire your work?

PARKER It starts off with the material, or the history of the material. For example, I made a piece using charcoal retrieved from a church struck by lightening and it then occurred to me that I'd really love to do a piece of work with something that had been set fire to intentionally, rather than it being an act of God. Some of the 'deaths' in my work are intentional and some are accidents, or something else has happened to them that is beyond my control. I was trying to track down an arson fire which led me all over the place. It's almost as if the hunt for material is what I really enjoy. I find the pursuit of a particular material fascinating because of the encounters I have on the way. Traditionally sculpture might have meant going to a marble quarry in order to find the right piece of flawless marble. I'm looking for a material that has been forged by experience out in the world beyond the realm of art. Material that has been transformed through someone else's hand, like the result out of an arson. I found out that recovering debris from an arson fire is quite hard, because its all bound up in law. An owner, for example, might not like me taking the debris when it is under investigation, especially if he were the person who had ignited the building. Suddenly, burnt wood becomes a charged material. I found out that a lot of things I'm really interested in have been taboo: like asking Customs and Excise to give me incinerated drugs, for example. Being incinerated, such drugs should be inert materials. They have been dealt with therefore they should no longer be potent, and therefore it shouldn't be a problem for me to acquire them as a material. But the people in charge, with whom you have to negotiate, are worried that those drugs might still have a potency, and I want them because perhaps culturally, I think they still have. It's interesting that we consider a bunch of chemicals put together taboo. That same bunch of chemicals configured in a different way might be something else, they might be a cure for something.

MEY Hearing you talk about your specific concerns for specific materials, and seeing your work you seem to take on the role of scientist researching certain aspects of the material world.

PARKER Or a historian, or an anthropologist . . . I just have a natural curiosity about the world, and the work is a result of that curiosity. I try to understand something, but in a very non-scientific/non-rational way.

MEY However, your objects carry a certain degree of control or communicate a very controlled way of manipulation, as though they are the result of a scientific experiment. For instance when one encounters *Cold Matter*.

PARKER They are formalised.

MEY Yes. What role do precession and exactness play in your work?

PARKER My way of working has to do with the balance between things within one's control and those things outside it. Take the explosion, for example: although I'd contrived it with the British Army, we didn't know exactly what was going to happen. You could find a garden shed, fill it

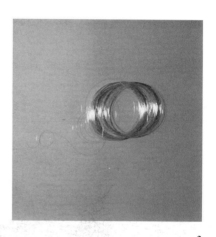

3

Measuring Niagara with a Teaspoon
Georgian silver spoon drawn to the
height of Niagara Falls, 61 x 61cm. 1997

with stuff and put explosives in there but you couldn't control the shape these objects might become. The objects are all transformed by this blast and so they have their own sculptural form. When I rebuilt the shed in the gallery I was trying to formalise the explosion. It was in trying to contain the explosion that I realised it was like trying to control the irrational. Sometimes life seems quite meaningless, you just can't understand the rationale behind this constant shedding of skins and dying and new things being born. It's a way of trying to stop that, to arrest things in limbo for a little while, to look at them and consider them, and to have time for contemplation. Everything moves on and has a momentum in this very fast world where you have hardly time to sit down and have a cup of coffee. I like the stillness you get out of trying to control something that's beyond your control. It's just a dilemma we all have, trying to defy entropy or gravity even though you can't. I enjoy the conflict and friction of trying to arrest something terrifying, mid flight, trying to understand it through its formal qualities.

MEY I'd like to return to the point of researching, searching for traces, for history(ies), archaeology. You removed dust from Freud's chaise longue some years ago . . .

PARKER Yes, all this dust.

MEY It seems to me that you look for and record traces of human existence in varieties of forms and spaces. That's where I align your practice with a scientific approach. It's not so much to do with being in control, but rather with attention, with the exactness of the process of planning and conducting your work and recording its results.

PARKER Last year I did a residency at the Science Museum, London, and so I

4

Feather from Freud's Pillow from his Couch
Projection. 1996

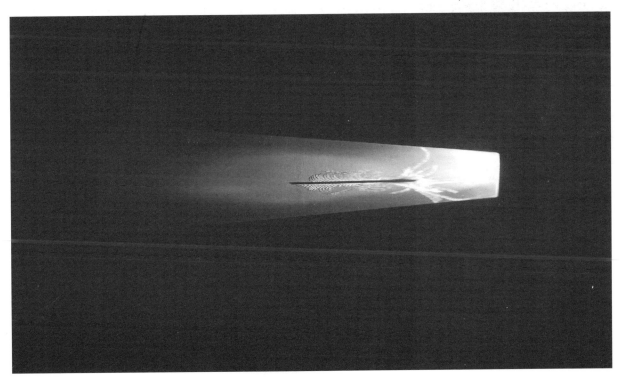

spent a lot of time talking to scientists. That made me realise how different my practice is, even though I might mimic some of their processes. I was using the microscope to look at things, because scientists are always looking at things through microscopes and extrapolating data from it. The data I was trying to extract seemed quite different. Then I went to the Museum of the History of Science and looked at Einstein's equations on one of the blackboards that he left his chalk marks on—through a microscope. The blackboard was fascinating, covered with very neat controlled equations which were trying to describe something that up to that point had been indescribable. Not even scientists working in the museum knew what these equations meant because they were all too obscure somehow. By looking at the chalk marks through the microscope you could see how loose and powdery and volatile these little molecules were and you realised, again, that this is something in flux. Somehow, these equations had a substance of their own which was made up of little tiny traces of fossilised animals, crustaceans. Looking at the chalk marks so closely through the microscope felt incredibly releasing and reassuring. I could understand these equations in a different kind of way, in a very material way. The resulting photographs look like the cosmos like the infinite space of the Universe. I did some similar things with Gladstone's Budget bag, which had been used for one hundred and fifty years in politics. It has always been this enigmatic object that has contained those documents that will change our lives. Looking at it through a microscope you can see all the tears and the damage done over these years of politics, a different kind of knowledge than the data that the briefcase contained. Sculpture made by politicians. Now they've got a new one. The damage will start all over again.

MEY Your insights take away the myth that surrounds these objects.

PARKER It was great getting to touch the real thing, although I couldn't actually get inside the bag because it was locked, but I could explore its outside in minute detail.

MEY Again, your interest has concentrated on the minute detail. How does this focus relate to the idea of the monumental and the monument, if it can be related at all?

PARKER I'm interested in the monument and the mundane too. My work either tends to be tiny or massive. I'm just about to do an exhibition in

5, 6, 7 & 8

Einstein's Abstracts

Photomicrographs of the blackboard covered with Einstein's equations, from his Oxford lecture in 1931, on the theory of relativity, 1999

Thanks to the Museum of the History of Science, London

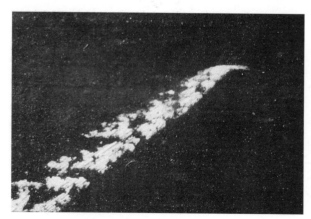

5

6

Aspen, Colorado, in the museum there. I'm showing one large-scale work which I made last year. It's made of chalk from a cliff fall from Beachy Head. A large part of the famous suicide cliff fell into the sea in January last year. It's a very white, sublimely beautiful place but it has this charged dark undertone. After doing the charcoal church-struck-by-lightening piece which is all black, I really wanted to do a white piece. The former is a charcoal drawing and the latter a chalk drawing—sometimes, I like the conventions of drawing. Chalk is loaded in a very different way from charcoal. I made this huge suspended wall out of the chalk, so it's like a very formalised, suspended cliff face. It looks like a cinema screen being about 20 feet long by 13 feet high—I'm not metric yet. Anyway, its quite big and called *Edge of England* because literally that's what it is: it's the edge of England. It's like re-hanging the cliff, like re-suspending this thing that's fallen through its own natural cause. Instead of something or somebody falling off the cliff, the cliff itself has fallen. In the same exhibition I will show some of the images of the chalk marks made by Einstein. So there are two different kinds of chalk drawing going on. One might seem to be about science and another about geography, but somehow they seem to link up. I like showing small things beside large things. So that's an idea of scale—there's the monumental and there is the other thing—however microscopic—which is culturally monumental: Einstein's equations.

MEY So your work is really not so much about discrete objects but rather about interconnections, about the relatedness of everything in the Universe.

PARKER Hopefully. I showed this chalk piece in Melbourne last year for the first time. When I made this work there, they said: 'Oh, this is a postcolonial statement bringing the coastline of England down to Melbourne.' I wasn't even thinking about that at all. But the Australians were reading a political message into it. I didn't mind the work accruing that meaning. Depending on where it's on display, this piece will have different meanings, and I very much like that the meanings aren't fixed. The construction of meaning has very much to do with the viewer and what they bring to the work. I like taking something that's identifiable rather than just buying a whole crate of chalk from a chalk supplier. I like to go and find a very specific piece of chalk from a very specific place

WIMBLEDON SCHOOL OF ART LIBRARY

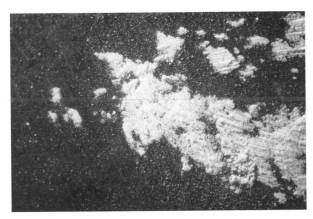

7 8

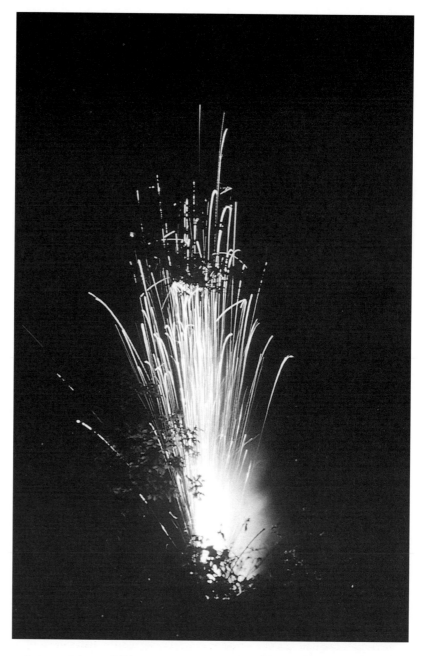

9
Meteorite Lands in Epping Forest
Firework made with iron
from a meteorite. 1996

because it has a different resonance somehow. I like the monumental and I like the mundane. I like the teaspoon and I like the White Cliffs of Dover. I like huge sublime pieces of geography like Niagara Falls versus all these little man made things that we define our lives with. Those are the kind of materials I want rather than to get raw material off the shelf and use that to depict something else.

MEY You use the term sublime very often. You make work that flies into space rather than remains on Earth.

PARKER After trying to defy gravity for many years, I've been doing a series of meteorite (re)landings which are ongoing. I did the first one in Tivoli

Gardens in Copenhagen, in 1996. I bought a meteorite and ground it up and put it in fireworks. Because the meteorite was made of iron it would be expressed as light and would come down in 'shower' sparks the same way the meteorite landed on Earth. And then I thought it would be great to send a meteorite all the way back, to send it out of Earth's orbit and let it go back into space. The meteor is something that has been drawn in by Earth's gravity and it would be a way of releasing it back. It's like putting back a fallen star. It has its own poetry, it's totally non-scientific, its return is not particularly useful to society except metaphorically. In fact, you wouldn't even be able to see the meteor. It's just the idea that something has been drawn in from somewhere else, and it's allowed to go free again. It just seems like a very pure, simple thing. After making very small works which were almost barely visible this endeavour felt as though the object was disappearing altogether. I've been doing a series of work called *Avoided Object* which is doing what the title suggests. The space-launched meteorite would be the ultimate avoided object because it's an object that has been here and has gone. It does not even originate from here. We send lots of man-made stuff into space and clutter up the Universe with it. The simplicity of such a futile gesture which seems to be so anti-gravity appeals to me.

MEY Is your gesture directed towards an anti-commercialisation of the Universe as opposed to space tourism and the like?

PARKER It feels like some kind of—although I don't believe in this—sympathetic magic somehow, in that it's some small attempt to ward off the fact that we might be hit by a meteor anyway. That the Earth's demise will be probably caused by something from outer space before any nuclear devastation completely wipes it out. It becomes an ever increasing fear. As we get to know more about the Universe we realise how actually more probable it is. Sending back this little meteorite is a gesture.

MEY Do you work together with scientists on these projects?

PARKER I have talked to quite a lot of scientists about it. I'm going to definitely have to have the help of the scientific community with the project, because at the moment space travel is in the hand of the scientists. If I had dressed it up as a scientific project then I would have had more success by now, but up till now I've resisted that.

MEY You have had many encounters with scientists and also worked collaboratively with them. How do they react to your work that often challenges and/or subverts their assumptions?

PARKER I've had a very varied range of responses depending on who the person is. I've had lots of very positive feedback, and I've had some negative feedback too. When I was doing research for the first meteorite here and phoned up people in the Natural History Museum in London about where I could buy meteorites, and what kind of meteor I should look for if I wanted it to be ignited, they were very perplexed and surprised, but they didn't say, 'You shouldn't be doing this.' In Denmark, however, approaching the corresponding people in the museum there created a lot of anger. They said, 'You will be destroying a meteorite. How can you do this?' I got a little bit annoyed by this, because there, huge quantities of meteoric material was being destroyed in the name of science. There's a big book of meteorites which lists all the meteorites and

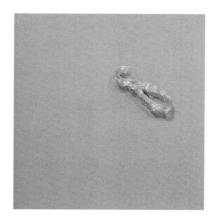

10

Measuring Liberty with a Dollar
Silver dollar drawn into wire the height
of the Statue of Liberty. 1998

falls and what's happened to them. There are infinite numbers, references etc. to dissected meteorites. They're constantly being analysed and destroyed for science, so I just felt that as an artist I had as much right as they to appropriate this material, because meteorites land on the ground. They are there for everyone, if you can buy one you can do what you like with it. Then I started to question where this meteorite had landed, who had found it, when did it become a scientific object etc. It landed in Africa where tribesmen used it for various semi-religious, ritualistic and spiritual things as well as for tools etc. Then, in the 1800s, scientists who went to Africa discovered that these more or less sacred things were meteorites, brought them back, put them in museums and used them for science. From then on, the market for meteorites has been almost exclusively a scientific one, except for those people who are collecting them out of curiosity. At the Science Museum I was met with varying degrees of interest. I remember talking to a chemist there about the ingredients of gunpowder which I wanted to use to make drawings. He was very angered by that. I don't know why. He questioned why I as an artist should have these materials. I wanted to acquire these chemicals in order to mix them optically rather than literally. Therefore, I was just trying to find out what their properties were so I could handle them safely. I didn't want to blow myself up in my studio, which was a real possibility. Gunpowder consists of three different, very fine powders. If they get in the air at the same time, they can all just combine and explode.

MEY Maybe you posed a threat to their authority and their closed worlds?

PARKER It very much depends on the individual, really. I found a lot of scientists who were very open, with whom I had very stimulating conversations. I'm constantly having those conversations with lots of other individuals other than scientists. People from the Customs and Excise, the army, people about whom you wouldn't actually feel that there might be anything in their world that could be inspiring in terms of creativity. But there is fantastic creativity going on all over the place, I'm having my assumptions and prejudices challenged all the time—and we all have prejudices and assumptions. These exchanges make me look at things very differently. If I talk to somebody whose views I don't necessarily agree with like the man from the Colt Fire Arms Factory or a card-carrying Republican in Texas, it's fascinating for me to try to understand their world through asking some very simple question like: 'Can I polish David Crockett's silver fork and take his tarnish away?' People can say no, and very often they do. Yet, they always come up with questions like 'Why do you want his tarnish?'

MEY What role does drawing play in your practice?

PARKER Even more so in sculpture, drawing is what I do. A lot of the suspended work are like drawings in space. Drawing takes a low position in the pecking order in terms of artistic pursuits, but it seems to be the simplest and most honest no-nonsense part of art. Looking at Old Masters, when it comes to the finished paintings there are so many layers of varnish and it's all so finished and sealed, whereas the cartoons or the sketches are much more fresh and exciting because you can see how something is constructed.

MEY They give you an idea about the visual thinking process.

PARKER Yes, exactly. It's made porous which is what I like. The word 'porous' is one I use a lot too. It's a way of understanding, something that's not sealed off, hasn't got a wall or a barrier, something you can absorb reasonably readily.

MEY Can the term porous also be applied with regard to a shifting, blurring or transgressing of boundaries within the social fabric of society through your practice?

PARKER You asked me if I was interested in the monument. The heavy lumpen monumental sculpture on the pedestal I'm least interested in. I'm actually looking for its antithesis, looking for something that was the opposite of its weighty character and earthboundedness. The opposite of that—almost literally—means turning the object upside down, hanging it from the ceiling, and breaking it down into lots of small things, rather than maintaining a monolithic structure. And yet, there are lots of statuesque things that I love in life. I love architecture because, although it is monumental, it's peopled, you can walk through it and it has got windows.

MEY In many of your works there also seems to be a desire to overcome earthboundedness. Is that related to overcoming gravity in a spiritual sense, to overcome fixity through regeneration of ideas, through playfulness? It seems to me that, although you highlight the transience of life—you don't mourn it but look for positive ways to come to terms with it.

PARKER Transience is a fact of life. It seems to be the most prevalent thing, and yet historically when artists made work, very often they were guided by a desire to preserve things for posterity, for the fixed. I think of transience as freedom. I've always thought art was about freedom: freedom of thinking, freedom of expression, about mobility, not having a fixed lifestyle, etc. When I went to art school I realised that making art can be exactly like anything else, it can just be as orthodox and 9–5, like going to the office. So, I've always fought against being a studio-based artist, I mostly use my studio for storing stuff. I just try to reflect what I feel about the flux of life, in my work. I was beginning to think how I could make something that encompasses all the range of moods you might have. It's very hard to do that in a single work. I think the exploded shed has got pathos and humour. It has a lot of the things I want from a piece of work.

MEY You mentioned that you are not a studio-based artist. You do a lot of research in situ. What significance does a location have for your work?

PARKER Quite a lot. You know when you're travelling you do your tourist thing, that is, you go and see out the things you know about the place. I remember going up inside the Statue of Liberty in New York. When I got to the top everybody was taking photographs, I took out a pencil and piece of paper and did a rubbing of a lock of her hair. People were just looking at me as if I was mad. I wanted to touch rather than take a photograph. I've got rubbings of all kinds of things including one of Edgar Allan Poe's doorstep, and an ever-growing collection of tarnish from famous people's silverware. I used to make work site-specifically, things up trees, in abandoned buildings or whatever. Now I feel, that the site is within the work. For example in *Measuring Liberty with a Dollar*— which is a silver dollar drawn into a wire the height of the Statue of

Liberty—the site is within the project. The work can be anywhere but the site moves with it.

MEY Rather the installation is something fixed, in a certain place, i.e. site-specific work in a literal sense.

PARKER I used to work site-specifically a lot, but now I like the white gallery space with no connotations. Nowadays, that gallery space is very accessible, like Tate Modern. It has proved incredibly popular, it's constantly packed with people. Whereas with site-specific work you usually have to trek somewhere in order to find the work. I'm now drawn more to the idea of going to the top of the Statue of Liberty or to a space in my head, and bring the 'site' back to a quiet space which is not that place. Once things are removed from their original context they become more enigmatic, there's more space within them for projection.

LONDON, 20 JUNE 2000

11

Edge of England
Chalk retrieved from a cliff fall at
Beachey Head, South Downs, England.
Chalk, wire, mesh, 1999

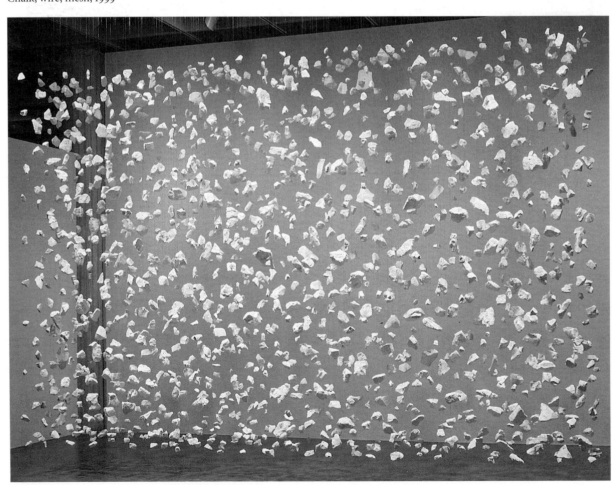

MONUMENTALITY

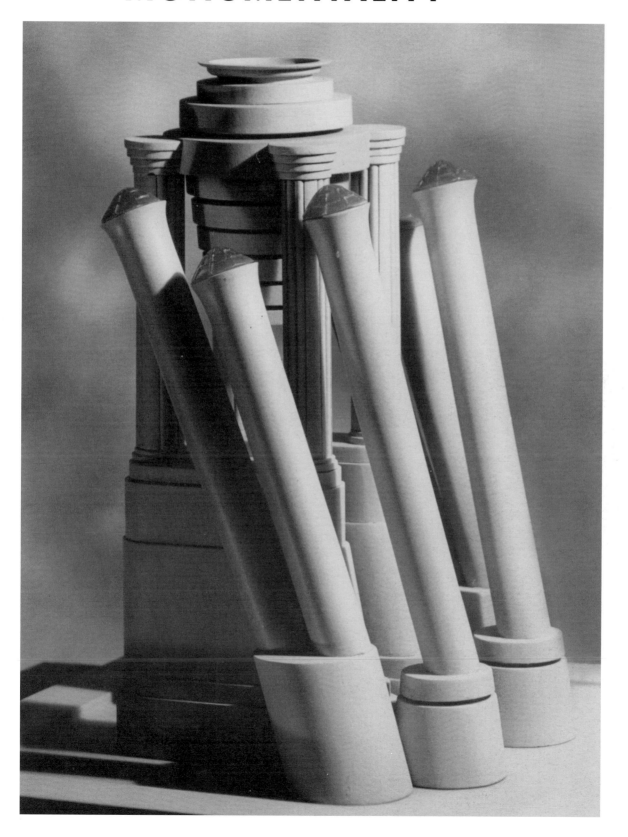

Michael Sandle
in conversation with
Alan Robb

MICHAEL SANDLE

Born 1936 in Weymouth, Dorset, UK
Lives and works in Devon, UK

Photographs © Michael Sandle

(Previous page)

12

Millennium Bell-tower Proposal
1: 10 scale model. Wood and polyester.
Height 66cm. 1997
Photo: Michael Sandle

ALAN ROBB It seems that if you support the notion of training, of the value of drawing, and other things which are important to both of us, then you are labelled as 'reactionary'.

MICHAEL SANDLE Yes. The other word that people bandy about is 'academic', and I find it increasingly irritating that this word should be used pejoratively. Why can't you have the same standards in visual art as in music? In music you need expertise and long training, you need discipline; you need all of those things that I associate with art. I'm talking about classical music obviously; perhaps it doesn't matter quite so much with pop music. But in classical music it is all to do with experience, it is to do with discipline, to do with that which I understand to be art. I cannot see why, if you practice this in visual art, it should be held against you. There are so many examples today—I have actually stopped teaching life drawing to my students because I have realised that I am damaging their career prospects! [Laughter.] A colleague of mine, whose name I shall not mention, is enormously successful, though his

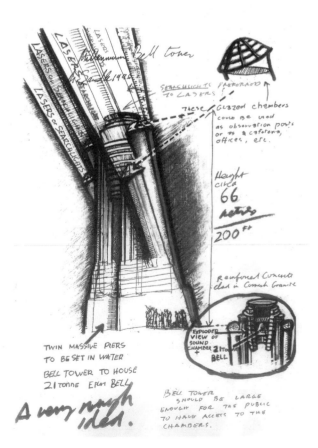

13

Millennium Bell-tower Proposal
Sketch. 1997

drawings are so bad as to be unbelievable. I have challenged people with this, and they think, well actually he draws this badly on purpose, as part of his strategy. But I think that this man cannot draw any better than this, this really is all he can do. He has no ability to make a choice, he can only draw badly, and so badly that it offends my sense of art history. When someone stands in front of a work of incontrovertible excellence and calls it 'elitist' what they are really doing is dishonestly attempting to deny its excellence, to undermine it. The Germans have a pejorative expression— *autoritär* (authoritarian)—suggesting that it's better to be non-authoritarian, it's better not to have the desire to be excellent because it's undemocratic. Well, I say that art has got nothing whatsoever to do with democracy. It also has nothing to do with being Mr Nice Guy. If you look at the history of art some of the worse shits that ever walked shoe leather were great artists—like Jacques-Louis David, a dreadful person—but what an artist! I say show me the art, it may not be 'politically correct', it might actually be rather wicked, but is it any good, in art terms? This is what matters!

ROBB The word 'talent' is being replaced by 'creativity'—and of course everyone is *creative*. But talent is elitist.

SANDLE Yes, talent is a very suspect word nowadays because people assume that if you are talented you are elitist and therefore you must be reactionary. They will say, for example, looking at art history, that this or that artist was used as a tool of the establishment to support its values. Well, I think that's rubbish. The church fostered art, but at the same time it placed constraints upon the artists, and the great art that resulted probably reached greatness because of those constraints. Why demand absolute freedom to 'toss yourself off', as it were—you wouldn't do that in any other discipline. I can't imagine that you could sit down and write a novel if you don't know anything about grammar or how to spell. It's impossible to think you could write a symphony if you couldn't string two notes together. Why is it that the visual arts seem to have a different set of standards? It doesn't make sense. This notion of creativity or 'self-expression'. The fact is that a lot of people have done a great deal of harm by attempting to teach drawing based on a misunderstanding. There was a person whose name I can't remember—and would rather not mention anyway—who got hold of the wrong end of the stick about the teaching methods of Tom Hudson. I taught with Tom Hudson many years ago, and we had a very successful system of teaching life drawing because it which was so intensive. We put a lot of pressure on the students, and they produced drawings of extraordinarily high quality because of that psychological pressure. When we took the pressure off, they went back to their normal standards—but while the pressure was on the drawings were absolutely phenomenal. And this had nothing to do with self-expression. This person whose name I don't want to mention has assumed that all you have to do is encourage the student to 'express themselves'. Now it's very easy to make an expressive drawing, and it is particularly easy if you say: 'What we are going to do, we will draw movement.' What you get is a lot of smears of charcoal, which are attractive, but they have little to do with *looking*. I'm all for mark-making, but I also want to see mark-making combined with an understanding of what that form is.

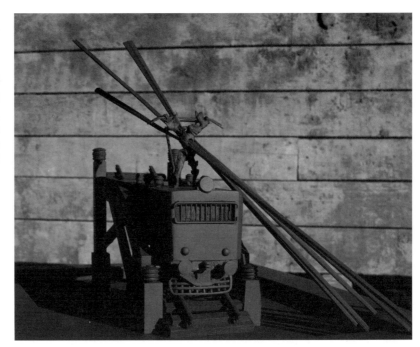

14

The Suicide—or He took the 'A' Train
1: 10 scale model. Wood, epoxy, metal.
Height 27cm x width 40.6cm x length
58.4cm. The proposal intended to be
realised life-size. 1995

(Opposite page)

15
The Viking
Relief bronze for the Erin Arts Centre,
Port Erin, Isle of Man. Height 340cm x
width 245cm x depth 30cm. Study. 1997

16
The Viking
Study. 1997

17
The Viking
1997
Photo: Michael Sandle

18
The Viking
1997
Photo: Michael Sandle

ROBB When you were a student were you taught anatomy?

SANDLE At the Slade we did anatomy. But I always had an ability to draw from a very early age—however, my drawing deteriorated as I became more and more self-conscious. But when I started off, at about the age of twelve, I could draw fairly well because I could see what was there and draw what was there. I could see shape. But it's amazing how many would-be artists cannot see shape, and I feel that they ought to be able to see it. Up to a point you see what you know. If you know what you are looking at, you know what to expect. I found it embarrassing when some students would come into my drawing class at the Art Academy Karlsruhe dressed as artists—big hat and the earring—based on Markus Lüpertz, God bless him—and they would sit in front of the paper and do a sort of scribble. And I would look at them and I could see they weren't looking. They would sit back and there it was. Usually quite awful; sometimes it had a 'naive charm'. I believe of course that it's an artist's right to go in for 'naive charm' if he wishes. But it is unfair for a student to miss the opportunity to have an alternative. He can end up with more authority if he makes the decision 'I choose to ignore the rules' *after* he has learnt to draw. It's then his decision, his choice. It's then about choice and not something which is forced on him by ignorance. Because I don't see how it is possible to justify ignorance.

ROBB If you look at the drawing of the young Lucien Freud (student of Cedric Morris), there is a struggle for clarity. He believed himself to be a poor draughtsman and developed an intensity of looking, examining his subjects.

SANDLE You have to struggle for it, and then when you get it you can simplify and select and hopefully become a master. One of the most sublime draughtsmen was Toulouse-Lautrec, who *could* get it right.

ROBB What was your early training like?

SANDLE It was in the Douglas School of Arts and Crafts (Isle of Man), when I was aged fifteen to twenty-one. I was taught bookbinding, lettering, lithography and lots of very useful skills which have stood me in good stead. I had a very good teacher, Eric Houlegrave, totally unpretentious but he knew his stuff. Amongst other things, he taught me how to sharpen my chisels. I am a self-taught sculptor, but another teacher, Joyce Manley, taught me elementary plaster casting and modelling—this was of enormous value. One develops one's own theories, one develops one's own philosophies, but you have to be able to transfer it into the tangible, you need to know a bit about how to do it. I wasted quite a lot of my life by teaching myself sculptural techniques. I taught myself to weld and taught myself how to use fibreglass. I suppose if I had learnt how to weld I could have saved myself a lot of time but I am very stubborn. No one could understand why it is that I would struggle and break something open and weld it again and again if it didn't work. They could never understand that I saw it like this—the struggle and the effort showed in the end result. Somehow it would inform my view of things. Had I chosen the facile way I would have got someone else to do it for me. It was of enormous value to learn through 'hands on' struggle. I use from time to time quite a lot of assistants, and obviously *you* have to know how to do it, and *you* have to have the authority to say, 'Well gentlemen it should be done this way, for these reasons.' Otherwise the danger is that they take over and say, 'no we are going to do it this way.'

 I have practically come to blows with some of my assistants.

ROBB One of the clear differences between now, and when you and I were students, is that no one expected us to leave at the end of year four as a fully fledged artist. We were clearly told, as students, that we were in training, and maybe if we were the right stuff we might emerge as an artist with a considerable body of work ten or twenty years later.

SANDLE Yes, I think that's a good point. I always thought of it as a lifetime's project anyway and I would expect there to be a long, long period where one probably wouldn't sell anything. Although, oddly enough, my career started as a student. I was very successful as a printmaker. While I was a student I sold prints to a number of museums and had a number of shows—this was because I walked into the St George's gallery as an inarticulate motorcyclist and the owner of the gallery was rather taken with my stuff. But I decided that this was not what I wanted to do, although I had studied printmaking and painting at the Slade. After going to Gombrich's lectures it slowly dawned on me that really I was going to be a sculptor, but not yet. I developed very slowly from painting into sculpture. I don't know why it took so long. I'm glad I'm largely self-taught though, this has given me a degree of freedom from what you should and what you shouldn't do and what is allowed and what is not allowed. Having been self-taught you tend to go into the history of it all in a sort of naive way, like a virgin, and you see that they did all these things. I mean people dealt with terrifying subjects, it's not new to deal with terrifying subjects. Death is now in—but they were always dealing with horrendous subjects in the Middle Ages; death and destruction was one of their favourite subjects.

15

16

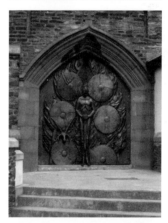

17

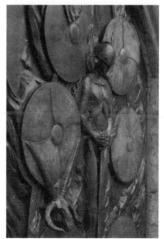

18

ROBB So you wouldn't like to have been Donatello's apprentice? Or worked under Canova in his studio in Rome?

SANDLE No, I'd rather be Canova or Donatello.

ROBB Your drawings were always volumetric rather than linear?

SANDLE I always felt—here I am, my drawing is getting influenced by the fact that I am now a sculptor, and the drawings have to somehow reflect that, and it would be stupid if I did drawings which didn't. I always felt that my drawings were getting better, because I am a sculptor. Had I not been a sculptor perhaps the drawings would not be so concise and have that sort of ability to represent form in a plastic way. An artificial way, because, of course, art is by its essence artificial.

ROBB Looking at your drawings, one can still detect a sense of the printmaker. There is a quality and density which you achieve which is similar to etching or lithography. One could almost think they were etched or printed lithographically, because you have an understanding of what materials can do.

SANDLE Yes, absolutely, a very good point! Printmaking liberated me in a way that nothing else had done, and it had a profound influence on the way I drew. Etching and, later on, using the engraving tool was a way of hacking out a form in a very precise way, and it was like sculpture. In fact, my first sculpture came from a very deeply bitten etching plate that was more interesting than the actual printed image. That was the turning point.

ROBB Presumably also you enjoyed this sense of a process—images emerging through a process.

SANDLE Yes—which you weren't entirely in control of, but by using the engraving tool you could then more or less impose your will. Lithography was somewhat different. Actually my lithographs are more like monotypes. I have two ways of working. One is where the line is important and I work it until I get what I want, I impose my will on it. The other one, like lithography, is a little bit more fluid, more like watercolour. You accept that you are not entirely in control, and you live with the accidents and hope to nurture them. Watercolour is so exciting. It goes wrong, and you think you can bring it back, and it looks wonderful, then it dries out and it's less wonderful, and you think, well, shall I risk it and go on—then you do, and it's wonderful again—and you think—I want it to be more wonderful—and then it could all go to hell, because watercolour is the art of the 'premier coup'—the first strike. You ought not to work it—but of course one does.

ROBB Wouldn't you say that the image can be actually created by the drawing process?

SANDLE Yes, up to a point. But I think you have to know more or less what you are dealing with. It's not like dealing with a set of random marks which might suggest something. I tend to clarify that which I am dealing with through a lot of sketches, which often are like automatic drawing, sometimes you forget them and pick them up later—I find ideas exist in my mind for years. I mean a huge period of time, I showed you the photograph of a model for the man on the train. I was in Canada in 1972—so that's now over twenty-five years ago. I read a report in the local paper, when I was living on Vancouver Island. A man committed suicide

by climbing on to an electric train and the train came to the station in New York with his body burning on the top of the train. I thought— God—what a way to go, what a theatrical image. I kept it in my mind and it was only last year that I thought, why don't I do a sculpture about that? And I started doing a whole lot of drawings about it. So the gestation period is very long for me. I did a lot of drawings last year and I made a model with shafts that were meant to be shafts of light, rather *à la* Bernini. I love the idea of making something as unsolid as light, solid. The sculpture would have to be full size, and I would either have to buy a disused electric train or make it myself. I would be prepared to make it in fibreglass or wood, rather than in bronze, because it would be incredibly expensive, but on the other hand I might even do that if I did it over a period of years.

ROBB But you could incorporate an actual train.

SANDLE Well, I could except I do like the idea of sculpture being permanent. Bronze is wonderfully permanent.

ROBB Could it be clad in bronze?

SANDLE It could be. It could be riveted in bronze or copper, or there is an alloy of copper called Tombac which is quite weather resistant, rather easy to use because it is softer than bronze. But, yes, this is an idea which in an way would be a combination of what I am doing now and what I did then. There is a touch of the monumental here with these symmetrical simplified forms. What one is always trying to do is to perfect a synthesis of the work that one did in the past and the work one is doing now. But this is a very ambitious project and would probably be my last big project. I can't do it now because (a) it is very expensive, and (b) I am not going to do it unless someone says they are prepared to show it and possibly help finance it. But it is still very much in my head. What happens is that these images, ideas that one has, become cannibalised, they go into other things. The process is one that boils away in your psyche, bubbles away, and it has its own time and it comes out when it is ready to come out, rather like the birth of a child—it comes when it is ready to come and you might have to wait a long time. I am not somebody who likes to work to a deadline, and I don't churn the work out, and I don't like artists who do because I think that in many ways they lose the distance. It is certainly one of the reasons that much of the art of the late twentieth century is so poor—the artist is under enormous pressure to produce at speed. The work that I really admire, really and truly admire with all my heart and soul, was done by artists over a longer period of time when art was the centre of their world.

ROBB You talked earlier about the importance of notebooks and how these are so important because they contain that evolution of ideas. It is something which doesn't stop but it is also something that you can return to and bridge that gap and be refreshed or refresh old ideas.

SANDLE This is true. What I do believe is that once you have done it, you have fixed it in your memory. It's a mnemonic process, this is the whole reason for drawing, it strengthens the image in your mind and imagination. If you don't do it I can't see how you can hold them. I can trawl through these images in my mind and I can recall them. Had I not drawn them they would still be in the stage of undigested, or unworked

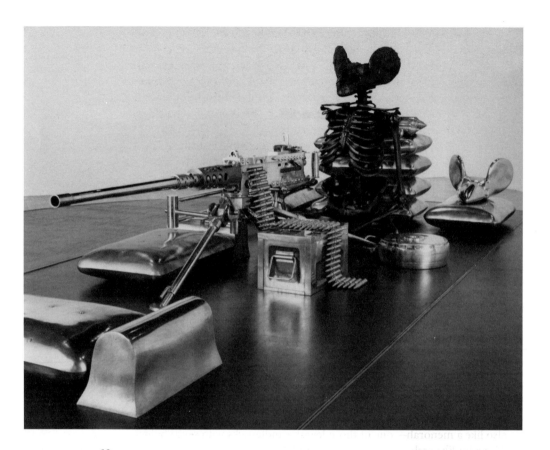

19

A Twentieth Century Memorial

Bronze on a painted circular wooden base. Diameter of base 540cm. Height of central figure approx. 130cm. 1971–78

Photo: Dave Atkins

raw experience. It's a process of attrition. I work through the idea so as to get it right. I don't consider this to be academic because, looking at the history of art it seems to me that every artist in the world works like this. They don't just pick up a paint brush and out it comes. That is a naive and simplistic idea. It might look spontaneous, but behind the illusion of spontaneity is experience and trial and error. Trial and error is terribly important. You say to yourself, what does it look like if I do this? And this might take a long time—but if you don't do it, I can't see how you can develop—I can't see how anyone could.

ROBB Perhaps we could begin to consider that process of attrition in relation to particular works. Let's start with *The Machine Gunner, A Twentieth Century Memorial.*

SANDLE *A Twentieth Century Memorial.* It was going to be called *Mickey Mouse Machine Gun Monument for America.* That's an interesting case. Do you want to know why I changed the title? The impetus for the sculpture came from a visit in the early Seventies to the University of California Berkeley Campus during which I witnessed the National Guard putting down a student riot. The students were demonstrating against Nixon's escalation of the war in Vietnam by bombing the Haiphong Delta. I felt that I should do a sculpture about this war, and my first knee-jerk reaction was that it was all the Americans' fault. However, I researched the war and discovered that seeds for the conflict had been sown by the British (Labour) Government. At the end of the Second

World War a General Douglas Gracey was sent by Britain to Vietnam, along with a small detachment of Indian troops, to receive the surrender of the Japanese occupying forces. He was ordered not to mix in internal politics. He did just that. He refused to recognise Ho Chi Minh as head of state, sprung the interned French forces with the aid of the Japanese and chased Ho Chi Minh and his supporters into North Vietnam. The North/ South divide started then. Even worse, the British Government connived in bringing back the corrupt French Colonial Power against the wishes of Roosevelt—and at a time when Britain was giving up her own colonies. I could hardly point a finger at the US, so I changed the title to encompass global perfidy.

ROBB What's this piece of work?

SANDLE This was an idea I had for a Dresden. A former student of mine asked me if I wanted to take part in a scheme which a society had set up to rebuild the famous Frauenkirche in Dresden. As an English person having a twinge of guilt, I readily said I would do something to take part in raising the money. I was going to do a sculpture, which I called *Mahnmal*, using iron from the Dresden church to cast it in, but I had some doubts about the organisation—they showed me all sorts of knick knacks that they were going to make from reconstituted stone to raise the money. I thought, well I am not sure that this is such a good idea after all and I was quite relieved when I got the letter saying that the whole thing had fallen through, so it is not going to happen now.

ROBB But meanwhile you had completed a large model.

SANDLE Well, I got on with the idea. It is obviously based on a bomber. It is also like a menorah—one of those Jewish candlesticks with seven holders. Also a bit like ecclesiastical furniture, and it has a strange quality because it is waisted in the middle, a bit like an insect or a pupa, with a sinister head at the top of the aeroplane.

ROBB The main support seems to echo Brancusi's *Endless Column*.

SANDLE I wanted this strange architectural piling effect. Now that you say that, there is a touch of Brancusi in that head come to think of it. He did do something I think called *King*. So yes, you unconsciously use things and forget where they come from, and that is possibly true of the head. By the time it is finished it will be a Michael Sandle although it won't be a typical one. I am quite pleased with it in a way because it is so different.

ROBB The Malta research material was exhibited along with *Der Trommler* and *The Machine Gunner, A Twentieth Century Memorial* at Tate Liverpool. What's been happening since that major project to commemorate Operation Pedestal, i.e. the lifting of the Siege of Malta?

SANDLE It is astonishing when I think it is now seven years ago. There have been some smaller sculptures. I took time off—one of the prices of being married, I suppose, and having a young family late in my life—far too late, if you ask me. Never mind. I took some time off to find a place to live in. This farm situated in the middle of such unspoilt landscape is the result. Apart from doing small sculptures I have been waiting, hoping, that someone would give me a commission. In 1997 the Isle of Man asked me to make a sculpture to be placed in front of this disused church. I offered to design a relief, a door which I felt was more appropriate. The Isle of Man has a strong Viking history so my theme became a Viking

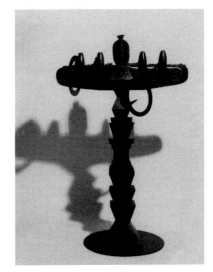

20

Mahnmal

Height 130cm x width 100cm x depth 35cm. Bronze. Edition of 4. 1998

Photo: Michael Sandle

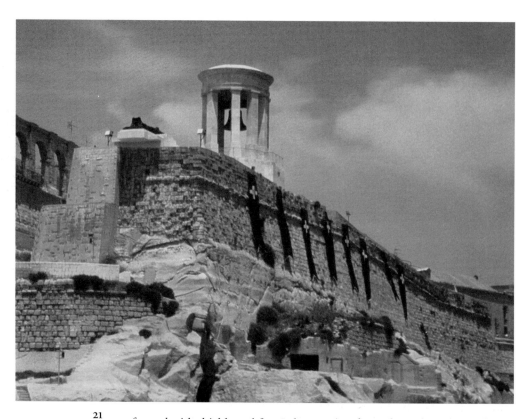

21

The Malta Siege Memorial
For of the siege during World War II,
1940–43, Bell-tower and Bell designed by
Michael Sandle. Sculpture executed by
Michael Sandle, 1998–92

Photo: Michael Sandle

funeral with shields and fire. I chose a view from above down on to the
funeral pyre. Note that the helmet hasn't got horns. I have done extensive
research into Viking history. Vikings did not wear horns at all. However, I
have probably been going through a period of revulsion or apostasy. It
happens periodically when you feel somehow you don't want to be part of
a particular scene. There is something in me which makes me not want to
have anything to do with a particular group of the popular avant-garde
(which is an oxymoron if ever there was one).

ROBB How important do you think it is for the artist to be an outsider?

SANDLE Very important—but I would not like to be a *total* outsider. I only
join things which I believe in. However, as I have got older—and I find
this the most heartening thing—I have come across artists who think like
I do. So that I am not somebody who lives entirely in his own dream
world, at the top of an ivory tower. I have met artists who are younger
than me, sometimes a lot younger than me, who do think like I think. So,
I think there is hope for the future. When I get depressed I think I am a
cultural dinosaur and that what I am doing is ludicrously out of sync, but
I don't think that too much any more. I met a young artist called Kier
Smith and was immensely impressed with his work. He was into the
Italian Renaissance, and you could sense the love, the admiration, the
genuine passion he had for it.

ROBB There have been a number of projects, in which you have invested
considerable time, which have been worked up to full proposals and for
which you were awaiting the results.

SANDLE You do invest a lot of time in public art, and you can't always win

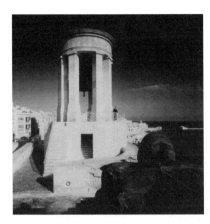

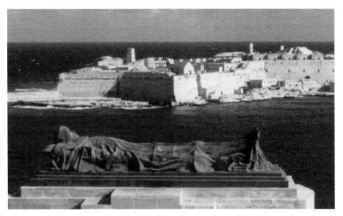

the commission. A recent example is a maquette for an Oscar Wilde statue. The panel didn't like it because they said it was too mournful. I tried to point out to them that Oscar Wilde was a tragic figure if ever there was one. In my rendering, you could see it was (a) Oscar Wilde and (b) he was a tragic figure. This is a rather battered maquette, but I am actually rather pleased with it and I thought that this splendid period base would fit in with it, because in a way it is similar in feeling to—though not as elaborate as—Gilbert's *Eros*. But anyway they turned it down in favour of a rather more cartoon-like exposition. I did an awful lot of work on it, but you have to live with this sort of disappointment.

ROBB A public art practice is very tough. The investment of time on preparation and commitment to an idea and not necessarily to be awarded the commission.

SANDLE Yes.

ROBB And then, because artists want to see their work realised in the best form, that most of the money is used in production costs and there is very little to invest in the next project.

SANDLE Yes, yes. The history of sculpture is full of sculptors who went bankrupt. You get involved in ambition and idealism. It has got nothing to do with making money and usually you overreach yourself. You end up losing money on it, because you are into the thing itself and the developers, etc., don't think like that—they don't have the patience to wait, and usually you are presented with the possibility of doing something long after the planning has been done and it is something you stick in—like an alibi—or the famous turd in the plaza. It is to do with fashion, it is to do with taste. It is do with what is in—the people who have decided what is in are people who are half-literate, half-educated. Everybody these days wants to be an artist. Art has got street cred. There was a time when I felt a bit funny about being an artist, I felt isolated because there weren't that many. But everybody, every Tom, Dick or Harry or as I like to say, Darren, Kevin and Tracey, is an artist these days.

ROBB In relation to the qualities and the judgement that a sculptor is required to demonstrate when bringing off a major project, we seem to have broken the thread with all of that understanding that was present in previous centuries, for instance the appropriate judgement of the plinth to the scale of the sculpture that it displays or supports. Thinking of

22 LEFT
The Malta Siege Memorial
For of the siege during World War II, 1940–43
Photo: Richard Waite

23 ABOVE
The Catafalque
Bronze, length 6m
Photo: Michael Sandle

Donatello's *Gattamelata* in Padua as a superb example of courageous plinth building to exhibit that wonderful equestrian piece—a model for public sculpture up to the First World War. What has gone wrong?

SANDLE It went out of fashion. It existed until the outbreak of the Second World War, and then sculpture came off the plinth, moved away from public places into galleries, into collections and into museums. All well and good, but then one notices the loss of that sort of tradition. Now there is a boom in public sculpture and so much of it is so appalling that it would be better if there was nothing there, instead of that dreadful lump stuck meaninglessly on a roundabout or some plaza which makes me feel how impoverished our culture really is. There is a lack of understanding about the relationship between plinth, scale and proportions. Think of the ludicrous attempt to occupy the empty plinth in Trafalgar Square with Mark Wallinger's figure of Christ. *Ecce Homo* was a life cast, a nonsense in this setting. Everyone is doing life casts nowadays. I am against it. It's a cop-out. Sculptors have lost the ability to model. The scale of a figure on this site should have been one and a half times life-size. Modelling allows for appropriate changes of scale and modifications of proportion. This is vital for creation of the monumental.

ROBB The plaza art of America, the Picasso head, or the Oldenburg bat in Chicago, or the Calder, how do you feel about those looking back? At the time the scale was impressive, the amount of material and so on, in order to capture the spirit of the time.

SANDLE Well I haven't seen the Picasso but I did notice the baseball bat by Oldenburg there. I thought it looked rather well. Yes, there are obviously some things that work quite well. It breaks my heart to say of Richard Serra in Bishopsgate that the scale is right, because I feel Richard Serra is greatly overrated. However, I have this feeling that the old rules, if you like, still pertain, and that people should have the opportunity to study them. The point is that public artists today are not trained. Instead there are people who say I would like to do this, and the lack of expertise, badly drawn figures or the crudity of the ideas, rather shows.

ROBB Picasso took a studio work and blew it up to heroic proportions to fit with the architecture of Chicago, but the quality of the architecture there is very high. Looking at Mies van der Rohe in Chicago, with the baseball bat opposite it, is pretty exciting.

SANDLE There is no reason at all why modern art shouldn't work as public art, and as you have quite rightly said there are cases where it does. However, there are areas perhaps in which an abstract sculpture or a simplified modernistic sculpture is not adequate to convey that which it is intended to be conveyed. All I am saying is that there is nowhere the artists can study public sculpture, and I think that they should. It should be part of the business of a School of Sculpture that people do have the essentials, for example that they should know what a line of sight is. They should know about proportion, and they should know about materials, and they should have historical precedent to work from. They can change them—they can say if they don't like them—but at least they should know they were there—it is all to do with a continuum, in my opinion, and not just the cult of originality.

ROBB Let's get back to your project in Malta, which, I believe achieves a

stunning balance of sculpture and architecture with the bell tower and the steps leading to the tomb, the catafalque in that amazing site in Valetta harbour.

SANDLE I had been doing small-scale catafalques and tombs for years. I was invited to design the memorial to Operation Pedestal (it wasn't a competition) and given the city of Valetta and the site, I jumped at the idea. I had never been to Malta, but when I saw it I immediately fell in love with the Grand Harbour there. It is phenomenal. Phenomenal.

ROBB The enormous fortress?

SANDLE Yes, the walls are wonderful—sublime—sloping up (battered is the technical term) built by slaves in the Renaissance. I thought. 'My God, I would die for this.' Anyway, having chosen the site, it seemed to me on reflection that it had to be architectural, and as I don't trust architects that much, I thought I would do it myself. I always thought of myself as an *architect manqué*. I seized the opportunity, and my first proposal was rejected for a number of reasons. They didn't like the cupola, said it was too brutal although it was intended to look like a bunker or a military installation. It also had a touch of a North African feeling about it which the Maltese didn't like.

ROBB They would rather associate with Italy?

SANDLE They would rather be thought of as European. So anyway it ended up as a neoclassical cupola with a very strong, robust, Roman feel—I believe it is successful. I believe it works very well.

ROBB If we look at the bell tower, the cupola, it is not a decorative building. I was thinking specifically of the design of the pillars.

SANDLE Yes, the design is severe because it is a memorial dealing with war and death, and light-heartedness would be out of place. Being naive, I thought the Maltese would be thrilled to pieces because I really worked very hard on it. I thought it was rather good, but you see the Italophile half of the Maltese don't like the other half, the Anglophiles. So the day of the opening it was criticised in the *Times of Malta* as 'This Fascist Wart'. Very nice, thank you.

ROBB Because of the lack of detail/decoration?

SANDLE Oh, because it has a Roman feeling about it. It is one of the tragedies of the twentieth century that people associate anything neoclassical with fascism, or socialism. Neoclassicism was at one time a language of revolution. The Malta memorial had to be classical and severe; it doesn't mean to say that it is fascist. In fact, it is rather human in its proportions. It is severe in order not to trivialise death and war.

ROBB It brings together a modernist feel with the severity of the memorial. It is monumental.

SANDLE The work relates to a lot of historical architecture which I love. I should think that all artists who know of them love the French Revolutionary Architects—I have been thinking about these people for many years. And when this happens it becomes part of your psyche. The eighteenth century notion of the sublime, which is to do with terror, a kind of concentrated feeling of awe, is part of my apparatus, even though I am not particularly erudite—I am a self-taught artist and a self-taught architect. However, I do look at the historical stuff and if I love it and respond to it, it becomes part of me. If you look at music, what interests

me is that there seem to be different rules for the game for visual art and for music. If you look at the history of composing, they all borrowed and used material from each other. In certain cases Beethoven lifted whole chunks of Mozart. He didn't even change it. They all seemed to incorporate Bach. They are all quoting each other. The visual arts, however, are supposed to operate on this kind of curious notion of originality which I find enormously suspect. I believe that you must have the strength of your conviction, the strength of your personality, using material that is there for everyone, to form your own vision over a period of time. It may be possible that you can leave art school at the age of twenty-three and make the enormously important breakthrough. It may be possible. One of the great artists that I admire was dead at twenty-six—Richard Parkes-Bonnington. Art is not the prerogative of middle-aged men.

ROBB You have a desire, not necessarily but maybe to compete with the artists of the past because you admire them.

SANDLE Well, it's a challenge, isn't it? I cannot be bothered with the sort of line where you say all of this is obsolete, it has all been used up, it is no longer relevant. People have said painting was dead. They said that not long ago 'Don't you know painting is dead? Sculpture is dead?—Do installation video, cut your prick off while the cameras are running.' I don't believe a word of it. It is up to the individual to make his own environment—as far as I am concerned the art of the past is in the present. I am looking at it now. Right? And there would be something very wrong if I couldn't respond to that and say well, I can take some of that, you know, because it speaks to me. It grabs me by the throat. Why do I have to limit my creative œuvre by thinking I only can do what the cultural Mafia say I should be doing. I have seen so much of it before. There is sub-Beuys everywhere. I have seen it about thirty years before. Instead of showing you this sculpture, which is the result of a lot of effort and thinking and attrition, I could say well, this is my piece, this table covered in junk. I would have more chance of exhibiting that in the modern art gallery than I would with a sculpture. Today people do not want to have art, they don't want to have artists who are better than other artists. They want irony, they want distance. They don't want people to deal with strong emotions and who have the gall to want to be able to go in for the pursuit of excellence. They consider that to be reactionary and authoritarian.

ROBB We're talking about a continuum, which has been broken in the twentieth century, particularly after the Second World War. The specific focus on New York School abstraction meant that the strong European tradition in figurative painting and sculpture was not renewed.

SANDLE Yes. Traditions in sculpture were—for a number of reasons—not renewed. That kind of public sculpture went out of fashion, but it could suddenly become enormously fashionable again. You must have seen the Sackler Galleries in the Royal Academy where Norman Foster has done that rather good conversion job—those superb sculptures by Thomas Banks and other wonderful neoclassical sculptures look so good in that environment. I am hoping that one day a major contemporary architect like Foster will suddenly say 'Right, let's have some sculpture!' People say

to me that all that glass and concrete and those clean lines rule out any kind of sculptural embellishment or 'lipstick on the Gorilla'—to quote Foster's famous but somewhat facile remark—in fact Foster (or one of his partners) has already created a situation with the Sackler Galleries that brought the past successfully into the present—which is exactly what I have been trying to do all my life

ROBB Let's move on to a major proposal for the *Millennium Bell* for Portsmouth Harbour.

SANDLE Portsmouth was in only a speculative site. It won't in fact happen. I got the idea to do another large bell tower because, as I said before, I am something of an *architect manqué*, and since Malta I find the idea of working on a huge scale exciting. I felt maybe I could come up with a really, truly monumental project this time—I had been working on this for some two years, possibly longer. Very many influences have gone into the project. There are a lot of my thoughts about French revolutionary architecture, and eighteenth century architecture in general; and there is a bit of Tatlin and a lot of Lutyens in there. I love Victorian bridges and the over-engineered massiveness of them, nautical engineering like the pedestals of the Firth of Forth railway bridge. They have that sense of scale which we don't see any more, because now it is all done by computers to save weight and cost, and everything tends to be rather slender and lightweight. I thought I was approaching a piece of architecture from a different agenda than that of an architect. It is intended to be a monument, and I believe that I have succeeded in so far that the design is truly monumental.

ROBB This is a proposal in which a gigantic structure will contain a bell weighing approximately twenty-one tons.

SANDLE Yes. It would be the largest bell ever cast in Britain. The largest to date is seventeen and a half tons—Great Peter, which hangs in St Paul's Cathedral in London. Twenty-one tons is possible—there is a twenty-eight ton bell in Cologne Cathedral.

ROBB It is a major engineering task to simply support this.

SANDLE Yes. It would be very exciting to be able to put it up in the enclosed sound chamber I have designed for it. My experience in Malta was that the bell there was too exposed to the elements, and as a result the mechanism went wrong. The quality of the sound will be improved by having the bell contained and the sound coming out of louvres. Also—in terms of the mythology of the piece—the conical shape of the sound chamber is like a womb and this is surrounded by six phallus-like towers: *A Bride Stripped Bare by her Bachelors*. It is very phallic—but the main part is a womb. And the womb houses the bell.

ROBB Its site?

SANDLE It needs to be set in water. It just so happens there has been a huge development taking place in Portsmouth on ex-naval MOD land. Portsmouth would have been an excellent site because of its historical connections. All of this happened after I had the idea; and the suggestion that I should think of Portsmouth came from Lord Palumbo, who was the Chancellor of Portsmouth University. His passion is architecture, so he has been very supportive. English Heritage liked the design because my idea contains historicity; it is not done from the agenda of contemporary

modern architecture. It is an attempt to encapsulate one thousand years of history through various styles of architecture, starting from something archaic. Its height was set at 90 metres. It has massive, I mean really massive pedestals which I think are very exciting. An architect would think they cost too much. The design is not cost-effective. But bollocks to that. It is to do with monumentality. It has got a slight subliminal Indian feeling about it. I have shown these photographs to a lot of people and I have had a lot of support, including the man from Ove Arup, who I asked to look at the construction side. Would it work? Would it fall down? He said it would stand up and it was a marvellous design.

ROBB One term that has been used a lot over the last ten years in relation to public art and the debate about the nature of public art, is 'site-specific'.

SANDLE That is a hideous term invented by arts officers. It is a dreadful word. It is almost as bad as 'public art', which sounds a bit like 'public convenience'. My *Millennium Bell Tower* idea, I have to admit, wasn't site-specific. I once approached Leicester, because I thought the tower had subliminal Indian content and would connect with Leicester. They said it wasn't site-specific, so that was it. Rubbish, of course. But if you did apply that term to Portsmouth, it would work extraordinary well. Because one of the ideas behind these rather exciting sloping columns or pillars was thinking about battleships—a spin-off from Malta, where the brief was Operation Pedestal, the convoys. Battleships have in fact long been a part

24, 25, 26 & 27

The Seafarer's Memorial

Winning proposal. To be sited at the International Maritime Organisation Headquarters, London. Model scale 1: 11, height 90cm x length 60cm x width 60cm to be realised in bronze 7.5m high, 2000

Photos: Michael Sandle

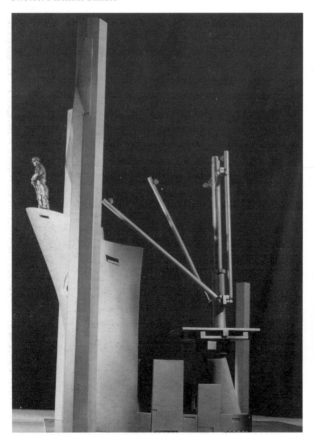

24

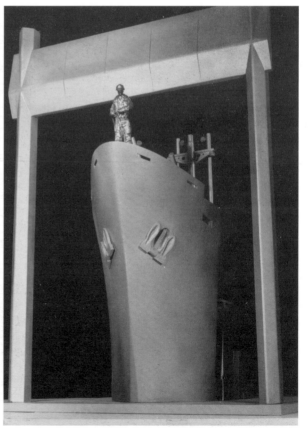

25

of my iconography.

ROBB So you see a sort of spiritual link between Portsmouth and Malta with two bells?

SANDLE It is not so far. Malta is architecturally by far the most overwhelmingly beautiful site, but Portsmouth has a touch of Malta. Granite, however, instead of limestone. Portsmouth is flat, but it is a historical harbour of enormous importance. My project would have been marine architecture, which I find just incredibly exciting. It is designed to stand in water. Bells and water go very well together. Sound travels. People can go up those pillars. All kinds of activities can take place in there. I don't really care what they do. I am only interested in the monumental quality. But people go up the Statue of Liberty. They go up the Eiffel Tower.

ROBB A wonderful example of monumental sculpture that springs to mind is Jagger's *Artillery Memorial*, your favourite.

SANDLE Only the American critic Robert Rosenblum still talks about him. He is one of my heroes, and one of my influences. Sargeant Jagger—he really was a relative of Mick. His major work, the *Artillery Memorial*, stands in London's Hyde Park, opposite another very good but academic First World War memorial from Derwent Wood—who studied in Karlsruhe. Wood did the *Machine Corps Monument* of a young man holding a sword and two machine guns left and right. Academic but well

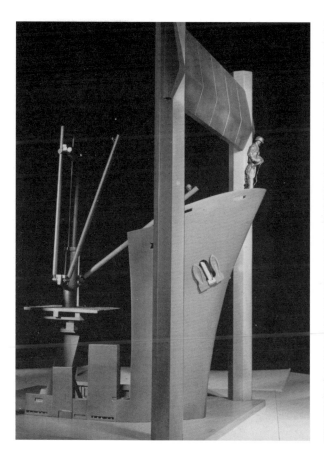

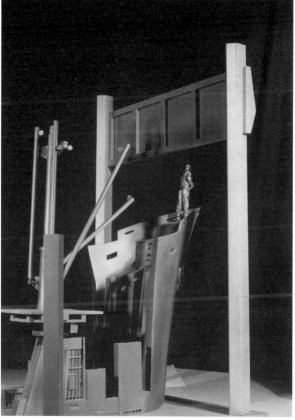

done. But I really do admire the Jagger memorial. It is stupendous in terms of its scale, powerful modelling and the use of archaic elements. The figures are wonderfully judged with increase in hands, feet and equipment to great dramatic effect. Sadly there is a deterioration in the stone which needs urgent attention. But the scale between the figure and the plinth is perfect, creating a great monument. It is forgotten that the plinth is so fundamental for the vision of sculpture. The monument is timeless. It deals exactly with the subject. It deals about death, it deals about the machinery—about the workings of war. I admire it a great deal. I think it is one of the greatest pieces of public art in Europe.

ROBB It is a collaboration between the sculptor and an architect.

SANDLE Yes, the architect was Lionel Pearson. But Jagger did the business—it was his idea. He designed it and did the stone carving. The odd thing is that the grandfather of my wife Demelza's ex-boyfriend, helped carve it. An Italian called Giudici. I don't like all of Jagger's work, but he seemed to have a wonderful ability to work with architecture. His figures for the ICI building are tremendous, particularly the one representing *Marine Transport*. He did a very powerful crucifixion which reminds me of work by the South German medieval sculptor Nikolaus Gerhaert in Baden-Baden. The man was so good! He was dead at forty-eight. It makes me feel guilty. Sometimes his work goes in a decorative direction; he didn't get it right all of the time, and some of his drawings seem to me to be almost verging on pornography. But what a tremendous amount of work! What power! What commitment! Also he wrote a book on sculpture which I read when I was a very young student—full of common sense and an obvious love of his craft.

ROBB You were born in 1936, so you would have been nine when the war came to an end. You must have memories of the bombing and so on. In my own case it is all sorts of things, an anecdotal history brought back by family members, of artefacts in attics, bits of bomb, a bayonet, and uniform, from both Europe and the Far East. And endless discussion, debate, dialogue about the war. Now you taught in Germany for a long time, more than twenty years. My experience with German students, when I asked the question, 'What did your parents discuss?', was that there was almost a total silence. What is your experience as tutor with your background, when you worked in Germany?

SANDLE That is something that was rarely discussed. For obvious reasons. It must be extremely painful for them to be constantly having it rubbed in their faces, particularly as they are students who were born after the war and are totally free of guilt. I know of a case where one young painter, not so young now, became interested in his past and the fact that his older brother had been an ss officer. The older generation in particular get very agitated, or sometimes very angry. I remember going to a dinner party with the then director of the new, huge, art and media centre, the ZKM in Karlsruhe. When the subject of the Second World War and the resistance came up he got very angry. He said people were always concentrating on the evil and not enough was mentioned of the people who did resist and lost their lives. Of course, the trouble is—there weren't enough of them.

ROBB You were at a conference, a few years ago, which attempted to deal with the architectural legacy of Nazi environment.

SANDLE Yes, in Nuremberg. That was interesting, because there was clearly a lot of guilt about actually admitting that they, the Germans, found the architecture exciting, but because of its provenance they felt really ashamed of it. I know that some of the architecture had been blown up by the Americans. It was destroyed because they didn't want it to be seen as a monument to the Nazis. But the point is that the Third Reich did happen. The architectural evidence should be preserved. It would be a terrible mistake to destroy it all.

ROBB Of course the Olympic Stadium is still in use. One of the Berlin teams plays football in there.

SANDLE Albert Speer was in fact a rather good architect. Anyhow, I decided I wasn't going to take part in the discussion, because here were these people examining their conscience and getting a bit neurotic about their history, It would have been unreasonable for a foreigner to have rubbed salt into their wounds. But what struck me as an irony, what I found fascinating, driving into Nuremberg, was to see a huge poster advertising a concert of music by Carl Orff and Richard Strauss. Now, in the conference attacks were made on people like Arno Breker etc., and I thought to myself: 'Here we have a symposium on the Nazi inheritance attacking Breker and the like, what about Richard Strauss and Carl Orff?' Richard Strauss was the president of the Reichskammer of Music, a figure-head for the Nazis, but he got very quickly rehabilitated, as did Carl Orff, who was also a favourite of the Nazis. How come that there always seems to be double standards for the visual arts and for music?

ROBB I like to make an equation between Adolf Wissel—a Southern German rural painter who was very popular with the Nazis—and the American ruralist painter Grant Wood. Apart from the scale of the pictures, perhaps, there is a terrific commonality between them. And yet Wissel was exhibited recently in the German Romanticism exhibition as official Nazi.

SANDLE I find it rather irritating that people get very emotional about Nazi art, but they won't actually look at it. It wasn't *all* bad. Why should it be *all* bad? I am sure that in the Renaissance some of the people who gave the commissions weren't the nicest lot. Political correctness is something I find very worrying, particularly as Expressionism was very nearly the 'official' Nazi art, and would have been if Goebbels had had his way. People seem to overlook the fact that Emil Nolde, for example, was a rabid Nazi. He was the first person to join the Nazis, he held Nazi Party card Number One and was heartbroken when he was thrown out.

ROBB Do you feel that you actually suffer from the labels which people attach to you because of these references?

SANDLE Some people think I am a fascist, which I find remarkable. I don't mind them saying I am reactionary, because up to a point I am, but I do find these facile labels absurd. It doesn't really inhibit me because I know that it is nonsense. I know that I am not a fascist. However, I am quite egocentric. Right? I don't take crap from anybody, but I don't push my ideas down other people's throats.

ROBB Let me come to your most recent commission to design a monument for the International Maritime Organisation's Headquarters on a rather splendid site on the South Bank of the Thames in London.

SANDLE Yes—the *Seafarer's Memorial*. What really pleases me is that it will be sited almost opposite Jagger's wonderful sculpture *Marine Transport*, which I've always admired, on the ICI Building across the river. However, the site is in fact a difficult one as it's one of seven identical bays at ground floor level, in a huge and rather anonymous building. Only a large piece would work here. My idea is for a twenty-five foot high sculpture, in bronze, based on a pre-containerisation cargo ship. The sort of classic cargo ship whose outline has not changed much from the late nineteenth century until fairly recently. I've concentrated on the bows of the ship and a platform supporting the mast and loading booms—the parts being an analogue for the whole. I'm putting the Admiralty type anchors on the bows, rather than modern ones, because I prefer the shape and because I want to fix the ship's origins in time. The *Seafarer* is standing on the prow of the ship dressed as a contemporary 'marine operator'—complete with hard-hat because this type of cargo ship is still in use. The vast scale of the building means the figure will have to be over life-size. This will be a critical factor because if the figure is too big the ship will appear too small, if the figure is not big enough it will not read at twenty feet above street level. Definitely no life-casting here. In order that the *Seafarer* can be seen by anyone approaching the building obliquely, the prow and the figure have to project from out of the bay and over the pavement by about five feet. I've worked on the model since the photographs were made, and the side-elevation of the bow section is now 'tougher'.

ROBB So everything is ready to go?

SANDLE Planning permission is set to be given. Thank God! If I had been forced to radically alter my concept, particularly where the prow of the ship projects over the pavement, I would very likely have pulled out.

DUNDEE, 24 OCTOBER 2000

SITUATIONS

28

Ecce Homo
White marbleised resin, gold leaf, barbed
wire. Life-size. Installed at Secession,
Vienna, 2000. 1999
Photo: Matthias Hermann

Mark Wallinger
in conversation with
Kathrin Rhomberg

MARK WALLINGER

Born 1959 in Chigwell, UK
Lives and works in London, UK

The public conversation between Mark Wallinger and the curator Kathrin Rhomberg accompanied the exhibitions of the artist's work *Ecce Homo* and *Threshold to the Kingdom* at the Secession in Vienna, Austria, in 2000

Photographs © Mark Wallinger

All photographs courtesy of Anthony Reynolds Gallery, London

29

Half-Brother (Exit to Nowhere/ Machiavellian)

Oil on canvas, 230 x 300cm. 1994–95.

Tate Gallery Collection, London

KATHRIN RHOMBERG I would like to start with the catalogue of the exhibition. Included there is an essay by the English critic Adrian Searle, who writes that Mark Wallinger is a 'singular, devious and deceptive artist'. Can you live with that?

MARK WALLINGER Devious is a bit presumptuous, isn't it? No, I can live with that.

RHOMBERG This statement was made in connection with your work from the eighties. But before we start to talk about the work from that period I would like to continue with Adrian Searle. He describes in the next sentence the artistic practice of Mark Wallinger as 'devious in the methods and deceptive in the sense of pinning down exactly what it is that he has to say'. He also says that you are 'often telling us one thing and ending up saying something quite different'. Is this true?

WALLINGER In a way, I hope, it is. I like to have my cake and eat it too. Especially in the eighties, in the early work, I was dealing with images of national identity and images that are rather familiar if not clichéd, to do with English art history, and presenting them in a way that actually undermines the normal assumptions about their meanings. It was a way of getting under the skin of—not exactly of the national character—but of certain aspects that were handy for the political moment, for the politicians and the situation as it existed in the eighties.

RHOMBERG What does the term 'Englishness' mean?

WALLINGER I do have a little trouble with the term. I think this aspect has been overplayed in respect of my work. People don't talk about Jasper Johns as being very American because he paints the Stars and Stripes. But Englishness to the English always sounds slightly parochial. I just felt it was important in the eighties when there was a kind of pressure through art schools to make the international style work that was being peddled around in various group shows and the art fairs. It seemed to me that one has to be true to one's own community in order to be able to reach out and have any meaning to other people. Englishness as an issue was almost by necessity part of examining how we get saddled with a national identity, how we find our allegiances and how that is then deployed or exploited by people running the country. Thatcherism looms rather large over my work in the eighties so one can't avoid mentioning her, really.

RHOMBERG How was life for you as an artist in the eighties, living and working in London? Thatcherism was very specific time in England. Did you work directly with this situation as an artist? Did the situation reflect on your work?

WALLINGER They were strange times. We suddenly had the most right-wing government since the war. We were engulfed in a war with Argentina about some remote islands. There had been a kind of consensual politics up until pretty much the point when I became of voting age. Thatcherism was very devisive, if you think about the Falklands War or the miners'

strike. The latter went on for a year and was a very planned conflict to break union power in the country. It was quite shocking. Suddenly monetarism became the dominant ideology so that everything else went by the wayside. And for the lack of community values they appealed to the more jingoistic right-wing instincts of the electorate.

RHOMBERG It was also the time of painting, especially the late eighties.

WALLINGER There was a new spirit apparent in the painting show at the Royal Academy which was a version of the *Zeitgeist* show in West Berlin. The painting of Neo-Expressionism was revived. It proved influential because I hadn't had any kind of art education worthy of the name. I rode along with that style for a couple of years. However, I took a part-time MA course at Goldsmiths College for a couple of years. The paper I wrote during the first year became quite important to me because I found myself pursuing an argument in which Neo-Expressionism was no longer tenable as was working with clapped-out rhetoric. In a sense, from then on I saw painting as having passed its moment in terms of modernism. Its trajectory had already fallen to earth in the sixties. What happened from then on could necessarily only be a pastiche.

RHOMBERG You are known as an artist who works in different media. When did you start working with painting, video, sculpture and so on?

WALLINGER In the mid-eighties. Paintings as such are very saleable, they are trophies, but they don't actually, in themselves, reach out to some other discourses. There are just too many other issues that couldn't be contained within painting. It didn't seem to me that painting was the dominant medium any more.

RHOMBERG In the early nineties you created paintings around horses, horse racing and horse breeding. I'm thinking particularly of a series of works entitled *Race, Class, Sex* and *Half Brother*. They are realistic portraits reminiscent of the work of the eighteenth century English painter George Stubbs. What is the basis of your interest in horses and other icons of Britishness like football or the British Empire? You often wrote about these icons during the 1980s.

WALLINGER It seems to me that sport in general was a strangely unexamined area. There were very few discourses about sport. Sport, and football in particular, was very much confined to the back pages of newspapers, and, generally, it was perceived as a working-class interest that we didn't have to analyse. It just seemed to me too rich an area to ignore. But horse racing has always been a love of mine anyway, and I've always found thoroughbreds the most beautiful creatures. For many years I avoided making work about that because I wanted to keep my passion separate from my art. But in the end the opportunity was too good to be missed. *Race, Class, Sex* was the first of those works—life-size paintings of four stallions which Sheikh Mohammed owns. Sheikh Mohammed is the biggest player in world horse racing. When I made the work in 1991–92, it seemed to me that he was actually involved in an anti-colonial reclamation because originally three Arabs stallions were brought to Britain at the beginning of the eighteenth century and form the bloodlines of all thoroughbreds. And now Sheikh Mohammed is buying back the breed. I have also always been interested the supposed 'standard pose' of the thoroughbreds. This pose still features in all the stud books

30

Half-Brother (Diesis/Keen)
Oil on canvas, 230 x 300cm. 1994–95
Private collection, Belgium

31
Seeing is Believing
Screen-printed light-boxes. Three parts,
each 127 x 127 x 20cm. 1997

and goes all the way back to George Stubbs. I thought it interesting that I was painting horses in a direct line of male descent, all the way through from *Eclipse*. I was painting a horse twelve generations later. I thought this was an interesting way of finding an affinity with the tradition of painted horse images.

RHOMBERG Was your work then also concerned with nationalism as part of the notion of Britishness? As you just mentioned, you were focusing on horses and horse racing which seems to refer very specifically to Great Britain.

WALLINGER The English upper class—the aristocracy—have been concerned about their own personal breeding and have traditionally been the owners of horses. In a sense, it comforts them to find proof that a kind of eugenics works, that if you put an Oak's winner with a Derby winner you are ninety-nine per cent certain to get a better horse than with the two ordinary thoroughbreds. It says a lot about attitudes that still hang around in Britain today. There is still a culture of deference. And the racing world in itself telescopes social relations, as well. There are exaggerated differences apparent: Horse racing is definitely a sport of the upper class and the working class, but there is no real middle class.

RHOMBERG You were invited to Windsor Castle to meet the Queen. Did the horse issue came up?

WALLINGER Being a good republican, once I was invited to Windsor Castle I didn't hesitate to attend a reception for the arts. The majority of invited guests were actors and TV people. Only a few artists were around and pretty much the whole Royal Family was in attendance. A friend of mine was determined that I met the Queen. So he shoved me forward, because I'd been racing a couple of days beforehand at Sandown Park and the Queen Mother had been there too. The first thing I said to the Queen was 'I saw your mother at Sandown Park on Saturday', which was enough to stymie any further conversation.

RHOMBERG In the late 1990s you started to create larger groups of works including *Seeing is Believing; Upside-down and Back to Front, the Spirit meets the Optic in Illusion* or *The Importance of Being Earnest in Esperanto* and *Angel*. All these works, motions or conventions are disrupted by inversions, sentences are reversed or slowed down or spoken in a distorted voice or in Esperanto. This work seemed more serious in comparison to earlier works. Is this right? Did these works mark a break within your œuvre?

WALLINGER Yes, there was a kind of break. A lot of the work through the

eighties quoted from art history. Because it came in a variety of forms, I had an audience that was slightly confused about where I was coming from, and the work that used racing for three years was a way of compacting all that and presenting it in a way that you had to unify to see. But at the same time, for me there was a growing sense of familiarity with certain tropes and devices, satiric reversals and so on. I felt that I needed to challenge myself more. I became increasingly interested in illusions, viewpoints and perspective—how Masaccio's and Brunelleschi's invention or discovery of perspective—whichever way you perceive it— formed an almost different kind of consciousness. Up to the Renaissance, icons operated with a kind of visual resistance. With the development of a new sense of perspective the viewer became implicated within the pictorial scenes. There and then we entered the interactive world with the promise of something that never quite arrives. We still suffer from the same kind of alienation, but we continue to search for this Holy Grail: a way of grasping the world that's a little more secure and forgiving than the one we have got. The internet is just the latest in a long sequence of these defining moments. Illusion became important to me in that respect; and puns. But puns have always been a favourite of mine because they actually show where language breaks down, where it just becomes a convention of noises. I made a few works in which the opening of *John's Gospel* plays a central role: 'In the beginning was the Word, and the Word was with God, and the Word was God.' You can say that the first five verses in particular constitute the best expressed theology in the *Bible*: Christ as the *Logos*. But, also, if you actually think of the word literally as language, and not as Jesus made flesh then it deconstructs that whole notion as well, i.e. there is nothing outside of language. 'In the beginning was the pun', as Samuel Beckett wrote. Illusions became important to me because they both beguile the viewer but once the trick is mastered one is returned to an alienated state.

RHOMBERG Two years later, in 1999, you created *Ecce Homo*. Can *Ecce Homo* be seen within that line of work dealing with illusions?

WALLINGER *Ecce Homo* evolved in response to a specific brief. There was a plinth in Trafalgar Square that had been vacant ever since the square was laid out in 1830. The idea of using that moment when Christ is brought before the multitude, who act as a kind of lynch mob, interested me for a number of reasons. I think it was important that the figure was life-size, that it operated as a kind of inversion of all the other statues in the square. The latter are like trophies and triumphant scenes of empire, and they are huge and black and oversized. Yet my figure of Christ was life-size and white.

RHOMBERG To understand this situation better, maybe you can describe exactly what Trafalgar Square means to the British.

WALLINGER Trafalgar Square has always been the place where people gather for protest and celebration. It is a place where people go on New Year's Eve to celebrate the New Year. In the past it was the site of public hangings. The first English socialist martyr died there. For many years a vigil for Nelson Mandela took place outside of South Africa House. It is a place where people go to make a point, and it is the place of the crowd in London. To me it seemed appropriate in the context of the coming

32

Upside Down and Back to Front, the Spirit meets the Optic in Illusion
Glass, water, plastic, mirror on plinth,
148 x 80 x 80cm. 1997

millennium and the context of that place and its significance, that I should pick this moment of the *Gospel*. At this point, Christ hasn't been crucified and he hasn't risen from the dead. He is essentially just a man with some persuasive ideas and rhetoric, and maybe a political leader, but only that.

RHOMBERG Are these the reasons why you decided to show or to create *Ecce Homo* for this specific situation or did you already work on this subject before the commission?

33
Ecce Homo
White marbleised resin, gold leaf, barbed wire. Life-size. Installed in Trafalgar Square, London. 1999
Edition of 3 and 1 AP

WALLINGER I made some video works which examine Christian language and the rhetoric of beliefs. Therefore, it wasn't such a leap to get to this work. It then became a question of trying to get it made in the best way possible. I always thought that the sculpture should be the image of a specific individual rather than a generalised figure.

RHOMBERG You decided to make a life-size figure, cast from a man of approximately the same age as Christ who I think was thirty-three years old at that stage. Why did you conceive a work for this specific situation in Trafalgar Square, for the empty plinth? Why was the plinth left empty in the first place?

WALLINGER On the corresponding plinths across the square is a statue of King George IV. William IV did not leave sufficient money in his will to pay for a corresponding statue. No one else could be bothered to raise funds. Ever since, the plinth has been empty for the lack of political will or impetus to get anything there. I think it is probable that my proposal for the plinth only went successfully through all the various rather conservative committees because of the intended temporary nature of my intervention.

RHOMBERG Was *Ecce Homo* always meant to be temporary?

WALLINGER No, when I was first approached—although everyone is denying this now—it was said that perhaps the most popular of the three works would become a permanent fixture. I think this aspect is important because I made my work with the intention of it becoming permanent and not as a kind of temporary stunt. I conceived a sculpture that would stands the test of time, a serious proposal, not an object with which to seek attention for as long as the media are interested.

RHOMBERG It is interesting that *Ecce Homo* is a sculpture conceived for a public space. After it completed its turn on Trafalgar Square you decided to show it at the Vienna Secession. You already knew the exhibition space of the Secession quite well. It is the first 'white cube' space. In short: a totally different situation compared to Trafalgar Square. Why did you decide to show your statue at the Secession in this way?

WALLINGER In producing the work, there are certain kinds of philosophical decisions to be made which go beyond immediately obvious details such as the fact that the figure will be positioned eight metres off the ground that he has his eyes shut, the specifics of the pose, and so on. In making the figure I saw it under various lights and was 'intimate' with it. And even though it was designed site-specifically, i.e. it was made to look precarious at a great height, I felt that certain things that I got intimate with got lost. The fact of the figure being life-size worked for that specific space, but, actually, you couldn't meet Christ life-size, you couldn't meet him as if he just stood there. I was thinking of the equivalent scene in Pasolini's *Gospel According to St Matthew,* where you see Christ as if you are part of the jostle in the main square when he is brought out and taken away. It feels like, 'Did it really happen?' This scene is so shockingly ordinary. I wanted some of that quality. Also, the substance of the marble resin and the way the different lights play over the space and the surface— all the natural light—became important aspects for the work. Perhaps the Christ figure could command that space and give something different back at different times.

Ecce Homo
(See plate 28, p.39)

RHOMBERG The specific situation of the Secession space is marked by its architect's intention. Joseph Maria Olbrich wanted it to be a combination of modernist style and sacred elements. The ground floor is shaped like a basilica. If you show a religious figure in this space suddenly it becomes very sacred. Unfortunately, I couldn't see *Ecce Homo* at Trafalgar Square, but I think that its perception there was totally different—more a human being standing on the plinth—very lonesome. As the figure is life-size and high up on the plinth it appeared quite small in comparison with the other monumental sculptures. Did you intend to give *Ecce Homo* this more spiritual quality?

WALLINGER Well, it kind of happened. I had made a number of works over the years that have sought to comment on how the aura of the gallery or institution sanctions or sanctifies certain works. This included owning a racehorse as a work of art which had to exist totally outside a gallery. I knew that putting *Ecce Homo* in a basilica-type space—even though it pretends to be the modernist white cube—something different would happen. Hopefully the light and the space here would lend it a slightly different emphasis. I thought it was necessary to make something that could be seen as a contemporary Christ. I couldn't help but to think about the fact that Christ was a Jew, and about the fate of the Jews in the twentieth century. But also in more general terms, it relates to political prisoners in other, more contemporary conflicts—the shaving of all hair is the ritual humiliation of the political prisoner. It surprised me how unsurprising Christ's boldness is in the space here. It seemed more shocking or specific than in Trafalgar Square.

RHOMBERG Seeing *Ecce Homo* on the pedestal at Trafalgar Square I can imagine that as a viewer you see the work in a very ambiguous way: it could be both a very radical or extremely reactionary work. In the Secession space the work is perceived differently. Maybe it has lost a bit of its ambiguous quality and become a more serious work.

WALLINGER The fact that Christ appears plainer here, that his eyes are shut and that he is facing up to his fate, i.e. that he internalises this crucial moment, becomes stronger in the Secession space. The vulnerability of a small figure on the edge of a huge plinth does so much but here, the actual specifics of the pose and some of the aesthetic decisions I chose to make come much more into play.

RHOMBERG We also need to discuss the change of the socio-political context, not just the change of location. Christian religion in England is dominated by the Anglican tradition which is based on a totally different perspective of the history of Christianity compared to Austria which has always been a Catholic country. And Catholicism has a very strong influence on the whole Austrian society. Even though the Church has lost some of its importance it still influences every section of our political and social life. Did you think about the possibility that your figure of Christ could maybe take on a different meaning in Austria compared to London?

WALLINGER Because I don't come from a Catholic society I couldn't quite predict how *Ecce Homo* would work in Austria, but I believe it worked. The Anglican tradition is a strange version of Christianity. The monarch is the head of the Church. Because of the Reformation we are a Protestant nation, there is no public statuary of a religious nature. In that respect,

Ecce Homo was quite a challenge to the normal order in Trafalgar Square. But it also was a kind of heresy against secularism: something nakedly about Christianity coming up to the Millennium.

RHOMBERG Maybe it would be similar if *Ecce Homo* would be shown in the Republic of Ireland or in the Catholic parts of Northern Ireland.

WALLINGER I think that would be interesting because in a sense the western art tradition is a Catholic tradition. The Unionists, that is, the Protestant community in Ireland might have a problem with any manifestation of Christ at all.

RHOMBERG I think one of the differences between Austria and Ireland is, that we have a specific past. We have two thousand years of violence and brutality also caused by Christianity. Catholicism and nationalism were extremely intertwined. For me that aspect is interesting because *Ecce Homo* in Austria has to be seen in this context. Our history is different from English history, of course. Theodor Adorno once said that poetry after Auschwitz is no longer possible. His famous statement ignited an ensuing debate in the German-speaking countries as to whether, after Auschwitz, after the Holocaust, it would be still possible to visualise ideas. Also if you look at the development of contemporary art, I am not sure if there are artists who are dealing directly with religious themes.

WALLINGER Going back to what you were saying about whether *Ecce Homo* was reactionary or radical. Britain supposedly is an Anglican nation but very few people go to church and we have no written constitution, and yet

34

The Importance of being Earnest in Esperanto
Found video, 100 chairs. Emmanuel Hoffman Foundation, Depositum Museum für Gegenwartskunst, Basel. 1999

we have a national religion that is wedded to the Royal Family. It's a complicated series of relationships. But what interested me was presenting that moment in the Gospel in a way that actually did make it problematic. My work did seem to be citing too directly what has been the dominant religion in the western world. It actually challenges some of the politically correct orthodoxy that pertains in Britain, and in London in particular. Although we pretend to embrace a multicultural society, to directly cite something Christian is the biggest heresy at the moment. Even though when one thinks about the laws that underwrite British society or Austrian society—which I think might be pretty much the same—they are predicated on the belief in the supernatural. That's quite a strange thing. We get our morality from the belief that you live on after death if you have been good. In that sense it makes this story strange again. I hope with *Ecce Homo* to make Christianity something that is too visual and present, something other that is feared because it isn't understood. I was also interested in the fact that there are very few sculptural precedents of *Ecce Homo*. There are paintings of *Ecce Homo* but not sculptures, because—perhaps—it's too problematic for an orthodoxy of imagery to be arrived at, whereas the Annunciation and the Crucifixion had become almost formal plays on a theme.

RHOMBERG In painting, particularly of the baroque period *Ecce Homo* was very often shown as a separate, devotional figure, if you think for instance of Caravaggio. I think the way your figure is displayed at the Secession, on its own in the 600 square metre space, its function automatically becomes religious, devotional. As a visitor you are faced with this figure of Christ and thus you are confronted with the history of Christianity.

WALLINGER I should emphasise, which I haven't thus far, that my figure places the viewer in the crowd that did call for Christ's blood. It was important to me to make that point. I hope the contemplation of that very moment necessarily involves a reflection upon the nature of democracy. Democracy means respect for the rights of minorities and not the majority browbeating people into their way of thinking. In that sense the work is more humanist than Christian.

RHOMBERG Do you consider yourself to be a political artist?

WALLINGER I suppose I've done in the past, but I haven't really thought of calling myself that for a while.

RHOMBERG You describe the situation of *Ecce Homo* in very political terms.

WALLINGER Yes. But one is reluctant to go too far down that road because you end up sounding like Monty Python's *The Life of Brian*, and that has to be avoided coming from England. If you start talking about the politics of Judean times then you come unstuck a little bit. But essentially there are enough historical records that attest to the fact that there was a man that fits Jesus' description, who was brought before the Procurator of Judea, and his execution was probably politically motivated.

RHOMBERG You're showing a second work at the Secession, called *Threshold to the Kingdom*. It's a video showing people coming out of the airport. Why did you decide to show this piece together with *Ecce Homo?*

WALLINGER Thematically and formally it plays off nicely, in that it's a totally different medium. If one was to be confronted with *Ecce Homo* as the only example of my work then one might take me for an academic sculptor. It

struck me that the passage through the no man's land of an airport and then through to customs, and the decisions one makes, whether to declare goods and all the rest of it, are the secular equivalent to confession and absolution. And also somehow the state requires or has an instinct for knowing that it needs this special moment before you arrive at the official terra firma of this different state. The title, *Threshold to the Kingdom*, is a play on the fact that I come from the United Kingdom. At the same time one could perhaps see this as the Kingdom of Heaven. These electric double doors open and give everyone a rather grand entrance into the arrivals hall. There is a guard on one side who could be taken for St Peter. It's sort of fanciful. It's one of those slightly instinctual works. But the music is rather wonderful which helps my cause. It's *Allegri's Miserere*, a setting of the Fifty-first Psalm which is a plea for contrition to a forgiving God.

RHOMBERG The video is very entertaining. It also deals with a religious theme but in a totally different way. Is religion very important for you personally, or just another icon for something else?

WALLINGER No, I am a seeker after meaning. I would like to believe, but I'm not sure how a leap of faith is made. At the same time I understand that the traps and assurances of religion can be empty. What interests me at the same time is that we are steeped with the rhetoric of religion and that there are perhaps moments in the everyday, where the feeling of spiritual uplift—whether it's bogus or not—can be achieved. It's quite nice to identify them or try and transform something as mundane as arriving at the airport into something that has some kind of beauty.

RHOMBERG In this sense I would like to quote you: 'playing with the possibilities of retrieving moments of defining spiritual unity in the generally uncompromising contemporary urban landscape' is one of your aims. Do you think there is a lack of spirituality?

WALLINGER I think there is. You don't need to have belief in a vengeful or

35
Threshold to the Kingdom
Projected video installation,
11 feet 10 inches (video still).
Edition 100 and 1 AP. 2000

judging God, but there is perhaps a way of spiritual unity in terms of a general respect for your fellow man that tends to feel like it's been pretty much trampled in south London, specifically. I suppose in my video *Angel* where I deploy an escalator as a means of transporting me to heaven, there's something that might colour people's perception of overlooked spaces—mundane machinery for ferrying bodies about the capital.

RHOMBERG In that way you found a new way to address subjects coming from religious traditions, from art history. What is also very obvious is, that right from the beginnings of your art practice, your works were always running counter to general trends in contemporary arts. However, in the past few years you have become quite famous, and within the British art world you hold a very unique position.

WALLINGER I don't feel a particular affinity to a lot of British artists at the moment, to be honest, and I haven't for some time. So I have had to go my own way.

RHOMBERG When you look back on what you have done as an artist over the almost past twenty years, what do you see as being especially memorable? What was very important to you?

WALLINGER I think the greatest moment really was driving to Goldsmiths College where I was teaching, and being late enough to hear the 10 o'clock news which came fresh with the resignation of Margaret Thatcher. So I was able to break that news all around the college which was rather wonderful. At the end of the day I met the artist Basil Beattle who had somehow managed to survive through the entire day without hearing the news, and when I told him he simply wouldn't believe me. So we went over to the Students' Union to watch her resignation speech on TV. Just this look on his face as he kept saying, 'I don't believe it, I don't believe it.'

RHOMBERG That's a nice conclusion. Are there any questions?

AUDIENCE Did the Trafalgar Square Project have an influence on the notion of public art and, more specifically, on your future approach to public art?

WALLINGER Obviously, the project in Trafalgar Square was about the future of public art. Because of the high profile, I think it will affect future projects in London and around the country. I have worked with bodies that are specifically there to create opportunities for artists to work in public spaces, and have consistently found them misguided and condescending in their view of what constitutes the public. There does need to be more discussion about who wants public art, who needs it. I think the plinth in Trafalgar Square was interesting because we spent the last century getting sculpture down off its plinth, and then I put it back on its plinth—but it wasn't a plinth meant for that figure. In my work I'm interested in dematerialisation—the point at which meaning empties out the object. A lot of my works make themselves scarce. They hopefully raise one or two issues and then remove themselves. They can't be easily fetishised or coveted—I hope —like some other trophies. They don't particularly want to play that game.

VIENNA, 3 AUGUST 2000

POSITIONS

36
Mama Folklore
Lime-wood, oil-
colour, charcoal.
292.5 x 91.5 x
90.5cm. 1997

Georg Baselitz
in conversation with
Kerstin Mey

GEORG BASELITZ

Born 1938 in Deutschbaselitz, Germany

Lives and works at Schloss
Derneburg,Germany

The interview with Georg Baselitz
took place on the occasion of his
exhibition, *New Paintings*, at the
Anthony d'Offay Gallery, London, UK.

*Photographs © Georg Baselitz,
Derneburg*

All photographs courtesy of
Galerie Michael Werner, Cologne and
New York

KERSTIN MEY Let me start off with the press release issued by the Anthony d'Offay Gallery for your exhibition here. There your seven new paintings are described as 'Vintage Baselitz'. Vintage means mature(d), exquisite, excellent. It's also pointed out that you refer to and work with your early images. What relationship do you have to your early works?

GEORG BASELITZ Actually, it's a relationship like someone alien may have to others, admiring or despising them. They are distant from me. I have nothing to do with them any longer. Early work—when does that start? Well, I have been painting images for forty years. I have tried to classify that a bit. The first remarkable work was *Die große Nacht im Eimer (Big Night Down the Drain)*, in 1962–63 and a group of paintings, called *P. D. Füße (P. D. Feet)* in 1963. They were followed by the so called *Heldenbilder (Hero Images)* or *Der neue Type (The New Type)*, in 1965–66. Then, in 1969, came *Wald auf dem Kopf (The Wood on Its Head)*, i.e. the reversal, etc. These are several completely separate groups of work. You could say, they may be works by different artists. It almost looks like it. The game could have always been over. Right from the beginning I was never in a situation where I could have said 'I am happy or satisfied', or I have created the greatest thing'. Rather, there was—and still is—such a great restlessness. You know, like children, who always throw away the toy they had just been given and only used for five minutes, and then shout to demand another one. I must say, it is a really unhealthy relationship I have to my past. Not that I mistrust it, not at all. In retrospect I can see that I did interesting things in the past. But I would really like to do something that looks different. Maybe—I am closer to it now—to something that looks different—than ten years ago. Maybe. But there is already a new vintage. These pictures here have been succeeded by a new group of paintings which look a little different.

MEY Does that mean that you consider a phase finished because you have exhausted a theme or a certain way of painting and you want or have to move off into another direction? Or does that happen automatically?

BASELITZ I can only say what it looks like in retrospect. I think that all my paintings can be identified as my works or pictures by me, despite their initial and fundamental dissimilarity. Always when I create a new painting or a new group of works, and then exhibit them, one says 'Good heavens! What's the matter now? Things went so well, or everything was all right. What have you done now?' And, in time, things fall into their place. I don't alter completed paintings. They stay as they are. But they fit into things, or [get] adapted. Or it is simply a way of working, which is different from the way Morandi worked, who only turned his bottles. What does *only* mean? He created a fantastic body of work, but not by buzzing from blossom to blossom, instead he kept to one and crept into it. I'm different. And I also think—I've many doubts concerning the painting of pictures in general—painting pictures is not an activity I

trust. And when I see myself amongst painters then I only feel all right because artists are pleasant people, but I don't feel good when I think of all the pictures produced. I then always think, 'I don't belong there. That has nothing to do with me.' I don't know if others feel in a similar way. I've never asked them, but perhaps they do.

MEY May I return to the 'Vintage Baselitz'? The term implies a certain maturity. Your works here are different. They appear lighter. At the same time they require more scrutiny, because one wants to discover what lies underneath the veil. Does maturity make it easier to experiment in and with painting, perhaps because one feels liberated to a certain degree? Or does the opposite happen, because innocence and impartiality in dealing with the medium have disappeared over the years?

BASELITZ Something really happens in the course of time which one ought not to try to manipulate or to long for. It happens anyway. Changes take place—whether one wants them or not. The first thing that changes when one gets older, is one's biology, psychologically and physically. One has to come to terms and live with this situation. Not all at once but gradually, growing or sliding down—or whatever one wants to call it. In the past, critics treated me with reservations, because they thought of my work as apparently being aggressive and wild, or crazy. But no one said it was sensitive. But I felt that it was, because I'm quite a sensitive individual when it comes to images including my own. However, sensitivity was never attributed to me, maybe it wasn't possible. That's why I thought about ways to do others and myself a favour, or to live up to my expectations, if it were only a misunderstanding, and obviously it was a misunderstanding. I tried very hard to change the process of creating images, because I thought it only had something to do with the method. In the past there was something I could never do: to paint a picture very quickly. It always took me a long time to work on a painting, I always stalled, so to speak. I layered painting upon painting until I agreed on the image. Today, I don't do that any more. I've changed my methods, that is, I have completely changed the way I work, because I understand now that I'm not superficially primarily interested in the motif but in the method. This includes the methods occurring and employed in the making of images in the history of art, too. And during the past few years I've rediscovered what I'd already found out during the 1960s: I'm interested in Asian painting.

MEY Have your paintings become deliberately more poetic?

BASELITZ Well, that's something one should talk about. It's difficult to relate paintings to poems. It's even more difficult to relate them to music. And yet they are related. A painted image is something you constantly see. It stands in front of you, you can't escape it because it works visually. It's created optically, controlled and experienced visually. Once you've seen it you can put it away, but then you've to come to terms with the memory of it. And then it becomes speculative very quickly. However, I still think pictures have got themselves into an awkward situation, because they have always pretended a relationship to the environment, to their surrounding world so to speak, and, sometimes, they've achieved just that. That a landscape painting has anything to do with the landscape one sees is a misunderstanding too. It's a great misunderstanding, if one really

checks out the comparison, it doesn't work. If all pictures were scrutinised based on a comparison with nature, then the images by Picasso, or also Ruisdael or Malevich, etc., would not be possible at all. If one knows that or has discovered it, then one has already got closer to what a poem says or how it comes into being. Once it's realised one can analyse a poem too. One can draw conclusions of a biographical, geographical, social and cultural nature, in a way possible in art history in general. But one faces difficulties explaining the specific choice of words. A poem is a creation not unlike a song or a piece of music, that sounds through words. And those words create something specific in one's mind: for instance mood, sentimentality. To achieve something like that in painting is quite difficult. You can ruin things quite a bit in a picture. You can distort things a lot. You can deform things. However, it's very difficult to create a mood. You said: 'to be poetic'. That's usually achieved rather late in life. But then it can be achieved. If you look at Matisse's works on paper, the very late works on paper, there you can observe such a thing. Or in de Kooning it becomes very obvious. In de Kooning's case it becomes dangerous, because he was regarded as being a bit senile during the last years of his life, and that his pictures were not stable at all within themselves, because they were always compared to de Kooning's early work, perhaps even to the ugly women he painted, these evil women. One shouldn't really embark on comparisons within these works and the decades that span between them. That's wrong.

MEY Do you link certain colours to certain sounds or emotions? There are musicians and poets who associate something specific with the colour red, or with green, or with a certain blue. Is that the case with you, too? Or does the meaning and value of a colour shift within the overall relationships within the picture?

BASELITZ You can do that best with a collage, or if you use alien materials for a montage. That's possible. This whole idea is alien to me. Not only alien, I think it's a completely unnecessary process. I regard it as an unnecessary process in music too. I consider imitation, reconstruction, naturalism really dangerous or totally superfluous. It's simply stupid to compose music by taking sounds from nature. You can play around with them. But one has done that at some point and there's no need to do it again. Notes have a different function and are also of different origin. The development, that is, the production of instruments has remained relatively stable over several centuries until the present day. And the materials one has at one's disposal in painting are entirely sufficient. If one were to arrive at a situation where one says, 'Everything has been done. There are no new images any longer. Everything has already happened. One can't imagine anything any more,' then painting would be over. However, that can't be the case, because we see in the history of art that there have constantly been overlaps, new beginnings and claims contradicting the preceding ones. And the interesting thing is that there's no progress in art. When one paints a picture it's not about designing a better world or about making it more just, and to live in it, but it's about something that ought to happen beside the better and more just life. It's about the mind as enterprise, or experience as enterprise, and that takes place in art, in music, in literature. I think that the next generations create

something new, that entertains or stimulates us.

MEY Does that mean you consider the claims to be wrong that painting or the painted image is dead?

BASELITZ They are correct. They are correct because you are faced by such a wealth of art. Unfortunately, there are neither any termites in the museum, who would eat away what's hanging on the walls, nor is there mould. Therefore you are incessantly confronted with the creations of your colleagues of the past. And these creations are so great that you can't help but to yell, 'Set the museum on fire!' That already happened several times. Every artist has to try in his/her own way to get to terms with it. I too. You can see that in the results. My claim, that I have nothing to do with painting or with the images produced comes from a similar direction. Actually, one can't really take it seriously, yet it's meant that way, because I'm serious about painting and making pictures. What remains? What happens in England at the moment? There was Francis Bacon. And when I was a student a group of English sculptors took Europe by storm. In England, quite often art emerged that looked like a school class trip and then appeared in the rest of Europe. Now we have these dirty things mainly made by girls, who come along quite provocatively, but who are—and I have tried to think about this kind of phenomenon—not concerned with changing the image in its form or appearance. It is about making the motif and the contents more cruel, about showing things that are forbidden or taboo. In 1963, that's more than thirty-five years ago, I painted *Die große Nacht im Eimer (Big Night Down the Drain)*. In this image I opened the (fly of my) trousers a bit. There was an Irish poet, Brendan Behan, who—as it was claimed too— did that whilst reciting his poems in public. That shocks, of course, and it's meant to do so. It has nothing to do with truth, but is simply about provocation, provocation aimed at the viewer and at the satisfaction of society when looking at images. One has to do something about that. During the first two decades of the twentieth century it was done differently. Paintings were made that were abstract, or paintings that were only white or black. Or a knife was taken and the picture slit, that is, the formal appearance of a painting became affected. I have turned the painting upside down. This act also affects its formal appearance, though not quite. It's already a bit 'literatary'. This gesture is to do with convention, that is, with conventions in society. What happens in England now is exactly the same. Indecent things are displayed. And that is right. I hesitate to add that these works are of great quality. One can't just say that automatically. First of all, it's exciting to stage such a provocation and to make it public. I saw the exhibition *Sensation* which was curated by Norman Rosenthal at the Royal Academy in London, and came from there to Berlin. It was far less successful in Berlin, as in London, because, I think, Berlin is rather occupied with other issues at the moment. But I was struck by the presence of the works. They do not appear lightweight or petty-minded, but are extremely present, powerful and noisy. I found that astonishing. I thought that was a real new dimension. When I encountered American Abstract Expressionism with Jackson Pollock for the first time in 1958, something similar happened. These were paintings which one might have seen before as reproductions—although the

reproduction industry did not work as well then. However, one didn't have any idea about their presence through their dimensions. Abstract pictures were also made at the Ecole de Paris. Paint was dripped there as well. But these images could be hung over any fireplace, and they followed a different intention, led a different existence. It was the time of Existentialism. These images did not have an effect within their decorative framework, but in the mind. And there they can be incredibly small.

MEY You have pointed to your own artistic influences when you mentioned Abstract Expressionism. Foreign art critics in particular have always tried to describe you—together with artists such as Lüpertz and Immendorff— as a *German* artist and to anchor this claim in your motives, such as the tree-paintings or the eagle, etc. Do you have a close relationship to Germany regarding certain artistic traditions, and particularly German Expressionism? This question is also relevant in view of your sculpture, which has been received as being situated within the field of tension of artistic influences marked by Kirchner and Nolde, and even Lehmbruck. Likewise your painting. Are these traditions of artistic practices of importance to you? Does it matter to you, whose life is so closely linked to the history of Germany, to be a German?

BASELITZ If that's not meant or said as a reproach, then everything would be fine. But it's said in a reproachful manner. The German issue is only taken out of the closet as a negative comment. Of course, there is a German art as much as there is an English art or an Italian or an American art. And so it should be. And by no means should they be mixed up. Even during the main period of emigration in Paris, the different art traditions hardly mixed. Russian artists in Paris remained Russian artists. The situation was different in an America without traditions. There, art really changed, because the national detachment of the emigrants led to something different. But we don't need to talk about that right now. And it's not right, that a big nation such as America, a nation with huge potential and power, makes claims that amount to a colonisation of the rest of the world being dominated by American art, as it has happened in so many other ways in everyday life. Fortunately, the situation in art looks different. I always thought it interesting—without being able to escape it—to be a German—because particularly in Germany there's a tradition of paintings and sculptures, which is very significant and also interestingly different compared to the art in European neighbouring countries France and the Netherlands, and in Great Britain too. One need not want to continue this tradition, because if one's work remains truthful and serious, then it's already related to that context. Of course I'm very interested in German Expressionism. This interest did not awaken when it ought to have done, during my time as a student of fine art, but it started significantly later. One has to understand that by taking into account the specific postwar situation, for German Expressionism did not continue seamlessly after 1945. It could not be continued after the war or simply reappear. Expressionism remained invisible for a long time after the collapse of the Third Reich, and it took a long time until it re-emerged and became known to a wider public. The effort of art collectors and museum curators in particular contributed to its reappearance, since the images and the respective books and documentations had

37
Mother of the Garland
Lime-wood, charcoal, blue oil-colour. 310 x 94 x 81cm. 1996

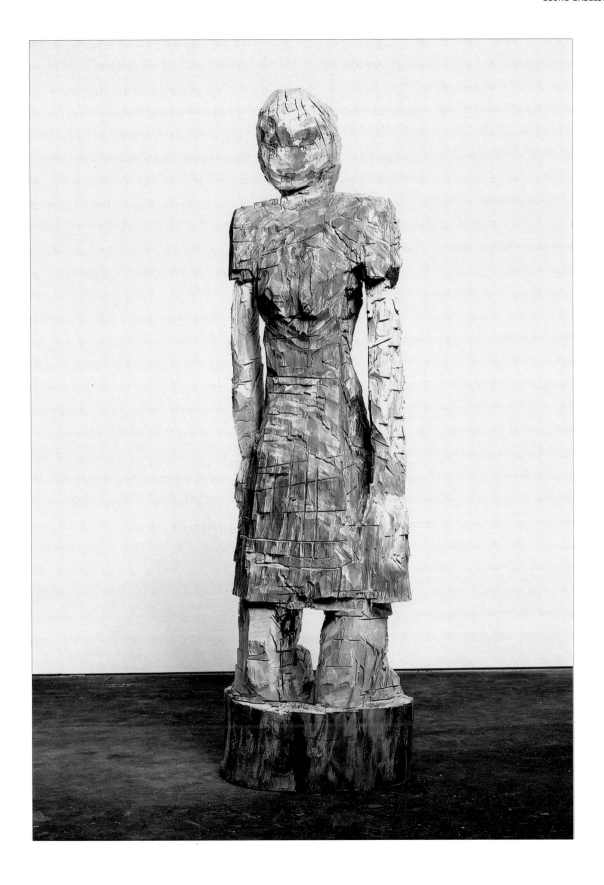

disappeared. Many books were burned during the war, paintings somehow found their way abroad or were kept hidden away. In any case, they were not visible in the museums. Then, a process of redress began in Germany, by trying to persuade those emigrated artists who were still alive to return home. There were also, of course, attempts to return the museums in Germany to the quality of collections they had during the 1930s, but without success. In addition, with the breakdown of the Third Reich all the usual hierarchies were destroyed too. There were neither intact art schools nor functioning hierarchies, there was no continuum of more mature and younger artists. If at all, there were younger painters, because the older ones were either dead or had emigrated, or free positions were taken by artist of lesser importance. One has to take into account this specific situation which was very depressing for the following generations of artists. Suddenly one had fallen from such a high level of culture into deepest provincialism, and that in every way. Regrettably, nothing much has changed in Germany to the present day. That becomes very obvious in Berlin. Very few things that would match the high standard of the past are developed in Germany. Instead, foreigners are invited to build in Germany. Almost everything under construction in Germany has been designed by architects from abroad. The museums are full of very good paintings by American artists, by British artists and so on, of course there are German artists too. There's a cultural mixture, which would be wonderful if the context were right. But the context isn't right, because, simply, Germany has remained a provincial enterprise.

MEY Because Germany hasn't got a cultural centre like for instance Great Britain. What's presented abroad as young British art usually comes from London, and not from Scotland or the North of England.

BASELITZ As I've just said, the hierarchies are destroyed in Germany and so are the centres. There's no museum, no place that could develop into such a centre. But, strangely enough, there are interesting artists in this country. Unfortunately they hardly exhibit at home but show their work abroad, where they become successful or start their career, even though they live in Germany. One shouldn't forget this interesting fact, rather one has to describe it without lament. Later, as I said, maybe too late, I became concerned with Expressionism. I intensely scrutinised the work of Nolde and Schmidt-Rottluff. They were my favourites. I followed them by reworking the motifs of Nolde, and in graphic art especially, the motifs of Schmidt-Rottluff. I found it extremely difficult to penetrate through the paradigm of Expressionism, through its exterior into its interior, and to see the crazy things Nolde made. It wasn't easy because there is a kind of veil or cliché, that there is this very timely expression of the 1910s and 1920s called Expressionism. One is satisfied with these Zeitgeist phenomena and does not make the effort to scrutinise further. It's similar in music. The situation is somewhat more difficult in literature, because one is rather unhappy about the appearance of the Zeitgeist, because, then,—language-wise—it becomes rather narrow, that is to say, in literature one depends on the contents. Beyond Expressionism there's, of course, German art which is equally expressive or equally ugly. I've always considered myself working within this context. Even what I do at present, although it may have become lighter or simply more senile, remains

within this context. Look at Dürer, not at Cranach, it has to be Dürer's images.

MEY That leads me back to your work on display here in the d'Offay Gallery. These works are saturated with tensions concerning the relationship between their pictorial space and their surface. In relation to that, could you elaborate on the importance of the painterly surface to you, and on your view of the relationship between line and plane (though I don't want to rekindle the old conflict between the flesh and the Platonic). I noticed that the line has been given a greater emphasis in your 'Daisy-pictures'.

BASELITZ The issue of surface in my work has always been brought up as a reproach or a problem. I reproach myself, but I was also reproached by others, because I use the canvas, use the format in order to do something in its centre. I use the canvas as carrier of an idea. I don't or hardly consider a painting as an object. Rather, an idea exists in the painting, like there *is* a drawing on a piece of paper—it's not quite appropriate to say 'is represented'. In that sense, there's trouble, I'm troubled with the surface. If I compare this problem to Barnett Newman or to Rothko or perhaps to Pollock, well, the surface, there, is everywhere, but there's nothing in the centre. That's why the whole painting becomes an aesthetic object, is regarded as the appearance of an object. In that case you've nothing else to do than to work on that surface. I've experimented and tried to work with illusions, as it is the case in this show. In these works here I've tried to avoid the damaged surface by distributing the daisies evenly over the surface, like on a piece of fabric. Yet, you can't say exactly whether they are situated on or underneath the surface, They are in limbo. Had I taken a piece of fabric as Sigmar Polke does, and painted the fragment—nude— torso on it, the result would have been completely different. I would have finished up with the same old surface problem and the problem of the pictorial centre. It shouldn't have been like that, rather I wanted to achieve two things: on the one hand, I wanted to express my relationship to painting of the Gothic period, to the Gothic ornament, to the Gothic picture frame, to the Gothic framework, to the picture within a picture. On the other hand, I was concerned with what, in art, is generally called 'torso'. And with the torso I'm specifically concerned with the typical, in painting the frequently cited depiction of the female nude. In mine it is my wife.

MEY And in view of the line?

BASELITZ Well, that decision. Now I know what one can do. In the past I didn't know that. In the past, I concentrated on a certain way of working without being aware of other possibilities. I achieved results, but now I can use my own things, things I did, I don't need to plunder other artists' works, but can recycle my own past. I am now able to work with contours as well as with watercolours, with varnishes and corporeally formed body parts. I can do really everything. According to what I want to do or what I've to do, I decide. Of course, it also depends on the respective situation. Recently, I painted with watercolours only. I used running paint which collided, that is, I operated with hardly any contours.

MEY Does that mean you move away from a kind of painting that tends towards three-dimensionality? It has been often pointed out that your

sculpture emerged from your corporeal painting as logical consequence in 1979–80. Could one not ask the question the other way round, that is, did your sculpting affect your painting at all, or are these two completely separate domains?

BASELITZ These are different things. In relation to this exhibition one could say that there is a similarity to sculpture in view of the figuration and the way of representation. But that's by chance, because one can see an object in my picture that resembles my sculptures—it's also yellow like them. I didn't work on any sculptures recently. I didn't have a reason. I couldn't think of anything.

MEY Have you brought sculpture to a conclusion?

BASELITZ In sculpture I don't work with such experimental series, or I don't have any resolutions or don't see an end in them. I haven't created anything of which I could say, now I've done everything, that's the entire vocabulary at my disposal, exhausted and finished now. That's not the case. The most recent three sculptures I've created and which are comparable, developed over a period of two years. They are called *Mama Folklore, Mother of the Garland* and *Mondrian's Sister*. All three are quite tall, over three metres high, limewood sculptures made in one piece— women in a blue dress, well, of course, I painted the dress blue. Their titles vaguely allude to what they are about. *Mondrian's Sister* is a very brutal, very crude and impertinent Russian peasant woman. It's called *Mondrian's Sister* because—and, of course, a bit of cynicism is at play here—I very much admire Mondrian and I think, one needs to get one over on him. *Mother of the Garland* wears a blue dress. Islam uses blue against the evil eye. I noticed in the streets of Berlin that many pregnant Moslem women are dressed in blue, with garments in a so-called Turkish blue. They wear this colour against the evil eye, so that they can't become bewitched and that their babies are protected against the evil eye. You can deliberately look out for such connections, but they reveal themselves all the time.

MEY Do you take inspirations for your work from outside the history of art?

BASELITZ Yes. I'm very occupied with the history of art but also with its peripheral areas such as 'primitive art'. That's quite a narrow term but you know what I mean. I devote a lot of attention to folk art, to folk art from my native area, and also to archaeology, where you find both high art and folk art too. By the way, there's a kind of sculpture, I discovered recently, which is called *Lausitz sculpture*. It's very typical of the region where I was born and brought up. These figures are funnily crude. It's a kind of sculpture of the late Gothic, very much different from other groups of sculptures of the same period, which occurred in an area spanning from south Germany to France. *Lausitz sculpture* is distinctly different. Not of a lesser quality, simply different. I'm really interested in art—I own quite an extensive library—the art of the past, outsider and non-western art, contemporary art. I take from them. I work with them. I don't take much from the world outside otherwise. Well, all right, I painted quite a few portraits of my wife, portraits of my family, and more recently, portraits of my friends. These portraits of my family have to do with coming to terms with the past, with memories. By the way, portraits are quite an interesting 'story', very interesting indeed.

38
Mondrian's Sister
Lime-wood, oil-
colour.
278.5 x 102 x
74cm. 1997

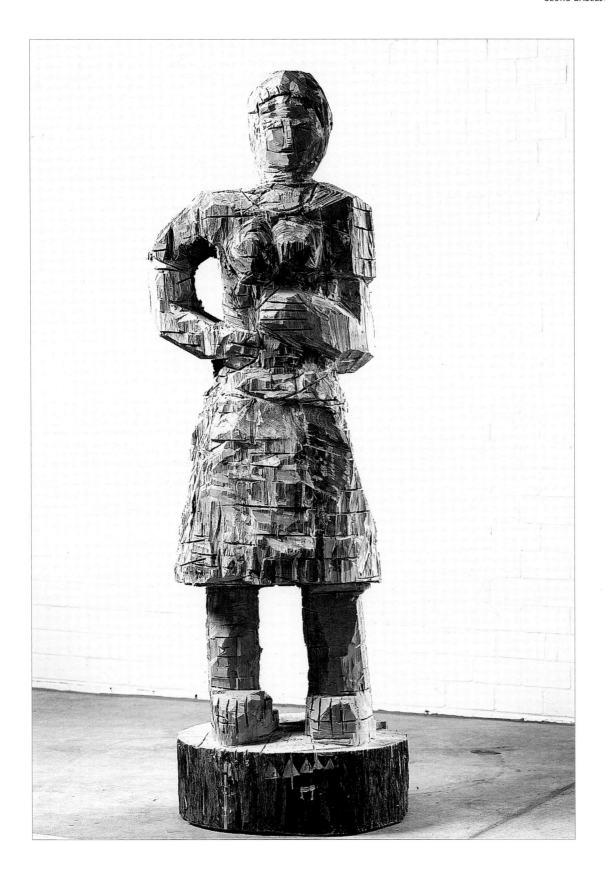

MEY Portrait is your main genre.

BASELITZ You can say so.

MEY About your painting process. You start off to paint on an unframed canvas that sits on the floor, constantly circumnavigating it and thus blurring the difference between top and bottom, left and right. Have you kept to this strategy in your recent work?

BASELITZ I have worked that way for years. I started it because it was convenient. It's known that it's not a strategy. It never was. It's easier to work on a picture that lies on the floor. Now, where I paint with liquid paint, nothing would remain on the canvas, it would always run and drip down. That's why I put the canvas on the floor. To turn them upside down makes things easier, because if a painting lies on the floor, nothing on it stands on its head, because you move around it in all directions, all the time. And something else happens: Given the size of the format you can't quite oversee what you are doing. But you feel exactly if the image is right or wrong, something you simply can't control optically. To feel the painting is more important to me then to scrutinise it in order to check whether it's right or wrong. I know exactly if an image is right when it rests on the floor. Completely by sensing it, by working on it, through the process of working and through feeling. I don't have to see it. Well, not that I would work blindly. Not that. I work on details. One could almost say—perhaps that sounds a bit provocative—it only needs square centimetres to allow the painting to become a great work, to make it right, to make it of a high quality. The rest could be rubbish.

MEY Do you determine the format before you start to paint, and then inscribe your images?

BASELITZ Something like that. The canvas isn't limitless. Although I try to work on canvases as large as possible and cut the actual images out of them, I always have an idea of the size of the images because it has to be framed.

LONDON, 19 JULY 1999

EXPRESSIONS

39

Why I Never Became a Dancer
Videotape. Edition of 10. 6 minutes 40
seconds. 1995
Photo: Courtesy Jay Jopling, London

Tracey Emin
in conversation with
Mark Gisbourne

TRACEY EMIN

Born 1963 in London, UK
Lives and works in London, UK

The interview here first appeared in an abbreviated form in *Contemporary Visual Arts,* No. 20, Autumn 1998. The intervening period of almost three years between commissioning and conducting the interview and its publication here are in part a reflection of the time it has taken for this first book in the new transcript series to go to press due to circumstances beyond the editors, and publishers, influence.

With the full publication of this interview it is intended to expand upon our understanding of the artist's life as art project, stressing both the tone as well as the means of expression used when Tracey Emin is talking about her work. It is in the context of this interview that the artist first speaks of her idea for the work *Bed,* the now infamous installation of her bed with its abject body traces placed in the Tate Gallery as a centrepiece of her 1999 Turner Prize submission.

Since 1998, Tracey Emin's international reputation has developed enormously with two one-person exhibitions in Berlin, *Cunt Vernacular* (1998), and *What Do You Know About Love* (2000), and one-person shows in Paris, *Tracey Emin* (1998), Tokyo, *Sobasex [My Cunt is Wet with Fear]* (1998), and New York, *Tracey Emin Every Part of Me's Bleeding* (1999). At the same time she has participated in some thirty group exhibitions, most recently *Sex and the British: Slap & Tickle—A Perspective on the Sexual Content of British Art since the 1960s,* held at the Galerie Thaddeus Ropac, in Paris and Salzburg. In all these shows the artist

MARK GISBOURNE Your artistic life seems to be concerned with confession and making things. Is this a fair analysis?

TRACEY EMIN No, because my creative life is spent thinking. That's the biggest thing. My practice is not really about being confessional its about how I think as in thinking.

GISBOURNE OK. Are what I've called the confessional aspects a means of telling a story, or a catharsis or purging, a killing off of the past? Is getting it out a means, as it were, of getting rid of it?

EMIN Yeah! Quite often, but I wish I didn't have to get it out in the first place. I wish it wasn't there. I would much rather be normal and have everything sweetly nice. But, then even when I do get rid of stuff, there is always a load more coming.

GISBOURNE What is the function of verbal narrative in your art making?

EMIN It starts off with working with what I know, and if what I happen to know is for example like a totally fucked up love affair then that's what I will be working on. Because that's what I know.

GISBOURNE Your use of sewing and stitching seems to suggest the domestic, habitation, and home environment, something to be performed in and decorated. Why is this?

EMIN It's a bit of a posh way to put it. No, I simply sew. I've always sewn and I'm actually quite good at it, and I find it a really easy way to make work. It has nothing to do with trying to come up with some super kind of female statement of the stitch. But, I do like the idea of humbleness behind sewing. From my stitches I can tell my mood. At the moment I'm pretty manic and I tend to do them really tight, and they are a bit twisted. But, it's definitely good for me to sew rather than to go around hitting people. You might think it's domestic but I actually think it's something you get in mental institutions. Who knows, you may see me there in forty years time, sitting there sewing the same bit of cloth again and again. It does keep me occupied. If you do it in bed it stops you from masturbating, because it doesn't work if you sew and then masturbate. There's just something not right about it. I can't really put my finger on it. Maybe this sex thing of Penelope and sexual denial is true.

GISBOURNE But, in a way, sewing is still about adornment as well, although you don't use the things you sew for your body very much.

EMIN No, but I used to make all my own clothes. I made a Mondrian dress once.

GISBOURNE A bit masculinist?

EMIN Yes, it was. So minimal. I can even do tailoring, jet pockets and cut pattern, etc. If I had more time I would actually like to make my own collection of clothes. It would be a nice thing for me to do. I spend so much money on clothes as well—designer clothes—that it would be good for me to make some clothes. At the moment I've to make a Red Indian outfit. Are you allowed to say Red Indian?

GISBOURNE Native American?

EMIN Yes, a first American native outfit for myself, and I'll have my hair in plaits. I have to collect a lot of feathers to make that outfit.

GISBOURNE I'm afraid the eagles are protected these days.

EMIN Maybe its not the most ideologically sound piece of work I've ever wanted to make. But I used to know why I want to do it but now that reason has gone. But I suppose I had better carry on and complete the task.

GISBOURNE You've an interest in travelling across America. You did that in 1993.

EMIN Yes, in 1994. I went across America with my Nan's armchair and stayed on different Indian reservations. It was good. Apart from the fact that they are tee-total. Yet, I tried to empathise with them.

GISBOURNE The studio, or room you have created in a gallery as a personal space, was very evident in the South London Gallery show, and in the *Ca-Ca-Poo-Poo* show in Cologne Kunstverein. What is it about living in the middle of your work as you are doing at the moment?

EMIN Well. As you can see, I'm in the middle of what I make. Personally, I would like to live and work in the same place. When I sit here people sometimes walk past and look in and say 'look there she is'. For them it seems they've seen my art by seeing me. It really irritates with a lot of shows where I've to be there. People get bitterly disappointed if they know I won't be there, whereas a lot of other artists don't have to go. It's always demanded that I've to be there whilst my exhibition is on.

GISBOURNE To what extent then do you rely on the complicit voyeurism of the world to gain attention?

EMIN I was thinking about the narcissism that lies behind what I do—because of the self—and how difficult it is for me to really share things, even though I'm sharing all the time. But in my personal life it causes a lot of problems, to the extent that at one point I wanted to sacrifice all I had to be, what I consider normal—if there is such a thing. The other day I hated my art so much, I wanted to kick it, to smash it up. It's like the way you treat your faithful lovers—you abuse them in a way. That's what I wanted to do with my art. I was so angry with it, because this is all I fucking have. When, I go to bed at night, when I get up in the morning, it's all I have that is true to me, and I just don't want to be like that.

GISBOURNE You don't think there's any more of you than your art?

EMIN No, It's not about me, but about the world. Some days I wake up and feel art is all I have left. I feel that I've no friends, that I've nothing else apart from my art. It's painful. I would like my art and the world to change. I would like to be a science fiction novelist, by pushing myself to the extreme. It's a contradiction, I know, seeing that I'm so straight-forward, seeing that my art is about real life. I would like to be released from this communication thing, especially from all this talking about myself. I was thinking about going to a therapist, for I can go there and talk about myself. Maybe afterwards I can start to ask other people about how they are. That would open up my mind a bit more, instead of it always closing in on me.

GISBOURNE So, creating your own world and environment doesn't give you a sense of control. Your communication as strategy has turned on itself,

40

Good Smile Great Come
Pink neon. 101.6 x 55.9 x 10.2cm. 2000
Photo: Stephen White

has continued to create work within her pluriform post-modern vein, drawing, sewing works, photography and video, while at the same time sifting and drawing upon memories of her past obsessions and former anxieties, present libidinal pre-occupations, and future fears and doubts about her life fulfilment.

Photographs © Tracey Emin
All photographs courtesy of
Jay Jopling, White Cube, London

increasingly so. It has almost become a punishment now?

EMIN That may make it sound pretty extreme, but after being drunk on television, I did want to keep a pretty low profile.

GISBOURNE They were all drunk as well.

EMIN This is what annoyed me. They were all pissed as well. No one ever picked up on that actually. Somehow I was more pissed than they were or appeared to be.

GISBOURNE Are you saying, they were drunk and behaving drunk, while they were drunk and trying to give the impression that they were sober?

EMIN I've got no regrets for what I said on that programme, for I honestly don't know what I said, and I have never seen the programme.

GISBOURNE Sexual intercourse appears in your work all the time, whether as a subject or a means of negotiating the world. Do you actually like fucking?

EMIN Oh, yes! I love it more than anything else in the whole world. But you have to be in love, you can't do it gratuitously, I don't even like masturbating gratuitously. Sex is just one of the best things ever. When you are having sex you lose yourself completely and become part of the other person. Nothing else can ever beat that feeling. Sometimes I begin to think I may never have it again. Maybe, between the age of thirteen and fifteen I'd more partners than I've had since. I knew what it was to just shag around and to love sex just for that physical thing. But now I'm older and don't want to do that. Yet, I like the idea of someone coming inside me, and the idea of sperm going on forever. You never know where it's going to stop. Just like the idea of immortality.

GISBOURNE But sperm also dies, only one makes it to the egg.

EMIN I was talking to someone about sperm the other day, in connection with female alcoholics and whether drinking effects the unborn child Me and my twin brother always talk about being sperms, like it isn't half and half. I try to imagine myself going up there.

GISBOURNE To me, you seem in some way to reflect the dystopia side of Virginia Woolf, for she expressed the need for a woman to have a room of her own. Your life takes its meaning when you expose it to the public scrutiny of world. I say this because writing is such a major part of your art.

EMIN Yes, but I'm a woman for the twenty-first century, aren't I. It's quite funny because there isn't that much that's interesting. Everybody knows everything. At times some boyfriends have said I should just sit in a room and keep my mouth shut for five minutes, then I could probably get any man I liked. I've never tried that. It's like sex. Once, a woman told me that sex was very good on the back. Well, I've never tried that either—it's the same kind of thing. I'm quite happy to be a woman and have my head deeply buried into a pillow. That suits me fine. I don't need to look in someone's eyes.

GISBOURNE As your past is now well documented and you've made the journey from Margate to Mayfair—what does the journey from that world to this world mean for you as an artist?

EMIN Well, I'm really proud. It's really good because I don't like the class system, I find it despicable. And, I love people who can bounce through it—I'm not just talking about the upper class. Art is really fantastic for

breaking down class barriers.

GISBOURNE Do you still consider yourself to be a painter?

EMIN No, I don't still consider myself to be a painter. I did some water-colours the other week. Yes, I trained at the Royal College for two years and did nothing else but painting and drawing, and I can paint. Also, I did three years of printmaking, so I can do a stone lithograph, and a woodcut and an etching. Sometimes, I actually teach printmaking at the Royal College of Art. This year I did only one day out of the nine days a year I am supposed to do. I forgot.

GISBOURNE What is a life in art today, what does it mean?

EMIN It means you don't go out without your passport because you are going to get on a plane tomorrow and you don't know whether you are going to go home tonight. To be an artist now is fantastic, especially in Britain: it's like super fast and has definitely a glamorous side to it.

GISBOURNE Which is the opposite to the more traditional process of being locked in your studio, etc?

EMIN I was locked in my studio in isolation after I left college and as a result I stopped making art. I gave it all up. I did a part-time philosophy course. I was such a crap artist at that time anyway. To stop making art wasn't such a great sacrifice to the world at the time.

GISBOURNE A very self-deprecating view?

EMIN Yes, but it's true! I think if they could stop making things for a few years and then reassess what they do many artists would become a lot stronger. I can do really good Edward Munch paintings and woodcuts. But what's the point of me doing what has already been done?

GISBOURNE You like very much the Expressionist tradition. Obviously, your drawings in their expressiveness, in their graphicness remind one a little bit of Egon Schiele. Do you think that life itself is a work of art?

EMIN Yes, definitely!

GISBOURNE I know you've spoken at length about it, but nonetheless tell me about your childhood. Do you feel you had a childhood?

EMIN I was thinking about this because I did a drawing that was intended to show how I was fucked up in my childhood when I was ten—I've a really brilliant memory, which is obvious because my work is about memory. But oddly enough, remembering my childhood I've massive blanks. Yet, I do remember waking up in the night crocheting. I do remember banging my head against a brick wall. I do remember putting a bamboo stick through my leg. I do remember all these weird things as events. But, I wasn't very happy as a child. I'm not very happy as an adult now when I come to think about it.

GISBOURNE But did you consciously edit your childhood memories out or did they just disappear?

EMIN They just disappeared.

GISBOURNE Your grandparents, parents, and twin brother seem like ghosts in the machine of everything you do. Is this true?

EMIN Yeah! Remembering where I came from, and using that as a foundation, as a platform for my art goes back to the sex thing, to the genetic hereditary aspect, to the power of blood. My loyalty to my place of origin has to do with it. The other day, someone remarked about how phenomenally strong I am in that I never kept a veil over the fact that

Margate is my home town. Not many people brag about their upbringing in Margate.

GISBOURNE Do you go back at all?

EMIN Yeah, I go back. My mum still lives there, and I'm going to have my birthday party there this year. It's going to be called *Chariots of Fucking Fire—An alive at Thirty-five Party.* I never thought I would be alive at thirty-five.

GISBOURNE Can you get things under control by naming and using language in your work?

EMIN Well. Actually, I write more than anything. I'm not so much a painter, rather I am a writer. I write a few thousand words a week. I send a lot of letters. Last night, for instance, I was drunk, but still I wrote a drunk letter and, about two o'clock in the morning, I went and posted it. Writing flows, it's a stream of consciousness which I enjoy. I'm writing a new book at the moment. It's working title is *Fucked up Crazy Heart.* The book starts with my great-great-great grandfather who was a slave in the Ottoman Empire. He was slave in the Sudan. It's entirely fictional and I'm making it all up.

GISBOURNE Could you talk about the materials you use in your work, not only sewing and fabric.

EMIN Sewing, neons, videos, Super 8 films, photographs, watercolour. At the moment, I'm making something really stupid. Someone gave me a really nice big pink dildo, and I decided not to use it. So I made little clothes for it, and even if I think about using it now I can't because I would have to undress it and that seems real pervy. I'm going to make a little doll of myself and wrap it around the dildo. I had a dream once, that I was holding on to a big massive penis and swinging on it. That kind of thing I would just make for myself. I would never sell it. It would hang around the flat.

GISBOURNE Do each of these materials have a particular relevance for you? Do they carry a meaning in each part of your practice as an artist?

EMIN Yes they do. The neons for example—I have this thing called high altar, high altar memorabilia, high altar images, high altar drawings and so on. These are things that go right to the top of my hierarchy. So certain sentences go to the top of the hierarchy. They command and deserve to be made in neon. There are certain sentences which strike of a stream of consciousness, an idea which then can warrant them being on a blanket. A blanket takes six months to make. Therefore it has to be a very strong idea otherwise I'll get bored with it. And the fabrics, for instance, for the appliqué of the tent, are high altar material, associated with events.

GISBOURNE This association with naming is interesting because you made something similar in the map piece at the South London Gallery show.

EMIN Well, the map piece was just fun. For instance, I spot my friends who take tons of cocaine in Colombia. One friend who is a curator and therefore is always looking for the new artist I put in Outer Mongolia. Friends who make site-specific work I placed in the Outback of Australia. Friends who I think really need a holiday, I put somewhere very nice. And, silly things like *Frieze* magazine, I situated them in Iceland. It's just very childish but I really enjoyed doing the piece.

GISBOURNE I want to talk about your drawings.

EMIN Well, I've never practised anything ever in my life. I can't cook. I can't speak a foreign language except a bit of Turkish. The only thing I have ever practised is drawing. I did two periods of life-drawing two evenings a week. I did lots of drawing courses. So I really learnt the craft and I used the knowledge of drawing for my pleasure.

GISBOURNE But is it just the pleasure, the love of the line?

EMIN Yes. For years, I hadn't done any drawing. When I started again I called the outcome illustrations from memory. I went into the back of my mind pulled out memories and put them down on paper. They're the drawings of the young girl. In America I got into trouble for those drawings because they were believed to be paedophile drawings. But, they're not, the drawings are about me, about my events, about my life.

GISBOURNE Maybe because your drawings are about memory, they tend to be very haunted and tentative images in some way.

EMIN Yes. I recently had an exhibition in Berlin and some people I know went to see it. When they came back they were almost in tears because to them the drawings looked so sad.

GISBOURNE I want to bring up the issue of writing, and of story writing in particular. Do you see your writing as literature, or do you see it as a sort of diary, or just as a case of recording the moment?

EMIN When I'm dead my notebooks and my diaries are what will be rummaged through first. So, when I write now it's with a consciousness that one day it might possibly be read. When I was younger I had this writing file called *Only read me when I'm dead*, where I put down my most inner thoughts. Now, I haven't got that file any more. Everything is just mixed up. Recently I wrote something that was quite a shock to myself, which gave me a fantastic feeling of energy. When you actually write you might not know what you're going to write next. It might be in your mind but once the thought is put on paper it might be devastating.

GISBOURNE Are you working on a book right now?

EMIN Yes. Actually, I wanted to do a book for my show at the South London Gallery this summer. But during the summer of last year my mother was taken seriously ill. I looked after her for quite some time whilst she was recovering. After that I needed to get away and went off travelling for a year. The book I'm working on at the moment contains a lot of stuff: my writing, part of my diary from last year March to this side of March, and even faxes I sent to people. All sorts of things, really. It's just called *Tracey Emin*.

GISBOURNE And, who is publishing it?

EMIN We are. Jay Jopling has put a lot of money towards it. The Arts Council of England are giving some money. And friends gave me money towards it, because I didn't have enough money. The book comes out at the middle or end of July.

GISBOURNE Creating a museum seems to me to suggest you're interested in art as history, placing things in time. Do you feel that when you are working now that you are doing this consciously?

EMIN Yes, and I also think that about interviews and any documentation of my life.

GISBOURNE Is it like a palimpsest being inscribed or do you see it as chronological?

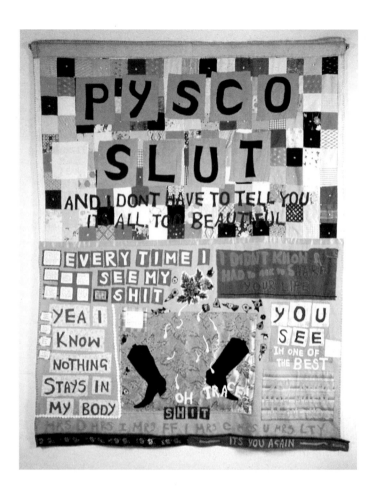

41
Pysco Slut
Appliqué blanket. 244 x 193cm. 1999
Photo: Courtesy Jay Jopling, London

EMIN My work is not quite chronological. I wrote the book *Explorations of the Soul* which dealt with the moment of my conception to when I'm thirteen. Now I'm writing about my life from when I was thirteen to the present day. I also recently made a film called *Tracey Emin CV Cunt Vernacular*, which deals with my life from 1963 to 1995. Everyone asks, 'Why does it stop in 1995?' I don't really know. I could have gone on, but then I thought a lot has happened between 1995 and 1998. I can fill another film up just with those three years.

GISBOURNE There is an enormous amount of work in those three years. You became internationally known at this time.

EMIN Yes, but it's not about the work I make, it's about my life. Often, when you read the CV of artists you have no fucking idea what they were thinking about at a certain time.

GISBOURNE Does it worry you that you are seen as much as an art personality as an artist? Are you a sort of performance artist as such?

EMIN Yeah. I do performances but they are pretty low key. I don't exactly run around with pig's blood or swinging from the ceiling, but I could.

GISBOURNE It's already been done.

EMIN It's the way I was brought up. I think, my presence is important to the work.

GISBOURNE You also like certain words which come up all the time: 'cunt', 'blood', 'flesh', and so on.

EMIN Yes, 'cunt' comes up, but not on its own. It comes up joint with other words like 'cunt international' in the room I made and in my last ever painting. And 'fucking', which I use in my work as a real term.

GISBOURNE In a sense it's reappropriation. For example a word like 'cunt' connotes this very negative view of women when it was used by men.

EMIN What am I going to write, 'my fanny is wet with fear?' It's not going to ring true. 'My cunt is wet with fear' and you get the idea, you get to know exactly what I'm talking about.

GISBOURNE In that sense do you consider yourself a political artist as such?

EMIN No, not in the obvious sense.

GISBOURNE What is political about your work?

EMIN Freedom of speech, non-censorship of the soul, I'm entitled to my opinion and so on.

GISBOURNE But no particular cause as a woman artist.

EMIN I see myself as a woman.

GISBOURNE What about the future, does it concern you?

EMIN Yes, it concerns me so much at the moment that it's driving me up the fucking wall. I see my future as dogged with depression. I'm frightened of being lonely. I'm frightened of waking up at fifty and looking at my castle with all my jewels, and thinking 'what the fuck is all this about', and I certainly don't want to die alone. I'm frightened because I'm thirty-five and I wanted a baby. But I can't see it happening. Therefore I think about the terms of creation. To have a baby would be the pinnacle or doyen of creativity. That's why I'm talking about this regret with my art, because it's nothing in comparison. The reason why I know this much is because I've had two abortions and a miscarriage. These events have changed my attitude to my work and actually stopped me from making art for a few years. After I'd this horrendous abortion that all went wrong, where I actually saw the foetus and everything, I'd an idea of where true things come from. The things that I'd made in comparison justified being in the world. I'm not talking about the breeding mentality but about the fear I've at the moment. I'm just being honest about it.

GISBOURNE Do you think if you had a child it would unreservedly love you? Is that what it's about?

EMIN It's about that. The child would love me or I would love it. This love is unconditional. When I made my abortion film *How it Feels*, the person asking me the questions told me the reasons for her not having children. But I replied that one of the reasons for having children is that if you have a lot of love to give, and you don't give it, it can make you go very warped and twisted. But on the other hand, you can love the whole world.

GISBOURNE Is it just the biological clock ticking for women of a certain age?

EMIN Too bloody right it is. I've to cut out smoking and cut down drinking. I've to swim three or four times a week. I've to have a good diet. I've to maintain a healthy body if I want to have a baby when I'm forty. And, every single day my eggs and womb are drying up. They become like a scab inside me.

GISBOURNE That's a very hard word, isn't it?

EMIN Yes, it's true. That's what it feels like. I'm not getting any younger.

GISBOURNE If you did have a child would you give up art altogether?

EMIN Oh! Definitely! No, I wouldn't give up anything. I've worked it out: to have a baby on your own you've to have seven hundred quid a week, every week. I can do that. When you are pregnant you've to give up a few things such as wearing high heels, drinking a bottle of vodka or smoking forty fags a day. Being an artist, I don't intend giving up anything at all. Maybe cut down on travel but I would have a nanny anyway. Or I would give the baby to my mum. But my big joke is that my mum says, 'You can't have a baby.' And I say, 'I know I fucking can't have a baby. I know I can't.' My friends were joking about me ringing up different bars and clubs, to ask if I left something there last night! Whoops! It's small with dark hair—my baby. I seriously see myself waking up in the morning with a terrible hangover and going, 'Where did I leave it?' But my real fear is, that I can't have a baby for whatever reasons.

GISBOURNE Let's move on. Where do you see your art in ten years time?

EMIN Sewing on school labels, scarves! Yeah, it's going to go monumental probably. At the moment a lot of my ideas are about major big sculptures. The more shows I get offered in museums, and the more finance I can get behind me, the more I can do that kind of thing. I'm just going to be stepping into the male world in terms of my making.

GISBOURNE Do you see monumentalism to be masculine, to be historical?

EMIN Yes, historical it is. My big idea at the moment is for making this room that measures 11 feet by 7 feet with wood-panelled walls and a light bulb. In it is a bed and it's all shit, blood, used condoms, dirty underwear, creams and different kinds of things. There is a line of shit on the pillow case on the left hand side, and the pillowcase on the right hand side has just been ripped in half so that there are feathers everywhere. In the middle of the room is the hangman's noose, but it's made out of anything but rope.

GISBOURNE Your description of the room sounds a little Louise Bourgeois-ish. Do you like her as an artist?

EMIN Yes, it does! But, Louise Bourgeois wouldn't have all the used

42
She Calls Herself a Soul Girl
Monoprint on calico with stitching. 41.3
x 50.8cm. 1998
Photo: Stephen White

condoms and all the shit everywhere. My room would be a cross between my bedroom and the room I had at the shop with Sarah Lucas, the bird-room upstairs.

GISBOURNE Do you see your work then as making fantasy real? This is where I would differentiate it from the surreal-fantastic convention of Louise Bourgeois: you take fantasy and drag it by the scruff of the neck into the real world.

EMIN Yeah but as I've already said, I would quite like to be released from the world and make something that's just for me like the Red Indian dress. But, one thing I'm doing this summer is to make a film of me riding across Margate beach on a pony, dressed up as a cowgirl and so— that's quite a fantasy. It's the prodigal daughter riding home.

GISBOURNE On a white pony?

EMIN No, this is going to be more like *High Chaparral*, because I like the idea of cowboys fucking, and I like to fantasise about it. The only time I like fantasising about men, really.

GISBOURNE You like the idea of cowboys fucking? Women or each other?

EMIN Each other.

GISBOURNE Why is that?

EMIN Because I find it really sexy.

GISBOURNE Instead of being the object of voyeurism, you would want to become the voyeur.

EMIN As I get older I would like to be the voyeur, yes.

GISBOURNE I notice that you have become very involved with the business aspects of art as they relate to your work. I saw you staring at me at Heathrow airport in the Bombay Sapphire advertisement.

EMIN I've been taken up for company endorsement. A friend said to me, 'Tracey isn't there anything you'd say no to?' I replied, 'Charles Saatchi actually', which was quite funny.

GISBOURNE More and more, given you are associated with Jay Jopling's high profile White Cube Gallery, you may well be drawn into this art and business relationship.

43
I'll shoot you too
Monoprint. 30 x 42cm. 1997
Photo: Stephen White

EMIN Jay and I work very well together because he's never had to push me on that kind of thing. Being a professional artist is just a natural organic process, it just happens. For example, a few months ago, all I'd to do was blow my nose and it was in the fucking newspapers. It's very easy for me to get publicity or gain some kind of stir. I think that's why companies, like Bombay Sapphire Gin, or others think I'm a good person to push their product. They have now stopped my supply of one crate of gin per month.

GISBOURNE The art world today is more business-oriented than perhaps at any time. Does that concern you?

EMIN No, it doesn't bother me. It's just bollocks that money and spirituality shouldn't go together. Someone said to me that, in a sense, today you can just make art about jumping into rich people's swimming pools. I said, 'If I want to I could do whatever I liked.' People think that because my life has become more comfortable my work will get insipid or watery, which isn't true. On the outside my life may look very comfortable, but inside my heart is still in turmoil over things. I still go to bed crying at night. I still pray to God for a better life. I still curl up in a foetal shape and cower from the world. Those feelings never change. So with all the confidence and all the success on the outside, internally I'm still broken, for if you have a broken heart it's very difficult, it won't mend.

GISBOURNE Do you see the child we mentioned as part of the healing process?

EMIN Yes, definitely. Someone said to me the other week that I need someone to look after me. Actually, I need someone to look after because then I will look after myself. You've to, don't you? It's like with the oxygen mask on the aeroplane: it comes down and you've to put it on yourself first before you put it on the child. That's why I like the idea of having a child. I never felt it before but over the last year, I feel I've become a woman, but now I'm frustrated because the woman side of me is feeling incomplete.

GISBOURNE Oddly enough, the idea of until you love yourself you can't love anyone else seems rather a Christian one.

EMIN I've been on this rather destructive course over the last two years. In the last ten years I've been very well despite drinking a great deal. But the last two years I've been drinking almost every day—apart from the last three weeks—and I realise that I've been in denial. I'm on a destructive course because I'm a really fucked up mess. I would drink a bottle of wine, half a bottle of vodka, as well as few beers every day. You can't have a baby doing that. I see two pathways: one of degradation, destruction and denial, of alcoholism, an orgy in a seedy kind of hedonism. The other way is about self preservation, about being classy of mind, and being a really strong human being. That is to be guarded by those things I feel are right.

GISBOURNE I notice that you return to say that you want a child, but there is no real mention or necessity that you want a partner, husband or lover. Do they go together or does the child come as a separate package?

EMIN Well, finally they may come together. But my family is totally dysfunctional, therefore I have never seen a necessity for a complete family. Baby and partner are not a package. But, there again, on the other

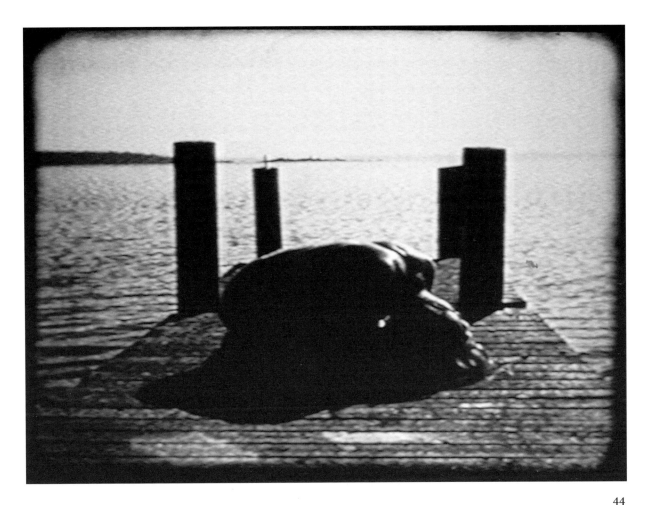

44
*Homage to Edvard Munch and all
My Dead Children*
Video. Edition of 10.
Duration: 1 minute looped. 1998
Photo: Courtesy Jay Jopling, London

hand, I'm not looking for someone to fuck. With a baby it doesn't work like that because I would have to be in love in the first place. However, I've got lots of gay friends who would like me to be the mother of their child, funnily enough. That fulfils their fantasy—the cowboys and whatever.

GISBOURNE But, with that you try to steal *Tom of Finland* off them.

EMIN Yeah, but I don't really come on to that. I'm useless at relationships anyway. So it's too difficult for me to think about that.

GISBOURNE Do you feel happier in the companionship of men or women?

EMIN There is no difference as to whether my friends are male or female. It's the same with sex as well, except I don't want to sleep with women any more, because I like a good shag. I also think that for me to have sexual relationships with women is almost like I'm being abusive to them because I'm not in love! I fall deeply in love with men. With women it's just like a bloke to start with, a casual thing.

GISBOURNE How is your relationship with the so-called generation of the yBa's? Of course, Sarah Lucas is obviously an old friend.

EMIN It's a good group of friends, it's great. For the first time in my life I've actually felt quite confident with the people that surround me. Usually when things in my life go wrong I run off and reinvent myself. Nearly everybody I know now, I didn't know six years ago. Now it's just taken for

granted that I'm just part of the yBa's.

GISBOURNE But, they are a strange group in the sense that they're not a group as such but rather this yBa phenomenon. Is it reality or hype? Or, are they just a group of people going in a certain direction?

EMIN They're just a group of people going in a certain direction. Today, just as many phenomenally good artists work in Britain. If you go to Holland, you can't find forty top international artists of our age. Neither can you find them in America or Germany or Sweden.

GISBOURNE Why is that? It's obviously not a genetic moment. There must be conditions that have generated the yBa phenomenon.

EMIN There are two things. There was the educational system in the seventies which everyone seems to want to forget about. The other main thing is the dole. Everyone on the outside seems to think that all yBa's went to Goldsmiths. In reality probably only thirty per cent went to Goldsmiths and the rest went to other places. Quite a few studied at the Royal College of Art. I really get irritated with the Thatcher's children crap, because—personally—I think Margaret Thatcher should be on trial for crimes against humanity. It's rubbish to say, 'We are all Thatcher's children.' One has also to remember what was happening in the arts in Britain in the early eighties. Art then was not exactly retarded, but incredibly conservative. God knows what you had to do in order to be able to show in galleries in the 1980s.

GISBOURNE Do you see any boundaries in your own work such as genres in any pronounced way, in the way that traditional art categories have existed. Do you just assume that work in any medium, like video, drawing, watercolours, sewing, or whatever, collapses the boundaries between fine and decorative arts in your work?

EMIN Well, I recently got this canvas bed, and sewed lots of flowers on to it, it's weird and it's almost like a rich Daddy-type of thing, or a shroud, as if the body had been laying in it. It's truly a piece of furniture. Is this high art? Well I don't think so. But, on the other hand, I really like this object so much that I'll be damned if I'm going to sell it. To me it's a really beautiful thing. Certain artists want to make a room more beautiful for the sake of pure aesthetics for example, and other artists want to communicate a message with their art, maybe a political or a social one. There's a place for all different kinds of art. There's a definite place for Gary Hume's paintings for example. He is one of my favourite artists, I love his paintings. People are quite surprised about this because his images are just about aesthetic beauty.

GISBOURNE So, in a sense this plurality of expression marks the nature of the world today?

EMIN Yes, definitely.

GISBOURNE And, you see the old debates of 'high' and 'low' as not having any relevance any more.

EMIN Yes. But I'll say James Joyce for example was a true artist or writer. There are people who live in the New Forest and paint hundreds of paintings of ponies, but they are not artists necessarily. So I'm a bit snobby when it comes to that kind of thing. Also, I'm particularly snobby about having sex with someone who I didn't think was essentially a good artist.

GISBOURNE What you describe is what a lot of artists in this century have claimed, one thinks of the Surrealists particularly, that your art is essentially urban art? You are not for Laura Ashley and a dinky cottage in Dorset.

EMIN No, I'm definitely not.

GISBOURNE Then your practice is very much concerned with the urban issue of art and life.

EMIN Yes, definitely! Life first, art after.

GISBOURNE And life for you is a work of art. One is again reminded of the Surrealists who used to go on walks around Paris and see this as the central condition of being surreal.

EMIN Yes, being an artist is like that. Well, when people telephone me on a Sunday morning about work now, I say, 'Not today thanks, it's Sunday.' I'm starting to make some provisions about that kind of thing. I got quite upset once when I was on the Tube eating a Macdonald's, crying and looking pathetic. Someone came up to me and said 'Aren't you the artist Tracey Emin?' I could not stand that. That's my problem. Because of my openness with my subject matter, people feel that they can approach me all the time. Sometimes I go out and people talk to me. They bombard me with extremely personal questions, and I know that's because of my work. But it can be a problem.

GISBOURNE But isn't that the consequence of voyeurism?

EMIN Yes. But I've also a sense of other people's private lives. I'm very careful about what I reveal about someone else. I'm aware too, that in terms of history everything will blend into one. When I did the drawing called *You Break My Fucking Heart*, I dated it, but no one knows when or what time period I'm talking about.

GISBOURNE You obviously believe that there's such a thing as falling in and out of love then?

EMIN Well, now I've changed my mind about this because I've had quite a few relationships, but I've also spent quite long periods of time on my own. Recently I realised that my first love and last love have a specific significance in my life.

GISBOURNE Why, are they like a bracket for certain things that have happened to you, and will that change if you fall in love again? Do you see them as staging posts in your life? I know there was a man you were keen on recently.

EMIN Yes, fuck him! I see these two people as brackets, definitely. Me and Sarah Lucas were at a shop and she made a T-shirt for me which said: 'No time wasters please.' Now I'm coming up to thirty-five, I'll be fucked if anybody is going to fuck me over again and waste my time. I haven't got the energy or the capacity. And what's more my heart can't take it much longer. Because now I'm too single-minded, I know what I want and I can't have things coming in to mess this up.

GISBOURNE But when you look back do you look back in a sort of parallax-effect? I know it's a posh term, but what I mean is that when you look down the street you see lines of telegraph poles or markers. Do you look back over your life in that way?

EMIN Yes, I see, it's like Plato's Road to Larissa. So I see the telegraph poles. I see each one. Although I'd a really good laugh the other day when I found

45

Why I Never Became a Dancer
Video. Edition of 10. 6 minutes 40
seconds. 1995
Photo: Courtesy Jay Jopling, London

out that my first big love Philip slept with my best friend. It only came out in the wash last year. But if I'd known at the time, I think I would have fucking jumped off a bridge or so. Now it just makes me laugh and doesn't bother me at all. Obviously time heals, and distance. Yet, it annoys me in a way that you think you have recovered, not from a person, but from a certain feeling in your life.

GISBOURNE It's interesting to me, because you deal with themes like love, sex, religion in your practice and yet when one looks at your work it isn't particularly religious.

EMIN Well, I'm not religious. I wasn't christened, I don't believe in that kind of thing. 'God' for me is a word like love, it explains something like the autonomy of one great thing. My favourite philosopher is Spinoza, and I like the idea of all things connecting.

GISBOURNE Pantheism?

EMIN Yes, and the fact that time has different dimensions which connect as well. So, when you think about the world and its structure an so on—all things connect. It's like death. The most beautiful thing for me in terms of my own death would be to become part of the sun. If I die in hospital my soul just rises up through the next ceiling, through the roof, up into the sky, past the cumulus clouds up into the stratosphere and then straight into the sun.

GISBOURNE That's interesting because this idea is nearly always associated with the masculine, with the male.

EMIN But then I remember fantasising about being a sperm. I profoundly believe in life after death, but not as we know it. If this life was all there was here, if this is it, then I would have left a long time ago. Art for me is what I do to spend my time with while I'm here, but, basically, I can't wait to get off this fucking planet.

GISBOURNE What you say is very Schopenauer-like, very pessimistic, yet you appear so full of life.

EMIN For a long time I didn't want to have children because I really believed that if you've children then part of your soul would remain here. I saw this as one way of not having to come back, for example. But, now I've changed my mind, I don't mind that there may be a bit of me walking around. My soul would probably go somewhere else. I really believe in those kind of things.

GISBOURNE So you don't believe in any kind of institutional religion as such.

EMIN No, I think that a lot of religions can be very harmful. But, on the other hand, they keep people behaving themselves. Religion and certain rules keep everything within some terms of control.

GISBOURNE You use a lot of religious words, you talked about your high altar for instance, which obviously has connotations of religion attached to it. You talked in terms of the sacramental, you talked about blood which has a religious reference. A lot of words are religious in a sense. Even Christian.

EMIN Yes, lots of my friends are Christian too, and I get on with them extremely well. I'd a very good conversation with a lay preacher just this weekend. We were talking about our profound belief in Jesus. I said that I do, but I believe Jesus was a terrorist. There's no way you can have that

kind of history and not have your own bloody army. I mean it's more or less impossible. And, of course Jesus was crucified; they weren't going to let him march around the desert, were they?

GISBOURNE Interesting that the whole notion of an army metaphor is so often associated with religion, the 'Church Army'.

EMIN The Salvation Army. The problem with religious books such as the *Bible*, the *Koran*, or whatever, is that they are not interpreted for the times we live in, and if they were it would probably be pretty good. But they hold people as if stuck in a state of time, which I think can be quite harmful.

GISBOURNE You mean embedded in tradition. But in a way that is not unrelated to your work because you use your memories as your material. The tradition of your life is your material in a way. Religion doesn't throw anything away. You don't throw anything away, you constantly re-use things.

EMIN No, religion doesn't. But then you have to keep working on yourself, don't you, and, you see, religion doesn't keep working on itself.

GISBOURNE You mean it lets the past dominate the present.

EMIN Yes, exactly. I think Mary Magdalene was cool. A cool chick. You don't have to be Christian to be a good person. My faith is pretty phenomenal in terms of an understanding of greater things.

GISBOURNE But, in a sense it's more philosophical than theocentric?

EMIN Yeah, definitely.

GISBOURNE More pantheist, like Spinoza. But he thought material things were a sort of interchangeable part of a whole.

EMIN Yes, they are, though I'm not talking about a Buddhist kind of way. I said to someone the other day that now you are sitting next to something that connects completely to your heart, because if you hadn't been born you wouldn't see this flower.

GISBOURNE Your relationship to this is very palpable, for you use the most palpable of things of the real world?

EMIN Yes, user-friendly. Because you've got money, you've got sex and you've got God, right. But, people find it surprising that someone with my kind of spiritual feelings towards things can make a painting called, say, *I wish I was fucking in Hyde Park*. I find that fucking is one of the most spiritual moments of one's life.

GISBOURNE However, the cynical public might say, why Hyde Park? After all it's one of the most public of parks in London. There's the issue of the exhibitionism in your work.

EMIN Every summer I'm on my own, and I always have this idea of having sex in great places in nature.

GISBOURNE But again it's nature within an urban environment.

EMIN Well, yeah, it's not exactly like marching up the Matterhorn or something.

GISBOURNE I find that the issue of control, although you may not intend it, is very present in your life.

EMIN Well, clarity equals harmony. Sarah Lucas said about me, 'Tracey is one of the most fascist pigs I've ever met in my life.' But, really I've an order with things and I've a discipline with things as well. Which is what makes me a very good artist. Although I may have a reputation of being

hell to work with, but when it comes down to it I'm really fucking professional and on the mark with things—because that's just the way that I am.

GISBOURNE But, control obviously comes from your life experience where you felt a victim and out of control, for instance when you were a child.

EMIN I don't like this victim stuff. Although some of my drawings are very self-effacing, some of them are very sad, some just express this 'I was fucked up when I was ten' kind of idea. Going back to the same place and the idea of being a victim are a masochist-type thing really. People always mistake kindness for weakness, people always mistake tolerance for weakness. With some they can take it, like me, I can take a beating, I can really take it, ten times, and then, I'm talking metaphorically now, I will take a knife to someone's neck or I'll walk away. I'll tolerate things to a level of understanding, but I won't take it like an animal, because I'm not an animal. I was sexually abused as a child. One day I woke up to this fact and went around to see the person that did it, and I just said to him, 'What did you do that for?' It was really great. There'd been this pretence all the time that it had never happened, and I just said: 'What did you do that for?' Suddenly, this person was a victim, trapped in family history. I wasn't a victim any more.

GISBOURNE This concern with childhood had been very strong in the 1990s with the paedophilia debate.

EMIN Yes, but it's not a big side of my work really, it's just one small facet. The majority of kids were abused in some way or other. I did get into an abusive relationship in the early 1990s, where someone hit me and was jealous of me. In retrospect it was a valuable experience because I'll never forgive that person and that's their punishment.

GISBOURNE So you see that as you are in control again. Do you see your life as a journey to ever greater control?

EMIN Over myself, yes. But this is what is worrying about being thirty-five: you get stuck in your ways. And, the more I'm alone and the older I get maybe the more difficult it's for me to let other things in. The last year I spent on my own without having sex or anything in order to work out something. One of the things I really wanted to work out was jealousy, which is one of my worse traits, the one that turns me into an animal. Any area I've a problem with I've got to work on. With regard to working out my jealousy I thought I'd done really well but I haven't.

GISBOURNE The whole notion of vice and virtue, sins and saintliness forms a theme in your work in a strange way.

EMIN When I was a little girl there was a kid's disco for over ten-year-olds. I wanted to go wearing a long skirt. So, my mum made me a long skirt and I trotted down the road and then came back. My mum asked, 'Why didn't you want to go?' I put my nightie on and went straight to bed. I know that it was half past six in the evening, and I felt much better with a clean nightie and clean sheets in a much better place. I said this because I'm like that now with some things. When I'm not out with my friends I live this really little life: I make fish finger sandwiches, I sit on my sofa with my stuffed toys and watch *Brookside* and do my sewing, and then I go to bed and read a chapter of a book and get up with the sun the next day really early.

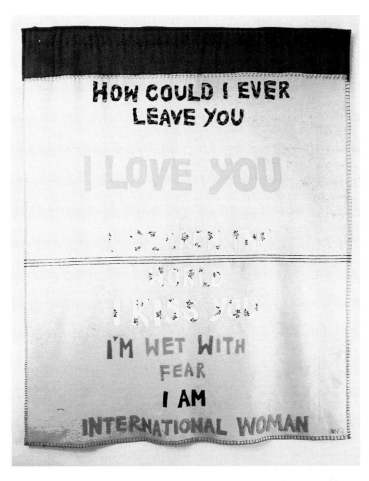

46
Terminal 1
Appliquéd blanket. 230 x 210cm. 2000
Photo: Stephen White

GISBOURNE What do you feel about the actual making of your work, are
you meticulous, obsessive? You have already said that sewing varies with
your mood as to the tightness of the stitches?

EMIN There's also a precise technical aspect to my work, because I've
deadlines and I know what I'm capable of doing. There is, believe it or
not, quite a conceptual approach in my work.

GISBOURNE But, how do you find space given that for instance in 1997, you
had shows almost everywhere. How do you find your space or time for
thinking through ideas?

EMIN On fucking aeroplanes. I went to Berlin, for example, to see a gallery
that is interested in my work. They wanted to do a show with me and
said, 'Well there's a slot at the end of 1999, or in three weeks time, because
someone has dropped out of the programme.' And, I said, 'Are you saying
I have to do a show in three weeks? Impossible!' But then I really liked the
great big beautiful space. So, I said, 'Right, hold on a minute. I got a video
no one's seen, we can show that in the projection room which we paint
Prussian blue. The film is called CV. I'll do a series of sixty drawings, I've a
photograph which will go very well with the drawings and the cv film
which reminds me of Man Ray . . .' So, I'd got a show. Thinking about a
title for the show, I called it *Tracey Emin CV Cunt Vernacular*, because,
basically, the drawings are about a talking cunt. I mean that in two ways:

I'm speaking from my womb, I'm speaking from my vagina. And, I wrote a text to go with the show about me being like—as someone said—a tornado, Tornado Tracey. If you're lucky you're just sucked up through the middle and then spat out of the top, and if you're unlucky you're sucked up the middle, smashed into pieces and then spat out of the top. And, I said, 'That is why I make art, that's the feeling inside me.' So, boom, during the flight and when I got off the plane I had the show worked out. The only problem was that I'd to make sixty drawings within two weeks, which was exciting and dynamic.

GISBOURNE Does this suggest that you've more work inside you then you can possible cope with?

EMIN Yes. Someone asked me a very good question about how I edit my ideas, and I said, 'It's just a matter of time and practicality'. When I travel abroad where I've got a big installation for a week, I take the watercolours and a mini-drawing kit, my writing stuff and my Polaroid(s). So even if I don't get things finished, the ideas can keep on coming out somehow. Quite often if I'm in a group show, people come to my hotel room, because it's like walking into the studio. I've always got stuff going on.

GISBOURNE In a way you're never off duty, you're almost a victim of yourself in that sense, drawing and making it a compulsion almost.

EMIN Yeah! When I went to Oslo with Channel 4 to do a programme about Munch, I got up at seven and just made a film called *The Scream*, of course, after Munch. It's a film of me naked, standing in a field screaming. Otherwise it would have meant that for three days in Oslo I wouldn't have got anything to show for the time.

GISBOURNE How many films have you made up to now?

EMIN Well, I got about five or six finished films, but I must have a hundred or so Super 8 films.

GISBOURNE Do you like Super 8 films? It's got that bricolage element to it, that you have with sewing as well. That's the putting together of disparate things like in the fabrics, etc. Do you take a long time choosing the fabrics?

EMIN Oh yes! Sometimes I do. Well, actually I cut up Matt Collishaw's trousers last year by mistake. When I ran out of fabrics, I asked all my friends to give me an article of clothing. Matt gave me a good pair of silk trousers which needed the button sewing on, and I immediately cut them up into pieces.

GISBOURNE Are you sure it was a mistake, and not a secret vengeance?

EMIN No, it wasn't at all, this is what is so funny about it. And then, Gregor Muir sent me his yellow shirt that I really love. How sweet! It reminded him of the good time we had in the shop or so. When Gregor came down to the South London Gallery, he went, 'You cut it up!' He thought that I was going to use it for something.

GISBOURNE As a present he didn't expect to see it on the wall quite so quickly.

EMIN But that blanket was all about my friends.

GISBOURNE Male friends? All friends?

EMIN Yeah! All friends, female as well.

GISBOURNE Who were they?

EMIN Well, it was really lovely getting all these really lovely parcels from the

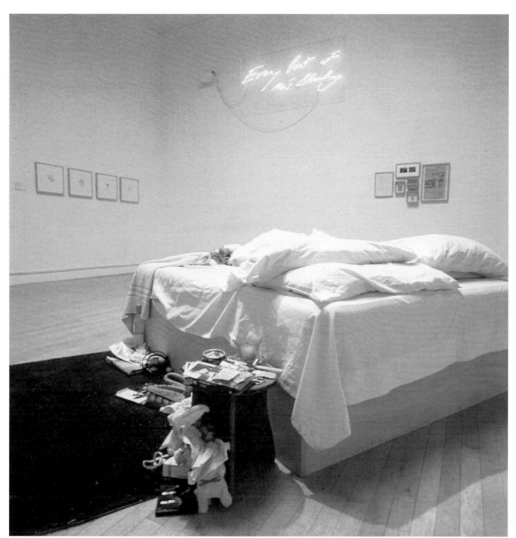

47

My Bed—installation shot: Tate Gallery, London.

Mattress, linens, pillows, rope, various memorabilia. 79 x 234cm. 1998

Photo: Courtesy Jay Jopling, London

postman. That made me take all the photographs of me wearing friends' clothes, because a lot of them sent things they thought would be nice for me, such as a nice coloured shirt. It was heartbreaking when I actually had to cut them up, but I kept all the scraps as well because I know one day when I run out completely I'll use the last bit of Angus Fairhurst or so.

GISBOURNE Things become materially locked into your work, then.

EMIN Yeah! My show at White Cube was made up of all my objects and things. I remember people's reactions. First of all it was not what they thought of as art. But, now every fucking student in every fucking college is doing stuff like that. And, secondly, they were surprised that I would sell the things I do care much about. When they get sold people look after them, I can't keep looking after them!

GISBOURNE Looking at the written elements of your work I notice that where there's an error of spelling or the word is being printed backwards you just let it go because you don't want it to look as though that

conscious articulation was edited.

EMIN No, I don't. Leaving school at thirteen I'm not bogged down by the grammar. A lot of people can't write how they think or how they feel or how they speak because they're too rigid in their upbringing, in their education and everything. But that never happened to me. I'm quite free when it comes to writing, and I write very quickly.

GISBOURNE The idea of all the errors, how do they function? Are they a sort of signifier of truth? Do they symbolise something? Everything is contained within everything else, even the slips of consciousness what used to be called the *pentimenti*. I notice in your drawings as well that you like *pentimenti*, you don't erase a line that you first made even though you may go off and change the line. Everything is present there always. Hence editing, or the lack of it, in that you don't edit, although you obviously edit out works or drawings that you don't like.

EMIN I recently had a show in Paris where I showed seventy or eighty drawings. I know that some of my drawings are fucking rubbish, absolutely crap. No doubt about it. But I've to have them in to make the other one's look really good. Sometimes some of my more crazy ones really were made when I was really drunk. Last summer I made a whole series of drawings called *Sofa Drawings*—I still do this now: I'm really bad, I sit on the sofa sometimes and fall asleep and think I must get up and go to bed. But, I curl up once more, and then I wake up about four in the morning when it's just becoming daylight. It's too early to get up and it's too late to go to bed. At those moments—twilight, times of loneliness—I sometimes have the strangest thoughts.

GISBOURNE It's a time of transition.

EMIN Exactly!

GISBOURNE So, you like to get up early?

EMIN Yeah! Well, I like to but I don't get up early. When I have been drinking, I just don't get up. There's only one good thing about being lonely and drinking: you can sleep for hours and hours.

GISBOURNE You don't have guilt about that? I would love to stay in bed in the morning but I never do, because I would feel so guilty about it.

EMIN No, I don't have guilt. In fact guilt isn't something I actually suffer from. Only when I've done something wrong.

GISBOURNE Is that guilt or shame?

EMIN Shame. I got blood on another friend's shirt the other week and I felt really bad about that so I bought him another shirt. But I don't suffer much with guilt but then, I don't do very much that's wrong, really.

GISBOURNE But then you're always presented within the context of 'the bad girl'. Such a paradox, isn't it?

EMIN Yes, it is really. I felt guilty last night drinking that bottle because I now have this thing about not getting drunk.

GISBOURNE It seems to me something of a paradox in that you have said the words 'lonely' or 'loneliness' twenty or so times, since you've been talking. But, yet the image of you is that of a gregarious 'out there' sort of person.

EMIN Maybe it has something to do with me being a twin, I find it very easy just paying out with people. That's what I am!

TRACEY EMIN MUSEUM, 221 WATERLOO ROAD, LONDON, 10 JUNE 1998

EXPERIENCE

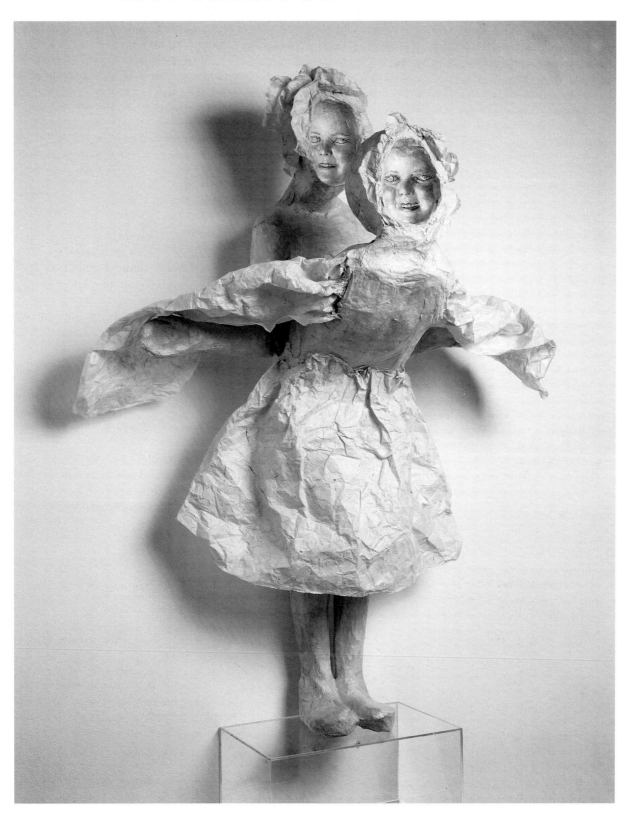

Kiki Smith – Artist Talk

The public talk is introduced and chaired by Mark Lambert, and continues with questions by Kerstin Mey

KIKI SMITH

Born 1954 in Nuremberg, Germany.
Lives and works in New York, USA

Kiki Smith talked about her work at the Fruitmarket Gallery, Edinburgh, on the occasion of her solo exhibition *you are the sunshine of my life is empty without you* on 31 July 1999

Photographs © Kiki Smith
All photographs courtesy of the Fruitmarket Gallery, Edinburgh

(Previous page)

48

Angels
Installation. 1999
Photo: Courtesy of Anthony d'Offay Gallery, London

49 & 50

Exhibition shots, Fruitmarket Gallery, Edinburgh, 31 July–11 September 1999
Photo: C. Grant

MARC LAMBERT I would like to kick off by asking a general question: Looking around the exhibition one sees individual works made up of discrete objects. However, their display suggests to me much more that you have created an environment. You've spoken before about cumulative work patterns, about using and reusing motives, and re-elaborating and adding on to the process of making in order to create an environment through conformities between different pieces. Is that right?

KIKI SMITH Yes. For the first year after we fixed this exhibition venue and date I did not think about the work I wanted to make or show. Making a show is a bit like showing one facet of a jewel. I'm not particularly interested in making travelling shows. I rather like the idea that you just create something precise and specific. Although, when you get to the exhibition venue this precision may fall apart. At any given moment I might be interested in different things and make different works. Then I try to figure out if I can bring all these different works together in one space and put other versions together in another space. The ideas for arranging my work always change in between making objects. I don't have a studio, I work in my living room. Therefore, a lot of things other people, whom I work with, realise for me, I won't see until they are unwrapped in an exhibition space and brought together there. I own a lot of my work, which I will pull out and reassemble or turn them into other pieces. A couple of years ago I got into the idea of making things in a contingent manner, so that you just have them together at a given moment and then they get dispersed. You could have site-specific pieces, which I normally do, pieces made up of different elements that feel like props or like character actors. After the show you disassemble them and configure them in a different way for another show. You could make your work like little camp fires. It's like in past wars where the troops were followed by whole 'cities': physicians, barbers, prostitutes, merchants and the like setting up camps close to the soldiers. You could make work like camp

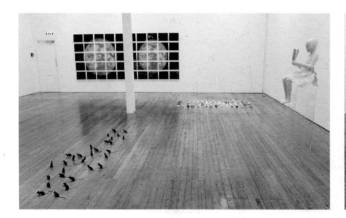
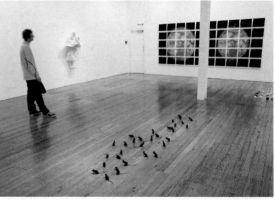

fires and move from one camp to the next and switch the works all around. The reason for that is my way of working which can be totally convoluted a lot of the time.

I often think, 'Oh that's interesting,' and then, for the next five years I contemplate making pieces like that. For instance, I was asked by someone to make an outdoor sculpture for his back garden in Texas, but I had never done anything like that before. Yet, I'm interested in weather vanes, so I started making the rabbits which are flat sculptures similar to very low relief sculptures such as Chinese funerary stones. Looking at these very low relief carvings influenced my approach to this commission. Because I'm not very good at sculpting I thought about making something that is in between drawing and sculpture. That gave me the idea of making all these rats or mice as flat objects and to construct them so that they were moving in the wind, like weather vanes. I started off trying to make models with ball bearings etc., but it never worked very well. Then I switched that idea since I still wanted to make the mice. After I produced all the mousy things I created bigger mice with black stars. That is, I worked with two different scales. Normally, I like to keep objects in the scale they are in real life. I always think that there must be a kind of integrity to objects, something that's inherent in them and determines their scale. We're all the scale we are because of gravity, of natural law. However, in my life things sometimes take on different scales, very large or small, but mostly I try to keep them in their 'natural' scale. Some of my drawings appear very small, but that's because eventually we will make them into animation and they will become life-size like a pixelation. Then I thought I would make them separate so that they can just be moved around others of my pieces like the moon. A couple of years ago I got on a 'moon trip' and began to create things around the moon resulting in about ten different works including a sixteen-foot glass painting of the moon and ink drawings. Another work consists of three large red moons inspired by the apocalyptic paintings of Howard Finster, an American outsider artist. He created these wonderful paintings about the moon turning red like blood. It reminds me of all those folk songs and of the end of the millennium. I like reading the Bible, I like the drama of the stories. The red moon and the red stars come from the apocalypse, but

51
Yellow Moon
Glass. 38.1 x 30.5cm. 50 units. 1998
Photo: Ellen Page Wilson
Photo: Courtesy PaceWildenstein, New York

the skull went with other stars. I have two other star versions: one consists of black stars and the other of clear stars with scat. The stars are the size you see them in the sky looking from the earth. In another of my works you see the stars with animal skulls. It almost looks like animal droppings from a deer or rabbit which implode together in the same space. I want to make some things fluffy and celestial and in other works create something more hellish, but then it falls apart too. I find a lot of inspiration in the iconography of European Christian art but I don't want to engage in Christian propaganda. I like to play around with themes and motifs. A year or two ago, I made a bunch of rainbows in neon, again inspired by these apocalyptic paintings. I'm often animated by moods I find expressed in certain things. I like to think about form, such as the circle, and colour. I have no clue as to why people make things in colour, other than that material informs the contents like in the art of the 1970s. Your choice of material informs the reading of the work and you use the inherent properties of the material to achieve colour and so on. Material that doesn't have too much colour itself may add a grey or a rather dirty tone to the work. This approach has nothing to do with Expressionism or Symbolism where you colour objects specifically. The latter I always found too personal, too eccentric, or too arbitrary. Although recently I have 'grown closer' to colour not least through my interest in tattoos and their images. But usually, I prefer to use things the colour they are. That's the way I first started out to make rainbows with all the different colours. But when these colours crash together they give a white light. There are about ten different shades of white in neon. So I made one rainbow that was almost white neon called *One.* Another one is based on the rainbow in Giotto's *Last Judgement.* I guess in Christian thinking only Christ is in a rainbow, but a mandala is a symbol for where God is. I like when symbols move around transculturally and trigger different associations. In a way it's like circles or teacups. There are very few forms and it becomes extremely interesting when one investigates what those forms mean, how and why they signify certain things.

My early work was abject, and more personal issues shone through it. I tried to work out my personal life, tried to make up a life for myself. There comes a point where you have figured it out or at least you have figured out a good deal of your life and it is not so relevant any longer for your art. Your work changes inevitably. Sometimes people ask you why you don't use certain materials any more, or motifs and so on. To me there's no point in reiterating your past, when it's over it's over. But one ought to acknowledge and honour one's past. I don't want to suffer or lead a bad life so that I can make blood and guts spilling out of me. I'm forty-five now and have to have my life together at least to a certain extent. Therefore I can start thinking about what I actually like to think about rather than thinking about my personal nuttiness all the time. From my earlier work related to the body I moved on to cosmology, the construction of identities, of relationships to people and animals and so on.

For a very long time during the millions of years of evolution everything was in relationship to another, in harmony, including early agriculture. Then things got out of sinc, became totally separated, the

environment polluted, habitats for wild life lost. I've to think about my relationships to the natural environment when I construct my life as a city dweller. For me it's interesting to go on the flip side of abjectness and to really do things I love to do. Modernism has brought an end to decoration, and to figuration. But they have reappeared one hundred years later in new constructions and contexts. They mean something very different now then at the time when they surfaced in opposition to religious dogma or German Romanticist landscape painting. Today artists such as Mark Dion or even Orlan manipulate the physical in completely other ways, for different reasons and as means for different ends. I've chosen to go into beauty, sleepiness, fairytales and all those things I related to when I was about ten, during my childhood. That area is equally despised as are for instance vanity sculptures. I like to go around acting like a ten-year-old, looking at children's books and trying to mix up the stories: like Little Red Riding Hood and the grandmother are born of wolves, or think of all the different bird stories. You can distil the imagery out of the story and use it as your story and turn it into completely other things. For instance if you take Eve and mix her up with Snow White and the Seven Dwarfs, and then link that to Newton and the apple. You can look at the different meanings of apples in different contexts and mix them all up in order to create your own meaning and message. Anyway, that has always happened. One example is the Virgin Mary and her changing meaning and significance according to the needs of the people and of institutionalised religion. It's fun to play around changing stories. As an artist I enjoy the luxury of sitting around and playing in that way all day long. I'm inspired by objects I see in a museum or at different places—although I hate travelling. The Royal Museum of Scotland here is fantastic. I had a good look around and took notes. When I get home, I will put some salt on them and dish them up with some other manifestations. It's a lot of fun.

LAMBERT Just going back to Newton, it was Keats who accused him of unweaving the rainbow.

SMITH Oh, yes.

LAMBERT We were also talking about history and about Newton's apple gravitating towards Eve.

SMITH I was making jokes, but it was actually about the other rainbow. I started making rainbows and then went to night school and taught a class about rainbows—teacher's pet so to say. I was watching British TV education programmes at night. Laura and Anthony d'Offay helped me by staying up until 3.30 a.m. every night in order to watch these programmes. One of them was about Newton, gravity and the apple, demonstrating that the larger body always attracts the smaller. Everything is in gravity. The larger body always pulls the smaller ones. They have more to attract. Eve is attracting the apple towards her. Therefore I think that without Eve there is no possibility for spiritual development. Eve is essential to the Christian story, she is the super-hero who challenges the order by going to the tree of knowledge. She makes the correct decision to go towards knowledge, enlightenment and spiritual growth. Her challenge provides the condition for spiritual development. To return to my starting point: I've to do things which are relevant to my life. I thought it would

be nice to transform Eve into the super-hero and to offer her the apples. Because I am overweight myself, having been an over-eater my whole life, I think about these issues and I like the idea of Eve. The first thing she does is eat. So, I'm totally within my nature. I like playing out the notion of the Host and the cannibalistic aspects of Christianity, that's an understanding of everything spiritual in terms of physical manifestations: you are taking in the body and the blood. The two big events in history happen around food consumption: like the breaking of the bread, and the sharing the fish.

LAMBERT With respect to the neon pieces, how important was the source for you. You reference the picture of the Last Judgement, a quite remarkable painting where the sinners are really punished.

SMITH I'm very attracted to all apocalyptic imagery, it's like I was in it. Much of what I'm influenced by, interested in and deal with originates from American television, or is trickled down from third or fourth source of French philosophy and after, it's like a supermarket kind of obsession. Once I was watching a TV programme on the relationship between music and healing. There an old French hospital was shown that had those enormous red apocalyptic paintings on the walls over the rows of beds. And in front of those paintings appeared people talking about all the bad things that were happening to them. After that programme I made approximately ten pieces consisting of enormous red drawings of little bed things which I manipulate. Formally, there are massive rectangles which together with the colour create a strange energy and a tangible imagery. The apocalypse to me is also the time when Hell and Heaven come together in one space, where you have these rainbows and people floating. Two years ago, once during the winter and once in the summer I went to see Matthias Grünewald's *Isenheim Altar* in Colmar. It is incredible how deep and contemporary the work is. It tells you all you need to know about painting. When I visited Europe when I was young, I was most struck by the fact that what I knew from Dutch paintings and the like was really there. It told me that every artist is just making a reality, that is, Grünewald was creating his reality and I make my New York reality.

When you go to the countryside you see those rainbows everywhere. In New Mexico we saw double rainbows very often. The idyllic appearance of the land makes you want to travel there to work. To experience the physical nature of life in the countryside changes you and also teaches you that everybody draws on what is real, what is happening around them. The distance to other life worlds make them seem strange and peculiar. I'm convinced that we are culturally and historically determined. I make my work based on my cultural and historical background as an American. My desire to do things forms in reaction to America. I began to put some overtly spiritual content into my work, firstly because it's my nature and secondly, I have had a lifelong interest in that field. I like to compare saints to actors, and I like the idea of attributes as a kind of fetishisation. In any way, Catholicism and art go well together because they're both very materially and ritually oriented. You take energy out of your body and squish it into something else and believe that it thus has some new property afterwards.

Sometimes when I did work about my life as a female or tackled more general controversial issues I would be told that I was a God-believer or something like that. I thought that I would have to talk like that in my lecture in college, you know, like God told me to make this or that. But I'm not vain enough to believe that. It would be like going to therapy and always being told that you have to acknowledge responsibility for your actions. Or similarly when you produce decorative or beautiful things you know that you don't want to be owned by fashion or the contemporary discourse. You just want to be able to move, to move towards attraction, to what attracts you. And I have always been very interested in the decorative arts. When I was a kid I wanted to become a potter, but I was too lazy. It was too much hard work. Now, when I go to places and I see something of interest I use it in my work. I have an extremely strong belief that my intuition is telling me when something is useful to my work and life. That's the hardest thing with regard to artistic work: to really believe in and trust one's ability. Half the time you may be tempted to say you are a mediocre or shitty artist because you are always aware of your limitations, but at the same time you are firmly committed to your work. And my art work will take care of me. For me the good thing about art is that it creates space(s), scope for playing around with possibilities. My father was the sculptor Tony Smith who made big flat geometric objects. These works haven't changed over the years. Although there might have been slight shifts in the subject matter they are still about spiritual abstraction. But, in a way, my instincts are really just jokes about my father's paintings because he made these big pin-up(?) paintings which consists of two spheres that look like bosoms. Maybe they're like jokes on Eva Hesse's work where she abstracted the body. I then thought it's funny to make grids with bosoms with milk leaking out of them. In a way they are humorous references to 1960s Pop Art and the like. I always think that people my age, like Felix Gonzales Torres or the work of younger artists such as Rachel Whiteread, have adopted aesthetic strategies influenced by Minimalism but with an injection of social conscience. When the social or personal come into it—and I deal with those aspects in a kind of Baroque way—it gets more complicated. My sweetheart Barry Le Va (I'll give a plug for him!) is one of the people who made his first scatter pieces in 1964, yet you could say that every art student and every artist, especially in the last fifteen to twenty years is working from them. People may not be aware of those links, rather they work randomly on it. You could say that in particular with regard to the wide influence of John Cage's work or artists such as Richard Serra. They started doing things that appeared quite haphazard. Other artists including Jason Rose then worked off those possibilities. Through their aesthetic reactions the former became plainer. Much of art practice has to do with play, playing with art history or with formal aspects or with your own personal histories or cultural icons. You mix them all up so that each art piece or project has five thousand reasons why you are working on it, but they don't always become apparent manifestations in the work itself. Many things are just rice on the floor. Many things can develop from an initial drawing or from looking at the accumulation of found things or art or during the formalisation of an idea. It's like baroque table

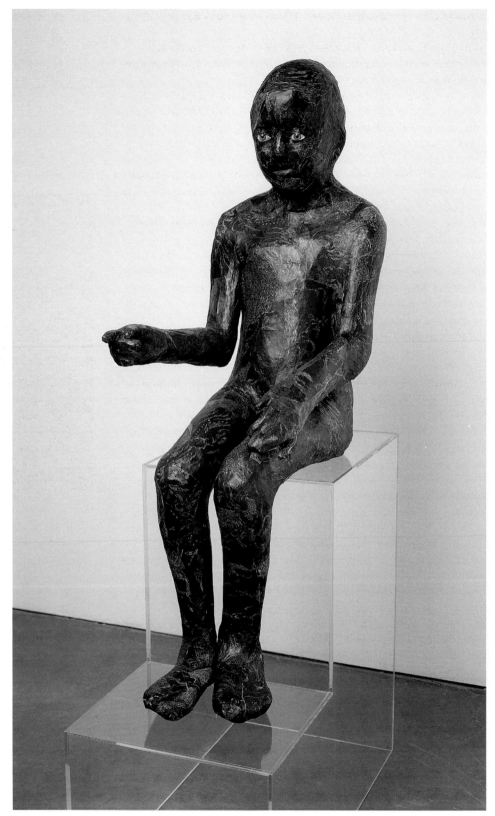

52
*Sitting Girl
with Globe*
1999
Photo: Courtesy
Anthony d'Offay
Gallery, London

decoration. To me making art means taking all the junk and playing with it.

KERSTIN MEY Your work during the 1980s and early 1990s was firmly positioned within feminist aesthetics and politics. What is your position to this specific political agenda today?

SMITH I have always said that all my agendas in my work are personal. Feminism actually taught that the personal is the political, that those two things don't exist separately. I always liked Bob Dylan's line that you don't need a weatherman to know which way the wind blows, which was of course a joke about The Weathermen in the SDS in the States during the 1990s. I don't want my work to be didactic. I want my work to be a whole, as contradictory as I am. That is, I don't want to promote a specific way of life neither for me nor for anybody else. It's similar to the material I use or the things I eat. One just wants different things all the time. As a forty-five-year-old woman who grew up during the 1960s and 1970s and lived through different versions of the feminist and other movements, I'm a totally conflicting person. And I have many things that are calling me at given moments. Sometimes they are in direct conflict to one another. That is, things at some point don't work in one's life any longer, that one changes oneself all the time is the normal state of being. I think there are very few people who have extremely strong visions or beliefs concerning the way they themselves or others should live. We may like people with strong views but I don't want to be one of them. On the contrary, I want to be convolutive, and like my work to be ambivalent: super fluffy and extremely scary, all over the place and concrete. At the same time I have my own desires and needs: I want to make a space for myself.

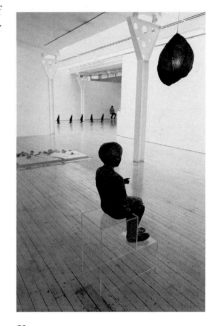

53
Exhibition shot, Fruitmarket Gallery, Edinburgh, 31 July–11 September 1999
Photo: C. Grant

Yet, social issues concern my everyday life, they are not separate. You only need to walk out of your apartment or your studio and you can see what is going on around you. My own agendas inform my work in specific ways at any given moment. Your experience of daily life informs your creative practice; you don't have to adopt a complex theoretical position. I'm someone who is very comfortable with one's inheritance, that is to say, I have inherited an interest in the decorative arts from my aunt who told me how to knit when I was little. And I like knitting. I knitted blankets and then made them into rectangular black void things. This is part of my strategy of mixing and interjecting different modes of expressions, materials, approaches and so on. I see it as a great strength. Although it's only a strength because women's work has been marginalised. If women's cultural practices were to form the centre, they would be just as boring as everything else. Yet, at the same time, I want access to the entire cultural production. I don't want to be limited or limit myself to 'knitted art' all my life.

One has to be aware of the different functions the application of craft techniques within an art context can take on. If Mike Kelly goes shopping and buys old blankets and children's soft toys it is regarded as a transgressive or subversive gesture because he is male. As a female I will be either marginalised for it or I have to flip it and jam it down people's throats in order to emphasise that I insist on expressing things my way, using the materials and modes of expression I regard appropriate without being ghettoised. I'm happy with the way things have worked out for me.

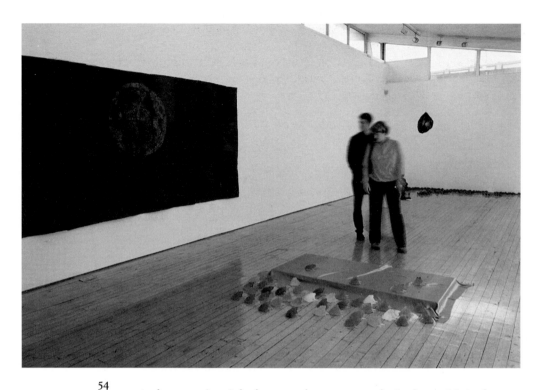

54

Exhibition shot, Fruitmarket Gallery,
Edinburgh, 31 July–11 September 1999

Photo: C. Grant

At the same time I don't want other women to be in the position of
having to knit or sew, if they don't like it, in order to conform to
mainstream expectations. Materials and their use have their own histories
and stories attached to them, and their significance depends on the
context. When I first started using bronze, a German painter remarked to
me, 'Oh, now you are working for your posterity.' The painter's
patronising remark was based on an ahistorical view of what bronze is.
Historically, bronze is the material that has been melted down the most,
that has been transformed frequently into other things. Metals are
reconstructed all the time but until well into this century they have been
primarily used as weapons material. All the nineteenth century neo-
classical sculptures in the United States were melted down for World War
One. Bronze is not just a material to make visual representations of
dignitaries or poets or whoever is been acknowledged by the dominant
culture. In reality it never has been a stable material though it may appear
to be. On the other hand, traditionally, paper or broken ceramics or glass
were not recycled at all. Having said that, bronze has lost part of its use
and thus value due to technological progress. For the first time in history,
the main applications of bronze are in manufacturing and arts and not in
weaponry.

To return to my point: As a person I want to make as much space as
possible for myself, and at certain times I care more about certain subject
matters than others because they are pressing on my life more than they
are relevant at other times. The concerns I devote my life to change over
time. For instance, ten years ago, I became very interested in all that
Catholic hocus pocus having seen a preacher on television, who said that
you have to ask yourself what you want to do. My reply was, that I wanted

to make a church for the Virgin Mary. It was the first thing that popped into my head. Then I made an art show working though those religious concerns and hoped that I could get them out of my system this way. I tried to make some other female deities in order to counteract the bias towards Catholicism. Now and then I still ask myself what do I want to make. Now I want to make a cathedral which is more specific. However, my main concerns in terms of visual practice focus on people in relationship to water, to the desert, to the forest, etc. There is a peculiar link to Christian iconography if one thinks for instance of St Genevieve with the deer and the wolves, or Moses parting the sea, and Jesus walking on the water. So it's an abstract thinking. It's like playing with different themes and motifs, mixing them up and seeing where things go, based on the trust that this way of working takes you somewhere new.

LAMBERT Do you collaborate in your work?

SMITH I work with assistants. I benefit from them. They are all well educated, having been at graduate school, bright and creative. Their talent and personalities work to my benefit. They are a great support and I trust them that they will look after me. The dialogue with them is very stimulating because they have a distance from my work. However, many of the things we do are menial such as paper-mashing etc. When they go home, I go out to dinner. On return I work for four hours at night on my own. I also work with John Christie who is a glass worker of Scottish origin. He came to the States at the age of thirteen. John does most of my glass objects. Sometimes I call him up and tell him to do certain forms of a specified size. For example, I had several versions of glass 'tears' made that can also signify blood, or a spill, or a leak or raindrops or dirty leaking water. I like to collaborate with people, it's inspiring. I worked with one guy in Murano who is one of the best workers but then he became too determining in my work.

I work in the foundry where I have waxes cast. The foundry workers have to finish them which can be a disaster if you are not there. There can be problems with the right patination for instance so that I have to send pieces backwards and forwards across the country to get them right. That is to say, sometimes collaborations can be very successful and at other times not. For my neon sculptures I just give the workers a drawing and asked them to make them. Even though I like to stay in control of my work I often find the chance element in collaborations very interesting because other people come up with ideas I would have never thought of myself. Similarly, if you send your work away for a show, exhibition staff unpack and assemble or install your pieces and might come up with good presentation ideas I wouldn't have had myself. Other times it doesn't work. (Now and then, a curator's presentation of my work may take the mickey out Carl André's work. One of my favourite paintings is Sigmar Polke's painting *Carl André and Delft* which was just like Delft tiles.) Chuck Close always says, 'Collaborating is like playing golf.' That means that you make a very broad stroke and then another one which aims more precisely followed by an even more precise one. However, no matter what you make it can always go in about fifty different directions. When I was younger it was harder for me to finish work or to understand the difference between having an idea and realising that idea, because in the

process of physical manifestation a lot can happen. Sometimes you are lucky and achieve a conclusive form, a satisfying expression. Other times you dismiss the outcome, or have to leave things unfinished.

I like working with people. I like going round people's houses sitting with them and doing my knitting in a kind of sewing circle which substitutes for the family I don't have. Being with people is part of my work. Furthermore, knitting continues to be a radical strategy for how to be creative in this world, even though it might not be a feminist one. However, being connected to the outside world is crucial, but it is equally important or more so to maintain one's own integrity and separateness.

MEY You mentioned that you respond to places. In your work on display at the Fruitmarket Gallery here, are there any particular responses to Scotland?

SMITH No. Graham Murray tried very hard to persuade me to come to Scotland and work here for the show. But I thought that would create too much personal stress and would be very time-consuming. I would rather have a fantasy that my boyfriend and I could come to stay here for a period of time in the future and explore the city, because I love Edinburgh's Georgian architecture, the northern light and the whole setting. Sometimes I do site-specific work. However, working in response to specific places can be very unpredictable. It may not be possible to come up with a literal or appropriate response to a concrete location. Instead a place may trigger lots of different associations and thoughts that move you on to something else.

MEY You also mentioned that your visual practice is very much based on everyday experience . . .

SMITH Yes, I think that looking is important and so is the experience of life. There are many different ways of knowing, but empirical knowledge is crucial.

MEY That is not exactly what mainstream culture favours and supports.

SMITH I think this is a failure of education. It's important to acquire knowledge through observation and listening rather than through reading books. But the latter wasn't an option for me so I had to learn empirically. I'm an extremely curious person and strongly visually oriented. I remember situations architecturally or visually or physically rather then recollecting what exactly happened. I've a very acute visual memory. People are different and I think that one has to use one's gifts and strengths to one's advantage. Apprenticeship is traditionally a way where people develop through learning by doing, physically by working with and through the body, physically inscribing experience in it, literally

55
Rabbits
Silicon and phosphorous bronze. 1998
Photo: Courtesy PaceWildenstein, New York

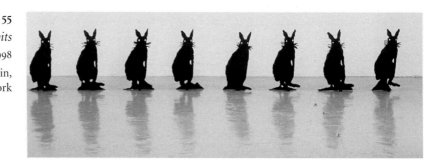

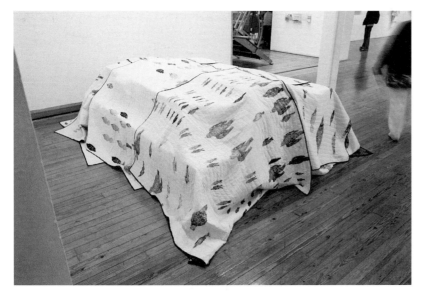

56
Exhibition shot, Fruitmarket Gallery,
Edinburgh. 31 July–11 September, 1999
Photo: C. Grant

grasping the world.

MEY Is that where drawing comes into it as an extension of your visual
memory, a manifestation of your visual thinking?

SMITH Mostly, I don't draw. I'm not much of a sketcher so I will do a
cartoon kind of drawing for a sculpture. I either draw in a very simple
manner in a notebooks in order to trigger my memory or I engage in
drawing from imagination. I might play with drawing by turning it into
animation or transform it in another way. That is to say, drawing is not a
tool, it's another creative possibility.

MEY Is drawing not a necessary preparation for your sculptural work or
installation?

SMITH I never use drawing in that way. If I want to make a sculpture I can
imagine it in my head, even though the actual object might look very
different from how I conceived it first. I don't need a record of it. However,
I do use a lot of photography of things I discover in museums or in the
streets or wherever. And I take always take a notebook with me. I'm a big
advocate of notebooks as an aid for one's memory. My notebooks also
reveal that I do the same things over and over again, though I may not
always remember them.

MEY I noticed that you acknowledge the input of students in your work.

SMITH Yes. I have done a number of residencies during the last few years
and that has given me some of the best experience. I like being in a
supportive environment and to feel free at the same time. It's different
from working under peer pressure. In addition, by being (temporarily)
placed in a learning environment you have all the access to information
and facilities that outside of the institution would be extremely difficult to
get to unless you are able to come up with lots of money and
administrative skills and support. Just think of school libraries, they are
such a rich environment. Also teaching, I've experienced as very enriching
particularly because of the enthusiasm students have. I make a point of
naming those who participated in my work because I regard it as
important that the students get credit for their labour and help.

MEY To move to a completely different area. Given the nature of your recent work in which you reference natural history, what relationship do you see between art and science?

SMITH My curiosity leans towards natural science and the natural world, or more correctly, how the natural world is perceived through science. Mainly, our relationship to the natural world is marked by quantifying it. Part of it is related to colonisation and the development of the Natural History Museum. They coincided. The Natural History Museum is just another form of the colonisation of the world. If I had been more academic I might have become a decorative arts historian. But I studied to be an emergency medical technician. I also went to a trade school for baking. I'm probably more interested in science than in culture. My interest in culture is determined by looking at it in relationship to nature rather than by assessing architecture or fashion or social interaction and the class system. Although our natural environment is of course completely entangled with our social environment.

MEY Yet, I think that your work often challenges western assumption about culture, about the way we gain knowledge and put it to use . . .

SMITH Land, labour, male and female, nature, all these categories are culturally and historically constructed. And so are our concepts of the natural world. It's just that I'm more comfortable to focus on the interconnectedness of reality looking at it from the perspective of the natural world. Anyhow, my main concern is to create viable possible spaces through my art, and I certainly don't want to be marginalised by dealing with bunny rabbits and the like, because it's as valid as anything else. The problem with a feminist stance is that I don't want my work to be didactic and to conform to a certain ideology. The complicated relationship between gender, sex, class and race has also a historical dimension, which is often forgotten. For instance, in the United States many people supported the anti-pornography stance by Angela Dworkin and the like motivated by a deep-seated puritanism. At the same time this movement led to big backlashes against moral concerns. We try to create consistent ideologies, we try to generate cognitive and mental maps in order to make sense of our lives, but the real processes and situations are always more complex.

My interests are manifold and diverse. I'm interested, for instance in animal sculpture, in porcelain animals and figurines, in things that are considered meaningless trash, decorative art aggressions. Yet those objects point to the complex aspects of what it means to represent something and of what happens when you produce an image, when you activate your visual memory, what happens when you place a visual object in a space. How to relate object and space and viewer to each other? Play is an important aspect of my creative strategy. I don't fix or adhere to any rules, rather I engage in a sort of intellectual play. I allow intuition, imagination and chance to play an active and determining part in what I do. Things change all the time. By trying to set up a certain situation, I'm at the same time interested in seeing which creative opportunities arise from that and to exploit them productively without necessarily knowing or anticipating the outcome in advance.

TRANSITIONS

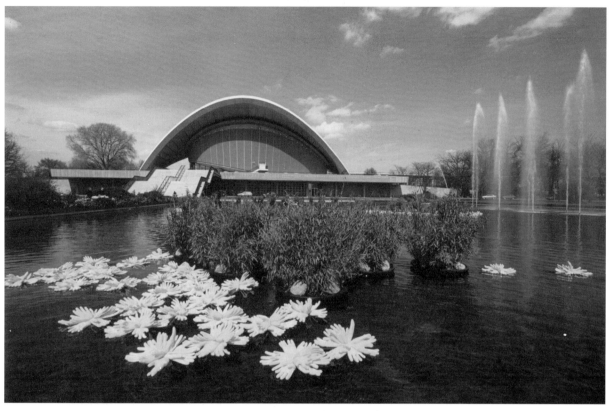

57
Palace of the Water-mirror
Installation, Berlin. 2000
Photographer: Werner Zollien
Photo © Ping Qiu

Ping Qiu
in conversation with
Kerstin Mey

PING QIU

Born 1961 in Wuhan, China
Lives and works in Berlin, Germany

Photographs © Ping Qiu
All photographs courtesy of the artist.

KERSTIN MEY Let me start with your project for the exhibition *Heimat-Kunst (Home-Art)* in front of Haus der Kulturen der Welt (House of World Cultures), Berlin. You arranged yellow household gloves so that they might associate water lilies.

PING QIU The exhibition took place in April this year. I placed groups of rubber gloves, arranged in stacked-up layers of growing circles, in the artificial water basin outside of the old congress centre which now accommodates the House of the World Cultures and its exhibition spaces. I called my installation *Palace of Water Features.*

MEY Did you plant the bamboo into the basin?

QIU Yes, I had the idea and I executed the whole project.

MEY Who funded the project?

QIU The curators of the exhibition invited a contribution by me. They really wanted me to take part in the show. Therefore they offered to pay part of the costs. In addition, they assisted me in winning sponsorship from a firm that produces household rubber gloves. This firm had already assisted me in some of my previous projects. For the Berlin project I needed two thousand pairs of these gloves. I thought it would be visually boring to only have the yellow objects floating on the water, so I wanted

58
Gathering Lotus Blossoms
Performance, Art/Omi, New York. 1998

to include lotus leaves in my installation. But, unfortunately, the plants would not have withstood the April weather. Therefore I followed the advice of a horticultural firm and put bamboo into the basin. The realisation of the project was by far not as simple as it looks. It takes a lot of effort and time to stuff two thousand pairs of rubber gloves. To help me the curators hired two people to help me stuffing the gloves. It took us ten days, but on my own I would have never been able to realise such a large-scale project in such a short time.

MEY Did you conceive the project specifically for this site in Berlin?

QIU Partly. I worked with objects made of rubber gloves that represented lotus flowers before, in New York, where they formed part of a performance installation. The Berlin curators specified that they wanted a similar work as part of the exhibition *Home-Art* for the water basin in front of the former congress centre. Only that the water covered a much bigger area compared to the small pond in New York. Therefore I had to produce many more lotus flowers in order to achieve a similar effect.

MEY How do you explain the strong interest in your lotus flowers?

QIU Through exhibitions and accompanying publications curators became aware of my work. Sometimes my work fitted into the theme of a show and sometimes it was myself as an artist of Chinese origin living and working in Europe that attracts interest, or both.

MEY My questions was aimed more at the aesthetics in your work. It obviously attracts people. Why?

QIU The aesthetics in my work . . . maybe. It is the first time that any of my installations has generated so much interest so that I am now able to attract sponsors too with my visual work. Recently I had a residency and an exhibition at the renowned artists' colony Worpswede, where Paula Modersohn Becker once worked, amongst others. I also took photographs of my objects and installations in the exhibition there. Being in the gallery space I discreetly observed the reaction of the viewers, for the majority of them would not dare to give an honest answer if asked directly about the work on display. I overheard a woman saying to her male companion in a rather loud voice, 'Look, over there are really big flowers. Lets go there.' When they approached the lotus flowers the woman suddenly screamed out, 'These aren't real flowers!' and started roaring with laughter.

MEY Maybe such reactions have to do with the transformation and the translation of the household rubber gloves in a different context.

QIU Yes, the rubber gloves maybe appeal particularly to housewives. Perhaps women in general, because the gloves directly refer to women's services in the domestic sphere as well as in the service and leisure sector. Women's work. Let me give you another example of an incidence in the *Home-Art* exhibition in Berlin. There, I had to repair some of the rubber gloves whose seams had burst so that they soaked up the water and started to sink. Whilst I was standing in the water repairing the gloves one female visitor came up to me and told me in quite an aggressive manner not to damage the work of art. I assured her that I wouldn't do that but stopped short of identifying myself as its creator. I am glad that viewers want to protect my work.

MEY Your water lilies—which take up and rework one of the most popular motifs in art history since Claude Monet's *Nympheas*—are site-specific

59
Finger Flowers from Venice
Installation, Italy. 1999

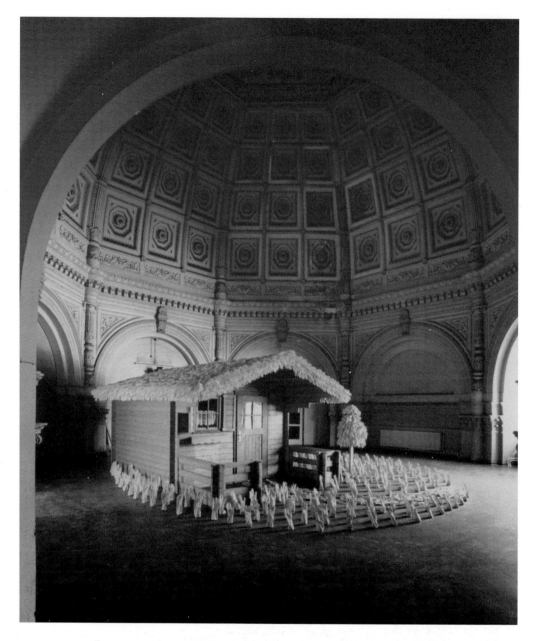

60

Dream Garden No.1

Installation, former Post Office's
Transport Department, Berlin. 2000

Photographer: Werner Zollien

Photo © Ping Qiu

installations for public spaces. When you conceive of ideas for visual work does it influence your thinking whether the projected outcome is destined for the public space or for the white cube, i.e. the modern gallery space?

QIU I like both aspects. I like to design work for a 'natural' or a public space. But I also need to be able to develop smaller work for the gallery. Both the large and small format are important to me.

MEY But of course, the audience that sees your public art work is different from those who visit a gallery or an art exhibition. The gallery space is more exclusive and not as accessible as public spaces.

QIU I don't think about these aspects when I am working. I am concerned with the actual project, and with its contents but not its potential

recipients. But once the works are on display I am curious about the viewers' reactions.

MEY In view of the theme of the Berlin exhibition *Home-Art*, that is, art as a home or a home for art, do you sometimes feel homesick?

QIU No, but my thoughts and feelings inform my creative work and is expressed in its outcome. I probably feel homesick, but unconsciously. I work through it, and work it off in my art. The curators of the Berlin show had conceived the theme. I was one of several artists taking part in the show. For this particular exhibition I did not think of a completely new kind of work. But for a forthcoming exhibition in London I have tried to come up with a completely new idea for small scale work as the respective brief specified. The exhibition is thematically titled *Animal*. From a number of ideas for the work I have finally decided to make small crab like creatures each out of a pair of stuffed rubber gloves.

MEY Where will the show be held?

QIU The exhibition will take place at the Cafe Gallery, London, in August 2000 to mark the tenth anniversary of the *Art Bridge* project, an artists' exchange between Berlin and London.

MEY Could you please say a bit more about your project for the former Berlin Post Offices' Transport Department. The derelict building with its rather splendid neoclassical architecture has suffered considerably from being left empty for quite a few years, but it is still an impressive site which is now occasionally used for art exhibitions.

QIU It was a group show in May of this year. I was only approached to take part in the exhibition at very short notice indeed. The invitation came about because of the success of my work in the *Home-Art* exhibition. The invitation faced me with a problem because I had already some longer-term commitments to a number of other exhibitions that were to take place at the same time. I considered the three of four weeks of notice as being too short to conceive of and realise any project and, therefore, at first, I declined the invitation. But then the curators offered me the central

61

Urform, 1997
Terracotta, exhibition shot
Galerie Timm Gierig
Frankfurt/Main. 1999

62
Red Hands
Garment.
Germany. 1998

63
Yellow Hands
Garment.
Wendtshof,
Germany. 1998

grand cupola space. I simply could not resist responding to this site. For a long time I wanted to do something in this rather impressive space. Within three weeks I realised my contribution. I had to think very hard about how to use both formal means, and my energy and time in an economic but effective way. Since I knew the space well I planned to erect a proper wooden bungalow in its centre. At first I wanted to measure and cut all the wooden planks and boards myself and construct the house. But the preparation time would not have been long enough to do that myself and it would have also been too expensive. That is why I have used a ready-made/DIY house building set. On to the roof of the wooden bungalow I stuck the rubber gloves. The idea of constructing a structure in which one could live has to do with my own experience of building a home for me and my family.

MEY I think your house is very humorous. On the one hand it epitomises 'My home is my castle', but on the other hand its scale and form allude to narrow-mindedness. In addition to that the household rubber gloves suggest the artificiality of our environment, of our life. The rubber-glove-tree in the front garden emphasises that point in particular.

QIU Actually, the tree is a scarecrow. But it is always perceived as a tree. Never mind.

MEY How important is the material in your practice?

QIU In the beginning I develop my visual idea and then I look for the most appropriate material to express it. I work with very different materials such as clay, wood, metal and mundane things like rubber gloves. I experiment with the material in order to communicate my visual ideas as effectively as possible. I am usually very good in mastering the different materials, I master the skills of the craft involved.

MEY Is the skill aspect important for your work?

QIU I think idea, material and craft have to come together. One cannot exist without the other.

MEY What role does the exhibition location/space play for the concept of your installation?

QIU If possible, I have a look at the exhibition site first, taking in its structure and its colours. In case of an exterior space I will take into account the season in which the work is shown and the potential weather pattern. For instance, when I planned the work for the House of the World Cultures, there were discussions beforehand in order to determine whether the rubber gloves should be pink or yellow. In April, as there a hardly any other colours around I choose yellow gloves. The curators agreed with my decision. In other words, the space and its surroundings plays an important role.

MEY Does that also apply to your project for the former Post Office's Transport Department in Berlin?

QIU Yes. I had seen the cupola room before. I wanted to respond to it with an installation. So I had carried with me the idea for the house for quite some time.

MEY Does that mean that the experience of particular sites and spaces does inspire your visual thinking?

QIU Yes, that is right. Sometimes a specific location or space does inspire me. Then I start to think that I could respond to the location in a particular way.

MEY Let us return to the issue of craft and skills once more. Do you think that the importance you attach to the aspect of skills has something to do with your education as artist?

QIU It is similar to painting, when choosing, mixing and applying the right colours, the choice of the right material is a crucial thing. I need to experiment. For example, I worked on a sculptural object based on a ball of wool but far bigger. First I used wood but then experimented with copper. The metal of course reflects the light whilst the wood absorbs it which has severe consequences for the quality of the volume and for the character of the form, for constituting meaning.

MEY What role does your own body, your own corporeality play in your practice? I am thinking in particular of the process of making of your ceramic vessels.

QIU I am very petite and slim. But the vessels I create out of clay really correspond to my ideal body image. It happens rather often that viewers, after they saw my ceramic vessels, imagined their maker was a tall, big woman. When they discover that I made them, they are very surprised or puzzled. However, for a long time I thought about the shapes of my ceramic vessels. I was inspired by traditional Chinese cookery ware. My vessels are very feminine and yet very strong and powerful too. I think my aesthetic ideal is not in tune with the modern ideal of beauty that requires women to be young, beautiful and slim.

MEY This dominant ideal of beauty is not that old. It only established during the 1920s in connection with Coco Channel and the fashion industry in Paris. In previous centuries, at least in western Europe, women were idealised having one or more layers of fat, having rounded

body contours. I think there are remarkable parallels between these ancient Chinese vessels and European artefact from a similar period, think for instance of the *Venus of Willendorf*. You quote traditional archaic forms, interpret them in a new way and at the same time you undermine them with irony, for instance when you include these sexually explicit handles.

QIU Yes, my ceramic vessels are very forthright, cheeky and aggressive. But eventually I began to have doubts about the extremely explicit sexual character of the shapes and restrained them. At the same time I started to use other elements such as water pumps which visualise the male principle. But I don't work any longer in this way.

MEY Your work has often been read in terms of 'gender-crossing' or 'gender-ambiguity'. That approach has been explained by critics with your socialisation in the very patriarchal system of the Peoples' Republic of China.

QIU This explanation is correct. Life in China is very brutal. Sexuality there is very restricted, regulated and repressed. When I came to Europe I suddenly realised that human nature differs completely from how it has been determined and fixed by China's law and order.

MEY Most European artists would probably shy away from expressing sexuality in such a direct and powerful way.

QIU Yes. I think the years of repression of that aspect of my life have led to such a directness. I had to release those energies and concerns. Now, I no longer have such an exuberant energy and pressing concern. I am currently work on clothes.

MEY Your own body as well as body concerns in a more general way play a prominent role in your new series of dresses made out of rubber gloves.

QIU I made a series of photographs of my daughter, my husband and myself being dressed in clothes made out of rubber gloves. For a show in the Museum of Modern Art in Luttich I photographed my daughter and myself as scarecrows, etc., in respective rubber costumes. I am currently continuing to work on 'clothes'. I intend taking photographs of them whilst they are 'modelled' by African women.

MEY Why do you want them modelled by women of different racial and/or ethnic origin?

QIU Above all, that has something to do with the colour contrasts between the pieces and their wearers, above all.

MEY What gave you the idea to design clothing out of these banal gloves?

QIU I got the idea when I was working with household rubber gloves. You have to know that when I studied art at the Berlin Hochschule der Künste I had to earn a living. For three years I cleaned in hotels wearing rubber gloves. This labouring has heavily influenced my visual ideas. And also, working with rubber gloves made me feel something like the hand on one's body. The good hand and the evil one. It drew my attention to what is connected to our hands, and also to the way in which hands touch our body and which sensations and feelings they are able to evoke.

MEY Your dresses in particular emphasise their erotic aspect and, in my view, refer to the way in which men see women. That is, they underline the traditional objectifying gaze and put the viewer into the position of the voyeurist.

64
The End of Parallels
Installation, Prisma-Haus, Berlin. 1998

QIU Yes, that is my intention.

MEY Your performance in front of the camera wearing the dresses and the setting of the 'shooting', i.e. a bathroom with lots of mirrors which allows for the inclusion of several aspects of your body oscillating between being covered and uncovered cites a popular motif in painting—and even in sculpture if one thinks for instance of Canova's *Three Graces*. How do you deal with western aesthetic and visual conventions in your own creative work?

QIU I studied art for an overall period of twelve years, of which I spent the first six years at the National Art Academy in Hangzou, China, and the remaining time at the Berlin Hochschule der Künste. Therefore I am very familiar with academic traditions. Although I mainly do installations I am very much concerned with the traditions of art—East and West. And of course, I am deeply rooted in my past. My experience of growing up, of living and studying in China permeates my work as an artist and beyond. I certainly differ from artist colleagues who have been socialised in Europe. I am quite academic, but if I was only to move within academic traditions that would become very boring.

MEY You reference academic traditions and aesthetic conventions and subvert them, for instance, in your project for the Prisma Haus in Berlin. The building itself breaks through the conventions of the modernist rectangle by taking the shape of an extremely pointed triangle. Its office space interior is marked by long corridors which don't run parallel but meet eventually in the glass-clad space that circumvents the administrative guts. You laid a white wooden structure along these rather anonymous white corridors. Your structure is reminiscent of railway tracks and at the same time re-works those regular and seemingly objective structures favoured by Minimalism.

QIU I am trying to understand abstract painting too. I play around with structures, with lines. But most of all I am interested in women's experience of everyday life.

MEY Your different projects to date demonstrate your versatility in terms of aesthetic strategies, materials and formal processes employed. What role does experimenting play in your work?

QIU The field of visual art is so expansive. I am still fairly young and want to try out as many things as possible.

MEY Such an attitude runs contrary to the mechanisms/principles of the art market. The market demands that one develops a personal style which allows your work to be recognised clearly as such—as a kind of trade mark—in order to sell and develop its value.

QIU The art market restricts artists very quickly. They stagnate whilst reproducing their works again and again. They remain caught within (their) conventions and become unable to develop any further or create anything new. When I first arrived in Berlin I was still quite young and did not know much about modern art. However, I wanted to look for a gallery and/or a dealer to represent my work. But then an experienced female artist, who was in her sixties, advised me against such a move. Instead, at the beginning of my career as a professional artist, she thought I should experiment with anything and in anyway I wanted to. She also warned me to think that I could live off the sales of work through a gallery/dealer, if I was lucky enough to find one. She said that I could be sure that the dealer would want to press me into a certain framework, and I would have to reproduce work that fits into the respective compartment of visual practice. Under such circumstances I would neither have enough time nor energy to try out different, new things. In the mature artist's view, high quality work could become visible and established as long as one tries to make good art and makes the effort of showing the outcome in public—even without being attached to a certain gallery or dealer. I think my water lilies are a good example. So many curators became interested in the work, that I now have to be careful how often and where I am going to show this kind of installation. In May I participated in five exhibitions out of which four showed objects made out of rubber gloves. In November my water lilies will be shown in Hong Kong. I have to limit myself and need to try out new things.

However, the reception of my own work has given me a fair idea of the crucial role curators play for artists in the contemporary art process. Their specific interest—often informed by the respective Zeitgeist—their perspective and direction determines the selection of artists and thus is part of the decision in which context one's work is publicly displayed and received.

MEY Is the curator a kind of kingmaker?

QIU Yes, yes.

MEY Finally, what do the terms sculpture and the monument(al) mean to you?

QIU I don't think it is appropriate that so many contemporary artists work in absolutely huge formats. The large scale is more often than not linked to their own desire for greatness and posterity, rather then with the meaning of the work. Energy and power can emanate from the small-scale too. I am against the monumental per se. I have produced large-scale work too. But my work is about the economy of formal means, about what is absolutely necessary to convey a certain meaning. The world is limited, is fairly small in scale, yet we are faced by a relentless overproduction of goods and also of art. So much rubbish is produced within visual culture which one is forced to visually encounter. 'Less is more', as the modernists say.

BERLIN, 7 JULY 2000

PUPATIONS

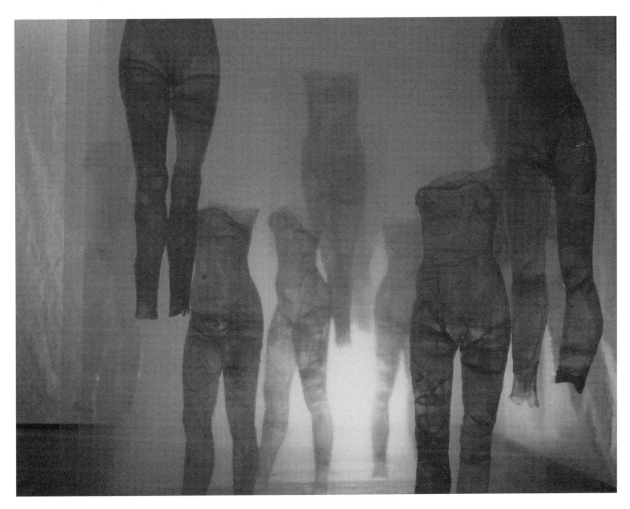

65
Transparent Layers
Installation. Plastic film. 1999
Photo: Azade Köker

Azade Köker
in conversation with
Kerstin Mey

AZADE KÖKER

Born 1949 in Istanbul, Turkey
Lives and works in Berlin, Germany

Photographs © Azade Koker
All photographs courtesy of the artist

KERSTIN MEY Since the 1980s but particularly in your most recent work called *Pupation,* surface and lighting of your objects have become more important. By placing considerable emphasis on the lighting of your objects and installations you thematise appearance and reflection not just in material terms but metaphorically. Why? What is the significance of this aesthetic strategy?

AZADE KÖKER In the past it alluded to life in West Berlin as an island. And in more general terms to life as an illusion.

The fall of the wall was a visible event of the invisible. One did experience a massive deconstruction of history. One tries to wipe off the traces like an illness or like the end of a war.

Berlin was no longer an island. But it still was.

Suddenly we felt the transience and fragmentation of the political and private life. On its expansion to the east, no longer did the free market in Germany have any inhibitions. The first important consequence has been an increased fleetingness and transitoriness of fashions, products, production technologies, working techniques and work processes, ideas, ideologies and established practices.

We feel as though we are living in a world of produced, transient realities.

We live and think only in fragments of time, which fly away on their individual trajectories and vanish in the void. The meaning of the future is lost.

Today, the image of places and spaces can be produced in the same way as everything else.

Time and space as meaningful dimensions of human thought and action have disappeared.

The transparency I produce in my work represents the transience and emptiness of life.

MEY With regard to your own practice, to your concerns for corporeality and for the human measure and body—how do you view the relation between absence and presence?

KÖKER At present the body is in a fatal situation. It is seen without being able to see itself. The body was created as an invented anatomy. It has become a fashionable object for the attention of the media. A transparent foil, a projection screen. It is desired as a pupa or a doll (*Puppe*), as an object, as the forbidden, as the alienated. My work is about the boundaries of active being and active non-being.

The body is right (richtig) *everywhere and nowhere.*

MEY What significance do you attach to corporeality and sensuality in art and in the environment given the fact that our society is increasingly informed by technology and virtuality?

KÖKER I am actually only familiar with motives and forms which perhaps make up a theme. In fact I don't operate dialectically but structurally. The

66 & 67
Mountain Crest
Installation. Wire, plaster, paper, casters, video projection. 1998
Photos:
Ilona Ripke

programme of my practice is based on the serial, on the repetitive, on the recasting (*Abformen*).

The ambivalence of the transparent works poses questions: Is it a doll? Is it a human being? This is the central issue of the 'work image' (*Arbeitsbild*) from which my art departs. The pupa/doll substitutes the body, it replaces the body. Neither the pupa/doll nor the human being are my themes but the spaces in-between. A pupa cannot be transformed into a human being, but it works the other way round.

Furthermore, my work evokes notions of life and death, society and body, illusion, fiction, traces.

MEY How do you consider the relationship between sculptural material and pictorial idea? What role do the specific properties of the materials employed in your work play in terms of developing and realising a visual idea?

KÖKER My work is not concerned with the translation of an idea or with specific technological processes. I don't like to tell stories because, in my view, narratives only develop out of the links between different factors. The visual idea crystallises when technique and material and space come together.

MEY Your work oscillates between object and location, between installation and space. What exactly is the relationship between these different aspects?

KÖKER I am interested in objects which possess an aura. I don't want to separate them from their context, if at all, I want to intensify them. Or I transform them into a different context.

MEY What meaning and function does the sculptural volume have for you?

KÖKER The void creates structure for sculpture as much as the positive, massive volume. Empty spaces are an important aspect of my work. But not in the sense of empty, of meaningless, spaces; they represent the 'not yet', or the 'not any longer', the in-between—hybridity, so to speak. I was five years old when I got my first blonde doll from America. I wanted to know why the doll talked in such a strange language, and where the voice was coming from. I took the doll apart. I removed the strange materials from the inside of the doll because they did not fit in, they were not

68, 69 & 70
'I unpack my library'
(Walter Benjamin)
Installation made from Japan paper. Mixed media. 1998
Photos: Azade Köker

coherent with its external beauty. The doll became silent but possessed an emptiness. It was this emptiness I became very interested in, later.

I can also answer your question regarding transparency, reflection and lighting in terms of my fascination for empty spaces.

I like to make visible the empty spaces which I produce using specific materials. The lighting creates the aesthetic dimension of the work. Points of departure are provided by the boundaries between the banal and the aristocratic. By changing lighting conditions—for instance from daylight to artificial light—ambivalence is achieved. When the special lights illuminate the figures from their back the charm of the emptiness, the idea of death and purity is clarified. The specific material works because of its transparency. This particular material quality takes on an active aesthetic role which informs the content of the work. If the back of the figure is left unilluminated the viewer is confronted only with the surface of the material. The stimulation is gone. The banal returns.

MEY Is your work always related to a specific space?

KÖKER No, but space is everything. Space is sculpture in the broadest sense. Sculpture is always about space, interior and exterior spaces. Work that is related to a space tends to lead to sensations within that space. The sensual experience creates newness on the level of perception by drawing on multifarious contexts. The newness produces its own boundaries and reality. Many site-specific, spatial installations lead to the collapse of different realities: of the reality of the art (work) and the reality of the place, thus raising questions about the immediate and wider social reality and about the viewer's own reality or realities. It also poses questions concerning the history and the present of the place. Thus the reality of the present becomes visual and tangible.

Even modern gallery spaces, the 'white cubes', have certain expressive qualities I would respond to specifically.

MEY In your installations you frequently employ other visual media such as photography and video. Why? How do you view the relationship between objects, spaces and projections?

KÖKER I use video projections as one possibility to simulate reality and create complex meanings.

My installations in real spaces are in immediate contact with reality, mainly critically or philosophically and in order to point the way to a deeper understanding.

My art is not about the mundane as a principle that needs to prove itself within the context of art. Quite the opposite: my approach takes issue with the concept of art winning recognition within the practice of everyday life.

Social, spatial and temporal relations are the main aspects my work deals with. In almost all of my installations I am interested in how the various spatial dimensions of the social space and the signifying space can alternately and simultaneously be penetrated. I oppose reality with my own sign system and transform the latter in a kind of performance. The work resonates with my own subjectivity, my own inwardness. I hope I am able to bring together in my installations my internal and my external realities and visualise their complex interrelations. To achieve that I use all possible formal means and 'aesthetic' materials.

MEY Could you please say something about your view of the monument(al) and the memorial?

KÖKER Our time has overcome the so-called system of memorials/ monuments (*Denkmal*). Art no longer sits on a pedestal, neither does the artist. I think that the only opportunities which might be on offer for art in the future will be in terms of a decoding of memorials/monuments.

MEY Michael Nungesser writes about a specific aesthetics of the mundane in view of the subject of your creative work and your preference for the use of materials which are rather untypical for traditional sculpture. How are the reality of your images and the reality of the everyday related in your work? What function do you 'attach' to your visual work?

KÖKER Any object can become a sign. When I recast an object in transparent foil its essence changes but not its form. The process provides me automatically with a sign. Only occasionally do I use 'real' objects as they are. The tension between the objects and its symbolic character would be too simple and obvious. The metamorphosis of objects creates a sign system. This provides a further dimension, a subtext that accompanies the main aspect. The impossibility of distinguishing between object and sign within an installation and the tension this creates are of interest to me.

Designers too often aesthetise our life environments (*Lebensräume*). I don't want to create an aesthetic space. I am concerned with the deconstruction of the reality of a space in order to create a new reality. A kind of transformation. The work with new media is shown to be a creative process as a work that breaks through or transgresses the boundaries of other spheres of social realities.

MEY Could you say something about the cultural influences which have informed your practice?

KÖKER Berlin is one of the most important urban centres in Germany, where different cultures come and live together with tension. Many people of different nationalities and cultural origins come together like the goods in a supermarket. Due to my own origins as a Turkish woman who has been based in Berlin for more than twenty-five years my work has been very much shaped by these influences.

MEY Your concerns for cultural and social life practices of women from different cultural spheres as well as your use of 'soft' materials such as paper and plastic foil suggest the interpretation of your practice should be within the context of feminist concepts and aesthetic strategies, of feminist aesthetics. Do you intentionally discuss feminist approaches in art practice and theory?

KÖKER One has to ask the question beforehand: Does culture have a sex/ gender? Until the twentieth century the female body appears as image in the public domain. But femaleness/femininity itself hasn't got a place of its own within the public discourse. As an image the female figure is not a direct representation of real, lived femininity but the representation of a male cultural project. The representation is never congruent with the real issues to which it refers.

Question: Do the image of femininity and the female body belong together?

I deal very consciously and attentively with this question.

71
Moving-Waiting
Installation. Mixed
media. 1998
Photo: Ilona Ripke

72
Garments
Installation. Japan
paper, mixed
media. 1998
Photo:
Azade Köker

73
Transparent Couple
Installation. Plastic film. 2000
Photo: Azade Köker

74
Untitled
Plastic film. 1999
Photo: Azade Köker

75
Media Trash
Installation. PVC, plastic film, steel
chain. 1999
Photo: Azade Köker

76
Intimate Space
Installation. Plastic film. 1999
Photo: Azade Köker

MEY How do you deal with the fact that you work in a cultural domain and with a visual language that has been traditionally dominated by men and their specific aesthetic concerns.

KÖKER I should mention here that I socialised in a way that was not specific to women. As a child and teenager I did not perceive a separation of social roles according to gender. My interests, duties and tasks and my perspectives were not specifically feminine, as it is the case for most Oriental women. The patriarchal/male concepts served as example for my own thinking at that time.

SEPTEMBER 2000

TRANSLOCATIONS

77
Biotope
Ornamental cherry trees, lawn, fence, steel posts and wire. 1998
Martin Luther University, Halle/Wittenberg.
Photo: Robert Arend

Luc Wolff
in conversation with
Ute Tischler

LUC WOLFF

Born 1954 in Luxembourg.
Lives and works in Berlin, Germany.

He works on the peripheries of architecture and urban spaces. His Translocations are minimalist dialogues within socio-spatial contexts. Since the beginning of the 1990s he has marked autonomous places by simple interventions, which, at first, evade the context of art. It seemed to be programmatic, therefore, that his contribution for Luxembourg at the Venice Biennial two years ago was only recognisable by insiders. In conversation with the Berlin-based curator, Ute Tischler, he speaks about his work and his strategies of intervening in public spaces.

UTE TISCHLER Your work *Magazzino* at the Biennial in Venice in 1997 was situated outside the official exhibition spaces. The storage space you used irritated the visitors. They missed the pavilion used as a means to encompass institutionally the artistic representative of the respective native country. In the end you occupied a place that obviously suited your work. Within the framework of the Biennial your contribution has shifted the interest in national representation on to a level outside the (art) institution and linked it to a critique of the cultural establishment. What role does the place play as a formal aesthetic criterion?

LUC WOLFF Luxembourg does not have a national pavilion in the Giardini. Artists from Luxembourg were always forced to look for a suitable place for themselves, before they could be certain to be able to realise a particular project. In 1995, Bert Theis, for instance, installed his work *Potemkin Look* in a niche between the Belgian and Dutch pavilions. He erected a façade behind which visitors could rest on deck-chairs outdoors. In my original design I considered creating a large and well kept lawn in the Giardini. Amidst the park stacked with art the lawn should lie there rather like a plot—kept empty and unused—it should be a place of rest, as it were. Through the permanent and thorough care I wanted to emphasise its void as a place and as an issue that is important and out of the ordinary. The only location possible for this work was a 300 square metre open space in the centre of the Giardini right beside the library.

TISCHLER Your landscape architectural project was not realised. Germano Celant, the artistic director of the Biennial, did not permit the display of works outside of the national pavilions.

WOLFF You are right. Ironically, just before the opening of the Biennial, a new lawn was created exactly in that area beside the library. Since I could not execute my project within the exhibition area as planned I had to find an alternative location in the city. Almost by accident I discovered the storehouse on Giudecca during a visit to Venice. This place, situated right at the fringe of the city, offered perspectives which I found extremely appealing, just because it was not situated right within the artificial context of the quasi unavoidable exhibition event.

TISCHLER At the Biennial this year Harald Szeemann did include the entire Naval Castle of Venice with all its arsenals, magazines and storehouses and thus, crucially, he tried to refute the significance of affected behaviour concerning national representation.

WOLFF Harald Szeemann juxtaposed the strange national pavilions scattered across the Giardini with the centuries-old, architecturally very attractive edifices as important exhibition venues. Because of that, the national venues as presentation spaces of the Biennial undoubtedly lost some of their importance. Szeemann used these impressive old halls as a stage, as a fitting backdrop for a colourful mixed exhibition. Seen as a whole, this display cannot, of course, really respond with its content to

78, 79, 80, 81

Magazzino
Grenai della Giudecca, Biennial Venice. 1997
Photos: Luca Giabardo
Courtesy of Galerie Erna Hécey

the past and present function of those spaces. In 1997, originally, I had the idea to design a work which should communicate the notion of 'the gap', of the break in a spatial and situational structure. That is a central theme of my work. The place as a formal and functional element should be taken into consideration in a decisive way. To me the *Magazzino* spaces seemed just right for my project. In a way it was also to do with the mediation between city and depot. Storehouses are commonly situated at the periphery of the city, and usually they are scarcely accessible to the public. Unmistakably, they exist at the limits of the familiar, functional *Lebensraum* and its rather undefined, alien surroundings. Inside a *magazzino* any activity is suspended—except for those that are necessary for the maintenance of the stored goods. Any realisation, any use of the things and raw materials kept in storage can only be a conceptual one, one *in potentia*.

TISCHLER The emphasis of the dimension of the potential and the unreal was without doubt one of the principle aspects of *Magazzino*.

WOLFF You can say that. The magazine was last used as storeroom by the adjacent congress and cultural centre Le Zitelle. I found a lot of exemplary objects and chaotically stored away materials, which are usually employed for the construction and equipment of cultural venues: parts for stages and backdrops, panels for makeshift display walls, a dismantled scaffolding, tools and diverse building materials such as paving stones, roof tiles and roofing felt. In the end, I emptied the magazine and cleaned it. After the complete clear-out, all those things that were previously lying around in chaos were then put away again. This time they were stored and stacked in small dark cellars which are situated in the entrance area of the actual *magazzino*, between its external space and the big storage space right behind. Two-hundred square metres of the storage space—almost two-thirds of its overall capacity—were left empty and but brightly lit. I wanted to show the peculiarity and meaning of a space that does not display any results of a process defined as creative whatsoever. Ideally, a kind of basic potentiality should manifest itself. Where the viewer expected art, at face value nothing could be seen—at least nothing expressed through artificial objects.

TISCHLER If I got that right, you were concerned with a kind of outline of relationships on the intersection of socio-spatial and basic aesthetic levels.

WOLFF Above all, my practice is about the resistance of existing relations that tend to become arrested. It is concerned with the exposure of the culturally defined *Lebensraum* to influences which would change it and keep it changeable. I find that a valuable aim. I cannot warm up myself to the thought that my works ought to be instrumental(ised), i.e. that they ought to serve an anthropocentrical view of the world and a respective way of life, which, in a continual effort of self-assurance and in order to protect its power and sinecure, hermetically delimits itself from anything strange and alien.

TISCHLER The architectural character of a place and its social definition are constituting elements of your work. What are your intentions when intervening in immobile structures?

WOLFF I am interested in the place in which I live, the space in which I work and which I bring to life. Of course that cannot be reduced

exclusively to a living room, a house or a particular city, but rather refers to the entire social and cultural environment I am in. Strictly speaking, I am concerned with 'appropriation', with the kind of mental and material appropriation of the space and its consequences. Today, built space or the space enclosed by buildings is no longer important for its protection against the incalculable nature, but for its strategic role in the internal arguments and external battles over power and proprietorial claims. Occupied space is fortified for its interior unity and isolated against its surroundings. The rigorous protection of its external boundaries does not lead to internal stability, but to internal paralysis because of the development of increasingly powerful and thus rigid structures. I think it is necessary to somehow break open or weaken the hostile and closed boundaries of a stronghold, and thus to subject the place to external influences. When the foreign and excluded become manifest in a place, then it is possible to relativise its identity accordingly, and to create the conditions for the necessary change by means of weakening the local powers. In this sense, the very prospect of a possible change offers a perspective of vital importance.

TISCHLER Since the beginning of the nineties you have favoured unspectacular and relatively unobstrusive interventions in urban space. You operate at the intersection of architecture and nature, often using modules such as walls and plants. What does the strategy of translocation mean to you?

WOLFF I was born and grew up in the countryside. Obviously, the contact with nature was there right from the start: my grandfather was a forester, and my father had a nursery and a horticultural business. In a narrower sense and figuratively speaking, forest and meadow for me were not only unlimited spaces for sports and play, but they existed as a boundless 'field of work' (particularly during the summer holidays, as you can imagine). Eventually, after I did my A-levels I took up vocational training as gardener, and then worked in my father's firm for a few years. Later, I even studied landscape architecture and horticulture for a number of semesters before I finally turned to art. Since then I lived in a city for many years. The subject of creative work is based on the intense

82

Parkhaus

Dyolen lace curtains, nursery plants, spotlights

Gallerie Parkhaus, Berlin. 1997

Photo: Angelika Fischer

83
Lawn
Preparation, rolls
of grass, fertiliser,
care
Contribution to
Oikos & Eigenbau,
Berlin. 1995
Photo:
Robert Arend

experience I made when changing from a familiar, rather 'natural' life-world into an alien one, that felt rather 'artificial'. It was difficult for me to overcome that feeling. At that time the Berlin Wall was still intact, and the impression the cut-off urban space left on me, the immigrant, was lasting. Behind the impenetrable wall lay a hidden world I did not know and I could neither penetrate nor enter. In addition, it could always be latently felt that one's own life was closely dependent on the situation of the country on the outside of the border. Today, I have to convince myself again and again that invisible or imperceptible, yet existentially essential processes happen at the outermost periphery of my limited and enclosed existence. These processes are difficult to assess and to influence.

Incomprehensible, elemental changes take place there all the time. The awareness of these omnipresent imponderabilities, of course, exerts a great influence on my view of things, on my view of the world (*Weltanschauung*) in the true sense of the word. Out of fear of the uncertain and open structure of my immediate environment I can shut myself off, I can withdraw into an internal exile and refuse being active altogether. Or else, I can try to accept them, in the hope of strengthening my own position through the experience of handling its uncertain circumstances. Maybe it is only from such a perspective that the angst that drives rigidity converts into one that drives progress. If I do not see a chance to improve something fundamental, then, under normal circumstances, I would not take up the opportunity to change my own situation. Likewise, I would not take the risk to expose myself to an unpredictable, incalculable situation, if it were not absolutely necessary or if I simply do not recognise its importance. I try to find ways and means

to demonstrate my experience of the necessity of change and my participation in it. As already mentioned, I have been motivated by a state of emergency. The emergency is a limit—a point where movement is sparked off. Inevitably.

TISCHLER Under the title *Biotope* you designed a garden for the Martin Luther University of Halle, which was realised in a courtyard on the university campus not long ago. The project was the result of a public competition you won. How clearly would you draw the line here between landscape architecture and artistic intervention?

WOLFF I do not draw a line between landscape architecture and art. Both are inextricably linked. The most virtuoso craftsmanship possible is mindless and trivial without a recognisable creative dimension. The project in Halle mainly consists of a field of about 1000 square metres on which around forty Japanese cherry trees were planted in regular rows. Being situated in the area of the Department of Biochemistry/Biotechnology the systematic arrangement of the plants might support the assumption that the field was created for research. However, I was not really interested in this symbolic reference. The tree area, which fills almost the whole area of the courtyard, is enclosed by a nine-metre high fence. The trees will have outgrown the fence in a few years. From a height of four metres upwards steel ropes are spanned between the massive steel posts so that the field remains open and accessible for the viewer. The whole installation is situated on a lawn which, like the whole project, will need continuous horticultural care. I was also concerned with a design that asserts influence on the form even if it is not the form itself. Trees and lawn are in permanent change. Their mobile form exists in contrast to the architecture, to the stereotyped fence, and in certain ways, to the compulsive order in public spaces. Right from the start expert care for the garden was included in my project planning. It remains to be seen to what extent the garden is really cared for and whether my planning pays off.

TISCHLER In the past years, services have been given more and more importance in your projects. Your *Space Extension Programme (Raumerweiterungsprogramm)* integrates simple, mundane tasks such as

84 & 85

The Gardener's Project

Wooden plant containers, nursery plants, tools, artificial light, video.

Contribution to *Lichtmittel-Mittellicht*, Otso Galleri, Helsinki, Finland. 1998

86

Biotope

Ornamental cherry trees, lawn, fence, steel posts and wire. 1998

Martin Luther University, Halle/ Wittenberg.

Photo: Robert Arend

cleaning, caring, repairing, planting, watering, etc., which have to be done by yourself as the artist as well as by the users or visitors. Obviously you do not seem to be concerned about perfecting the exhibition conditions. Rather, your interest focuses on an independent process module. What does the term 'work' mean to you in this context?

WOLFF When I am talking here of the necessity to weaken hardened, impermeable structures, and of the fundamental importance to allow external, foreign or unknown influences, these remarks always refer to a real space which I am able to perceive and to comprehend. It is a definable *Lebensraum* where I can get my bearings and with which I can identify if necessary. It concerns my own body and, for example, my own four walls as well as—in a broader sense—all rules and conventions that give my life its direction. Of course, it is also about the space I re-work in order to define and to comprehend it. Although intellectual and physical work or action actually mean movement in a space or changes of space, they do not—at the same time—necessarily open space(s) up externally. In any case, they mean occupation and appropriation. Considered in this way, the boundaries of the field of activity, i.e. the space, as well as the activity/ the motion per se form the centre of my interest. The main aspects of my concerns are the purpose, the functionality and, finally, the overall meaning of a particular activity. This questions includes artistic activity too.

TISCHLER What are you working on at the moment?

WOLFF I have just completed a temporary garden design on the balcony of the Villa Haar in Weimar as contribution to the project *Artists' Gardens* curated by Barbara Nemitz. We are currently documenting the work. In addition, I have also designed the model of a work—in collaboration with the architects Witry & Witry (Luxembourg)—for the cemetery Bois-de-Vaux in Lausanne, Switzerland, to be realised in 2000. The preparation for this project are already in full flow. Various 'urban gardens' will be on display in different city locations within the exhibition project *Jardins 2000*. At the moment I am preparing a show for the exhibition hall *Brandts Klaedefabrik* in Odense, Denmark.

BERLIN, JULY 1999

S(T)IMULATIONS

87
Exoskeleton
Bern. 1999
Photo:
D. Landwehr

'The artist also has something to say' – listening to Stelarc.
The artist in conversation with Robert Ayers

STELARC

Born 1946 in Limasol, Cyprus
Lives and works in West Melton,
Victoria, Australia

Ever since his infamous *Suspension* pieces first came to widespread attention in the early 1970s, Stelarc has been regarded as one of the more remarkable figures working within and beyond performance art. As the 1990s saw an increasing revival of interest in the body as a vehicle for the more pressing concerns that an artist might harbour, he came once again to be seen as an artist who might fascinate, challenge and inspire a younger generation of artists whose comprehension of the artistic possibilities of globalised digital technologies was perhaps more easily arrived at, but very rarely so radical as his. His interest in robotics, prosthetics, and the nature of control within complex technological systems, clearly strike a chord for those of us trying to make sense of our lives in a digital world. He and Robert Ayers had published a widely distributed interview in 1998.* The intention in speaking to Stelarc on this occasion was less to rehearse the history of the *Suspensions,* and more to focus upon the more recent projects. This interview was conducted at the Performative Sites Conference at Penn State University, where Stelarc and Robert Ayers were both performing, on 26 October 2000.

Photographs © Stelarc

All photographs courtesy of Stelarc

* *An Obsolete Body/Alternate Strategies— listening to Stelarc.* In: Live Art Letters [Nottingham], No.3, February 1998, entire issue, ISSN 1361-3731. Reprinted March, 1999.

ROBERT AYERS Stelarc, what I'd like to focus on in this conversation are your current projects. When I hear you talking to groups of people like you did yesterday, it seems that they're somewhat in awe of the suspension pieces, usually rather revolted by the stomach sculpture, but really drawn in by the possibilities of external body stimulation. This was obvious from how eager they were to talk about what you called 'intimacy without proximity' when you were suggesting the possibility of a pair of lovers, physically continents apart, but wired up so that they could stimulate one another's bodies with electrical signals.

STELARC Intimacy without proximity? Well, if two people were wired up and were both able to receive stimulation and transmit EMG signals to actuate the other person, this provides a plausible physical interaction. So, even though we can extrude human awareness and physical presence to remote places, we've now developed technologies, specifically prosthetic devices, where the possibility of physical interaction comes about and one can get a kind of phantom experience of the other. I mean phantom as in 'phantom limb effect'. In other words the person is not physically there but all the sensations are felt: you experience them as proximal to your body, as attached to your body, as part of your body. Your aura is of the other.

AYERS But isn't the objection that might be raised to describing it as 'intimacy'—whether or not proximity is involved—is that most people might expect that intimacy would have an emotional dimension?

STELARC Well, when we experience emotions, we're experiencing very real physical responses. We tag these with words like love, hate, jealousy which describe relationships between bodies in varying situations. Being intimate with someone means that there are real chemical effects occurring within the body, adrenal and hormonal flows for example, and I think you can achieve those purely through imagining, or you can generate those by being augmented with technological attachments or interfaces that provide phantom surrogates, that give you the experience of a physical presence without it actually being there.

AYERS With remote robots now, if we can see what the robots are doing, and if the robot does what we initiate it to do, this effectively collapses the physical and psychological space between this body and the remote robot, and the remote robot effectively becomes an end effector of this body. So this body might not be proximal to the robot, but for all intents and purposes, it's as if it's in another place producing real physical action.

STELARC This would not be mere telepresence as Marvin Minsky described it, it would be more like what Susami Tachi talks of as tele-existence. In other words, if we have sophisticated—which is to say multiple and immediate—sensory, tactile, and force feedback loops, then we have effectively produced an extended operational system between bodies and machines or between bodies and other bodies, remotely situated but

88
Exoskeleton
Bern. 1999
Photo:
D. Landwehr

89
Motion Prosthesis for Movatar
Sydney. 2000
Photo: Cyber Cultures

electronically connected to each other.

AYERS Obviously you've had a great deal of experience in this area of work. You've been wired into all sorts of systems: your movements have been controlled by the audience, for example, and you've controlled robotic extensions to your body by flexing muscles. I've been struck over the years by how much more sophisticated the relationships within these systems have become, the relationships between the corporeal and the robotic. Do you think that this is dependent upon making your control of the robots less and less to do with punching buttons on a console, and more to do with more subtle movements of the rest of your body? Or perhaps it's not about control anyway?

STELARC I'd have to admit that initially the seduction was that you could control a technological extension, but I see this now not so much as an issue of control but rather of blurring the distinction between the body and its machines, blurring the distinction between who is in control and who isn't, and in fact erasing control as a meaningful assumption: does it matter who's in control? In effect neither is in control but rather they come together as a new operational system. I think that's what's interesting. In this kind of electronic connection that results in physical interaction, what is important is not who's in control, but what is important is what kinds of alternate operations you are constructing in this extended space and what sense of awareness is generated from this

new connection.

AYERS Do you mean the artist's sense of awareness?

STELARC No, the system's. Because it's no longer possible to talk about
yourself as an individual or separate component in a truly symbiotic
system. In other words, the closer we get to successful symbiosis, the more
we erase the notion of interface, and the more we erase the
meaningfulness of the question of who or what's in control. The body is
simultaneously zombie and a cyborg. This body does not want to
construct awareness and intelligence that is simply embedded within
itself. Intelligence and awareness is constructed as that which happens
between us in the medium of language with which we communicate, in
the social institutions in which we operate, in the culture with which
we've been conditioned. That's the construction of what it means to be
aware, to be intelligent. Once you accept that, Platonic, Cartesian, and
Freudian constructs vanish really.

AYERS Do you see the system that you're using in the current *Movatar*
project as having that sort of awareness?

STELARC Well, *Movatar* is a motion prosthesis. It's the *Intelligent Avatar*
project which was performed in Sydney as part of Cyber Cultures last
August. This is the idea of an intelligent entity being able to perform in
the real world by accessing a physical body. The body would become a
prosthesis in physical space for the behaviour of this artificial entity.
Initially it was going to be a muscle stimulation interface. I decided
against that in the end because for thirteen years I've been using muscle
stimulation and it produces a smooth and rather natural-looking motion,
and I was more interested in generating a *gif*-like animation of the
body—a jerky, fast, precise animation of the body. So, because of my
recent interest in pneumatics, we constructed an upper body motion
prosthesis which generated three degrees of freedom for each arm
(allowing sixty-four possible combinations). Now, it would have been
great to have made a full-body motion prosthesis but what I actually
wanted was a split-body experience. The upper body was avatar-actuated
whilst the lower body was part of the sense organs of the *Movatar* in the
real world. It was able to feed back information. So, although my upper
body was actuated, with my lower body I was able to turn, twist, and press
floor sensors which were arrayed around me. These floor sensors sent
midi-signals from the real world back into the code of the avatar,
sometimes modulating the mutation rate of the evolutionary algorithmic
engine that was driving the avatar's behaviour, sometimes modifying the
tempo or rhythm of the performance, or prompting the avatar to alter the
complexity of posture settings that it was generating, which in turn
affected the upper body.

AYERS Yes. I can see how in a relationship like that it would be difficult to
imagine that either the body or the avatar was entirely controlling the
other.

STELARC Exactly. It was about a discourse between an avatar and a split
body: between the virtual gestures of this entity (and my upper body's
physical movements) on the one hand, and my lower body's feedback on
the other, which is trying to prompt the avatar to perform in different
ways. Sometimes the avatar would incorporate that and there was an

obvious effect that I would suddenly feel. It was quite amazing to be in this system where you sensed the behavioural changes of the avatar occurring in real time. So it was a kind of inverse motion capture system: instead of the body having sensors which allow it to capture a computer model and animate it, here was an avatar that would animate a physical body and effectively perform in the real world with the body as a prosthesis. *Movatar* is the name describing this system—an avatar that moves you.

AYERS I can't help wondering whether in such a complex and inter-dependent system there's really any relevance to the audience? I know that to talk about an audience at all might seem rather traditional to you.

STELARC Well, the notion of audience can be constructed in different ways. The audience can be simply witnessing something, or an audience can be a much more critical or participatory group of people. Again, I think the notion of the audience isn't a meaningful construct for me because often what the artist tries to do is either physically too demanding or technically rather too complex to incorporate an audience in a participatory way. They might witness it, but the notion of the audience is not structurally essential to the performance of the art piece. Having said that, the 1995 *Telepolis* performance that you mentioned earlier, with the connections between Paris, Helsinki and Amsterdam, and this body in Luxembourg, meant that nothing happened unless someone programmed a series of muscle movements through the touchscreen interface. These were transmitted to this body in Luxembourg, and a few seconds later this body performed that choreography. So there are some performances structured for people to participate. But would you really call that group of people an audience? They initiate the action and complete it through observing the consequence of their choreography.

AYERS Yes, I can see that. But there's a far more traditional sense of an audience in the experience that people have if they witness one of the *Exoskeleton* performances.

STELARC Yes, but really, with *Exoskeleton* there's no necessity for people to be there, but there's an audience because the project requires a lot of funding and because people are interested. The *Exoskeleton* performance is probably the first performance that is more dangerous for the audience than it is for me! (The word *Exoskeleton* means some kind of external apparatus for your body that allows you to perform in amplified ways, that might augment your lifting power or it might augment the movements of your body.) I'm on this 600 kilogram machine that is walking with a ripple gait forwards and backwards, and with a tripod gait sideways, and because my body is rotating on the turntable as well, I've got to be conscious of whether I'm facing to the front of the robot or to the back, because if I make a decision to step left or right I could step on someone and injure them, so one has to take care in the choreography that one is constructing, because people happen to inhabit the same space as where the robot is walking. So yes, one needs to take care of people in the performance space.

AYERS Well there's another rather traditional word. When you use a word like choreography there, how literally do you intend it?

STELARC The walking machine is an example of a non-intelligent operational system. The robot doesn't have sensors to provide feedback, and the body on the robot has no great cerebral capabilities. So this is an example of a non-intelligent in the sense that intelligence here is viewed as the interaction between the system and the world within which it is navigating. It's not simply this body directing the robot, rather that this body translates its own bipedal gait into a six-legged walking gait through arm gestures. These translations allow a human body to navigate the world in a very different way than it does ordinarily. It has a different centre of balance; it has to manoeuvre six legs instead of two; you have to translate your arm gestures into the leg movements. I like this notion of rewiring and re-mapping different functions.

AYERS An expression that I used to hear you using a lot, which you don't seem to use any more is 'Metal and Meat'. Was that an expression that you coined?

STELARC The expression 'Metal and Meat' comes from cyber punk literature. I didn't directly pick it up from there, but for me it had a very specific meaning: to bring home a point about the suspension performances. There were hooks into the skin and there was a notion of technology piercing the body in a crude way.

AYERS I wondered though whether in terms of your current work it seemed a less relevant idea, because now the continuum between the human body and the robotic—the 'meat and the metal', if you like—is more seamless now. Are you less aware of the extensions as being prosthetics of one sort or another?

STELARC Well, I'm intrigued by the possibility of electronically tagging my anatomy, so that we could construct a VRML model on a website. With all of these wireless technologies and global positioning satellite devices we

90 & 91

Extended Arm
Melbourne. 2000
Photos: T. Figallo

90 91

can walk around with small devices that can access a website and then communicate with it. So one could track where this body was at any time and one would be able to access it via the internet and wireless devices. This body could be actuated at any time and any place, much more so than before where the body had to be physically located and hardwired. There's a situation now where not only is the technology becoming more micro-miniaturised and bio-compatible but it can be also accessed and actuated remotely and this would be a step beyond the *Fractal Flesh* performance where the body and people had to be situated at specified locations where there were appropriate interfaces. I'm excited about that possibility.

AYERS It seems to me, hearing you talk about these projects that really your work is now pursuing two obviously related but almost opposite trajectories. On the one hand you've got things like the *Exoskeleton* which are enormous machines, and then there's the kind of work with wireless communication that you're talking about now. They're to do with the same issues, but there are these two threads—the heavily mechanical and, on the other hand, the wireless.

STELARC Yes, whereas in the earlier performances there was an oscillation between the physically difficult suspension performances and the prosthetic augmentation pieces that extended the body, now there's an oscillation of interest between the large mechanical extensions like the *Exoskeleton* and this notion of tagging anatomy and wirelessly accessing it. I mean it can be seen as an oscillation between two rather different sorts of concerns, but it's actually the same concern, and the oscillation is between two different manifestations of that concern. The thing is that this artist isn't interested in plotting a single trajectory (to do with the utopian modification of the body, for example). What's attempted is exploring the multiplicity of technical possibilities, of alternate interfaces, and trying to experience them and articulate them. And what's interesting is the body as the locus of this, and the concern about alternate intimate and involuntary experiences. That's what these performances are all about. Also, using medical and other technologies to shift Foucauldian concerns with control and coercion to experiences of the body becoming a host for multiple agency: the body being able to experience a split physiology in this sense of constructing extended operational systems, whether it's with machines or with other bodies.

AYERS I'm intrigued by the way that you're actually making work now. You're constantly on the move, travelling from one research lab to another, taking up residencies and fellowships, and conducting several projects at once. Some people might imagine that this would be counterproductive to an artistic sensibility, but I've come to realise that this research and development of projects actually is your art practice, and the performances are more like manifestations or statements of its progress. Do you think that this is something that could only be done now?

STELARC Yes, in that you're mobile. A lot of this practice is opportunistic: I had the idea of a walking machine three of four years before it was actually possible to do it. Why it was eventually constructed was because I was artist in residence for the City of Hamburg in 1998 and the residency

enabled me to use 50,000 Deutschmarks of the Kampnagel production money towards constructing this new machine. Then the local pneumatics company, SMC, was happy to donate about 25,000 Deutschmarks' worth of equipment. So all of a sudden this project was possible, but probably it was only going to be possible in Hamburg. Originally *Exoskeleton* was supposed to be a project with Survival Research Lab in San Francisco, but we never got funding together and when the opportunity occurred in Hamburg, that's how it happened. We had the help of a group called F18, which is an artist-engineer group who had never made such a large project using pneumatics before, but who had some experience with pneumatics and programming. I was very fortunate both to be supported by Kampnagel, which is a performance space in Hamburg, and also to have met a group of artists who were available and who were capable of constructing such a large machine. In the same way the new extended arm was constructed in Melbourne and the pneumatic system was fitted in Hamburg and I performed with it for the first time in Avignon. All of these possibilities only occur because you're mobile and because you don't commit yourself to one place— because that one place just doesn't provide you with enough opportunities, or enough support. The key to being a successful performance artist, or at least to earning your living as a performance artist, is to be prepared to go anywhere and do anything.

AYERS Whenever you and I meet, and you talk about a whole range of possible projects that might come off, I get the sense that you are constantly conducting a practical dialogue with potential hosts, potential funders, and potential organisations that can support you. As you say, in the case of the *Exoskeleton*, it happened that a certain set of circumstances came together and allowed you to actually make it, but increasingly I'm coming to sense that what you are interested in is the ongoing research. If a set of circumstances come together that allow you to actually explore one manifestation, that is still of enormous interest in itself, but what really interests you is this bigger continuing project.

STELARC Well, I guess so. You see, I'm neither a very political person nor a very calculating person. I don't plot and plan in any methodical way the realisation of these projects, partly because I know that a whole lot of complex financial, social and institutional circumstances have to come together to allow something to happen. As an individual person I don't have the financial freedom to simply throw money at people and get things built on the spot. Although that would have hastened the construction of the *Third Hand*, and it might have already made the *Extra Ear* project possible, and perhaps even undergoing the first couple of operations to realise it. But, fortunately, because other people get to know of your work, and because you're always on the look out, you meet people who may be able to realise this medical project because their practice straddles both the art and medical professions. For example, at this conference I may have been very fortunate to have met a couple of people who might not only be in a position to surgically assist, but they can also understand the desire to do this project. It is difficult: fifty or sixty years ago, cosmetic surgery was not what a real doctor would do, and it was limited to the rich and famous. Whereas now, cosmetic surgery ranges

92
Motion Prosthesis for Movatar
Melbourne. 2000
Photo: S. Middleton

from medically correcting deformities caused by traumatic accidents to changing or enhancing body features without medical necessity. But the notion of constructing an extra feature for your face, an extra ear in this case, just goes a little way beyond cosmetic surgery, and makes the medical profession unable to respond to those sorts of requests. Medical practitioners would probably not be allowed to practice any more if they participated publicly in something like this.

AYERS And is that part of your motivation, the fact that you are testing the limits of medical ethics?

STELARC No, not really. Just as the suspension events were not meant to be spectacular actions to shock, so these projects do not set out to deliberately undermine medical practice.

AYERS I really didn't mean 'undermine', I was thinking more of 'test' in the sense of extending those ethics.

STELARC Well no, again the answer would be negative. Essentially the attitude is, 'Here is an idea that is not interesting in itself unless it is physically realised, so how can we actualise it? It's going to need medical assistance or engineering assistance or computer programming, etc.' (If this extra ear does get constructed we are also dealing with an electronic component to it, embedding electronics in the ear to map new functions to it.) But there's no deliberate attempt to test the practice that I'm penetrating or appropriating.

AYERS When we were talking a little while ago about the idea of audience, and we were talking about the *Telepolis* piece, you said you weren't quite sure whether those people were audience members or whether they were collaborators. Do you see your work as almost a catalyst for collaboration? Do you think that one of the functions that it performs is that it gives a focus for different interests, and that it facilitates, or even permits, the bringing together of these artist-engineer teams?

STELARC Well, I think that this certainly happens, although I don't actively seek collaborations with other artists. I'm not necessarily against this; it's possible that I'll do projects in the future with other artists. (Probably the only collaborative piece that I've ever done was with one of the leading percussionists in Japan. I did an amplified body piece where I had amplified her muscle signals, so that the sounds of her performing percussion during the piece were mixed with muscle signal sounds. I guess that was the only truly collaborative piece that I've done.) But certainly, because almost everything that I get involved in goes beyond my personal practice, and the technical expertise that I have, and the knowledge that I possess, almost everything that I plan necessitates extra assistance. So, I don't see these performances, or these projects, as a means by which we facilitate interdisciplinary practice, it just so happens that that is what it takes to pull something like this off. It's the same with the audience. It's not that I hate to have an audience, but on the other hand, none of these performances are structured with an audience in mind. It's great if there are people there, great if they can vicariously experience what is happening (and sometimes even initiate and complete a performance like *Telepolis*) but, given that I have funding, the main concern is physically realising the piece. So the audience is, in a sense, an added pleasure, or an added feedback, or witnesses to what goes on. For

example, with the *Internal Stomach* sculpture, the object was inserted into my stomach cavity and the only people who saw that were the people who were directly helping me. That was because the endoscopist did not want to do this publicly, and didn't want any credit for it. So the only way we were going to realise this insertion of the sculpture inside the body was to do it in private only with people there who were helping to pull off the piece or who were helping to document it. I don't think it necessarily makes it any less powerful. I think that if the conceptual raison d'etre for doing something is strong enough then whether there's an audience or not becomes rather irrelevant

AYERS And the extension of what you are saying is that if the conceptual strength of the piece is sufficient then it doesn't really matter at what remove it find its audience.

STELARC Yes, but what is more contentious is the question of whether—if the conceptual *raison d'être* is strong enough—we have to do it at all physically. As a non-academic, the discourse that I articulate can only be authenticated by my actions. I'm not in the realm of language, I'm not in the realm of philosophy, and I'm not in the realm of learned academia, so the only way that what I say can be meaningful is because it's about what I do.

AYERS Well, of course, you know how sympathetic I find that idea. Talking about work like this is fine, but it really isn't anything like as important as doing it. Or experiencing it, for that matter.

STELARC Mind you, that's not to belittle the realm of textual discourse. It's just justifying what I have to say by indicating that it's about the actions, about the performances, and it's not something appropriated from academia. On the other hand, language is a technology in itself and it's a technology that is constantly modulating and transforming ideas and assisting in the construction of new paradigms. It's as much a physical entity as anything else. It's just that I am not in the realm of textual discourse, I'm in the realm of performance art and articulating these experiences. The artist also has something to say, that's all.

AYERS Yes. But this conference is not untypical. The experience of the last day and a half has been that there have been occasional moments when listening to what someone is saying has been illuminating, but speaking personally, it's been far more often when someone has shown something or performed something that has been important. What I find really communicative is the moment of performance.

STELARC I guess we're also making a distinction between philosophers and academics. One might say that with Jacques Derrida, or Wittgenstein, or Heidegger, the kind of discourse generated by such thinkers is conceptually blinding! There's a difference between that and people who try to comprehend by classifying, by associating, by talking so as to enlighten others. I think that philosophy is a much more problematic area and is on par with any other creative activity. One doesn't belittle philosophers because they play with words. There's not much difference between philosophers who play with words and artists who play with other bits of technology.

AYERS Can we just conclude by talking about a couple of your other current projects that I'm particularly interested in? Where is the extended arm

project going?

STELARC The *Extended Arm*. This is again a project that took a long time to
realise, because it begins with my Australian Council fellowship which I
received way back in 1995. But I didn't get enough money to physically
manufacture the thing. I had money to live but not money to actually
construct it. So I made little finger prototypes and just kind of
experimented. Then at Carnegie Mellon University in 1997 I was able to
explore the possibilities of a sound system for this new manipulator. It
was only in the last couple of years, with the help of a friend in
Melbourne, Jason Patterson who had helped me with the internal
sculpture project, that I was able to construct this new manipulator. Then
the pneumatics were fitted by F18 in Hamburg and I first performed with
it in Avignon. This *Extended Arm*, it's made in the same aesthetic as the
third hand using stainless steel and aluminium and acrylic. You slip your
arm through the acrylic sleeve, and there's a spring-loaded wrist
mechanism, and the new manipulator is at the end of my hand. You
construct an arm of primate proportions, and this arm has eleven degrees
of freedom. (The third hand had only a couple of degrees of freedom.)
This manipulator has wrist rotation, thumb rotation, individual finger
movements, and each finger opens and closes. So each finger is a gripper
in itself. In fact the prototype appears on the walking machine as a four-
fingered manipulator. The *Extended Arm* is a five-fingered, human-like,
manipulator incorporating the walking machine's functions and more. In
the performance at Avignon, and for the Olympics Arts Festival in
Sydney, whilst my right arm was automated and extended with this new
pneumatic manipulator, my left arm was involuntarily moving through
eight channels of muscle stimulation. (The most I'd used before was six
channels but that was all over my body.) Here my arm was being actuated
in a much more complex way with eight channels of stimulation,
allowing all sorts of individual finger movements. These performances
were performance installations. One was four hours long in Avignon, and
in Sydney it was three hours long. For that time the left arm was
continuously and involuntarily actuated, while the right arm was
extended.

AYERS And finally, perhaps the project that I've witnessed the development
of most closely. What about the *Radical Robot*?

STELARC Yes. That's related to the walking machine and it's a collaboration
between Barry Smith's Research Unit at Nottingham Trent University and
Inman Harvey in Cognitive and Computing Science at Sussex University.
It seems we've been successful getting funding to initiate this project.
When Inman saw the six-legged walking machine, he was very interested
in this idea of legged locomotion, because of course they teach their
robots to walk, or to learn to walk by themselves, using evolutionary
mating techniques. He became very interested in coming up with a
different model of the walking machine and he's developed a design that
would enable the body to be positioned within a more spider-like
structure where this machine would move not only through a set of
actuators but also through the body shifting its own weight and twisting
its torso. The general idea would be that six actuators would jerk the
machine to stand erect and then, by shifting its weight and twisting, the

body would initiate a six-legged walking gait. It would be a very interesting gait because it's using the potential energy of the body. As the machine walks forward—and at a faster speed than my *Exoskeleton* was able to perform—it walks lower and lower until a point comes where it would stop and then the legs would have to jerked upwards again. But of course you wouldn't have to wait until it stopped walking, the movement would be this beautiful locomotion, and also the body would be shifting its weight and bending backwards and forwards and turning, not only to direct the type of locomotion but the direction of the walking gait. You would have this undulating locomotion occurring. It's very exciting. This project might be realised within the coming year because we now have the funding for it. We've already planned and talked about it for over a year. There was a paper written on it and the respective computer simulation and modelling have been done. We're off to a flying start, so within a year we could be performing with this machine.

AYERS You're right. That really is exciting. Congratulations, Stelarc, and thanks for your time. It's been fascinating.

Selected bibliography

Generel recent publications on sculpture and related issues

ARCHER, M. et al. (1994),
Installation Art, London,
Thames and Hudson

ARNASON, H.H. et al. (1998),
*A History of Modern Art: Painting,
Sculpture, Architecture, Photography*,
London, Thames and Hudson

BENJAMIN, A. (1997),
Sculpture: Contemporary Form and Theory,
New York, Chichester, Wiley

BLAWZICK, I. (2001),
*Century City: Art and Culture in the
Modern Metropolis*,
London, Tate Gallery Publishing

BUSSMANN, K. et al. (1997),
Sculpture Project Münster,
Stuttgart, Gerd Hatje

CAUSEY, A. (1998),
Sculpture since 1945, Oxford, New York,
Oxford University Press

KRAUSS, R.E. (1985),
Sculpture in the Expanded Field, in:
*The Originality of the Avant Garde and
other Modernist Myth*,
Cambridge, Mass., MIT Press

MCEVILLEY, T. (1999),
Sculpture in the Age of Doubt,
New York, Allworth Press

MICHALSKI, S. (1998),
*Public Monuments: Art in Political Bondage
1870–1997*, London, Reaktion Books

POTTS, A. (2000),
*The Sculptural Imagination: Figurative,
Modernist, Minimalist*, New Haven, Conn.,
London, Yale University Press

READ, A. (2000),
*Architecturally Speaking: Art, Architecture
and the Everyday*, London, New York,
Routledge

ROOTS, G. (2000),
Public Art, Melbourne,
Images Publishing Group

RUHRBERG, K. and WALTHER, I.F. (1998),
Art of the Twentieth Century, Vol. 2:
Sculpture, New Media, Photography,
Cologne, Benedikt Taschen

Selection of recent publications on the individual artists

Cornelia Parker

ARCHER, M. and HILTY, G. (1997),
Material Culture, London,
Hayward Gallery

BONAMI, F. (1999),
Powder, Aspen, Art Museum

BRETT, G. et al. (1996),
Cornelia Parker—Avoided Object,
Cardiff, Chapter

BUCK, L. (1997),
*Moving Targets: A User's Guide to
British Art Now*, London,
Tate Gallery Publishing

BUCK, L. (1994),
Something the Matter,
London, British Council

BUTTON, V. (1997),
The Turner Prize 1997, London,
Tate Gallery Publishing

MORGAN, J. et al. (2000),
Cornelia Parker, Boston,
The Institute of Contemporary Art

Michael Sandle

ELLIOTT, A. (2000),
Sculpture at Goodwood 2000–01,
Goodwood, Sculpture Foundation

LYNTON, N. and AMERY, C. (1995),
*Michael Sandle—Memorials for the
Twentieth Century*,
Liverpool, Tate Liverpool

LYNTON, N. and FLOWERS, A. (1998),
British Figurative Art, Flowers East

MCEWEN, J. (2001),
Michael Sandle, Aldershot,
Ashgate and Lund Humphries

PETHERBRIDGE, D. (1998),
Sculpture at Goodwood 1994–98,
Goodwood, Sculpture Foundation

SANDLE, M. (1988),
*Michael Sandle: Sculpture and Drawings
1957–88*, London, Whitechapel Gallery

Mark Wallinger

CROSS, A. (2000),
Public Sightings, London, Photo Arts

HAYWARD GALLERY (1995),
British Art Show 4,
London, South Bank Centre

London, Tate Gallery Publishing

LONDON ELECTRONIC ARTS (1996),
*Pandaemonium: The London Festival of
Moving Images*, London,
Institute of Contemporary Arts

WALLINGER, M. (2000),
Mark Wallinger: Credo,

WALLINGER, M. (1998),
The Pygmalion Paradox, in:
Art Monthly, No. 218, July–August

WALLINGER, M. (1995),
Mark Wallinger, Birmingham,
Ikon Gallery; London, Serpentine Gallery

Georg Baselitz

BASELITZ, G. (2000),
Georg Baselitz, New York City,
New York, Pace Wildenstein

BASELITZ, G. (1999),
New Paintings, London,
Anthony d'Offay Gallery

BASELITZ, G. (1999),
*Georg Baselitz. Bilder, Skulpturen,
Studien 1959–95*, Stuttgart, Cantz

BASELITZ, G. (1994),
Georg Baselitz, Skulpturen,
Stuttgart, Cantz

BEUDERT, MONIQUE (1996),
*The Froehlich Foundation: German and
American Art from Beuys and Warhol*,
London, Tate Gallery

ECCHER, D. (1997),
Baselitz, Milan, Charta

GOHR, S. (1996),
*Über Baselitz, Aufsätze und Gespräche
1976–96*, Cologne, Wienand

WALDMAN, D. (1995),
Georg Baselitz, New York,
Guggenheim Museum

Tracey Emin

ADAMS, B. et al. (1997),
*Sensation: Young British Artists from the
Saatchi Collection,* London,
Thames and Hudson

BREHM, M. (1997),
Urban Legends—London, Baden-Baden,
Staatliche Kunsthalle

BROWN, N. et al. (1998),
Tracey Emin: I need art like I need God,
London, Jay Joplin

COLES, P. (2000),
The British Art Show 5, London,
Hayward Gallery Publishing

DE CRUZ, G. (2000),
Ant noises at the Saatchi Gallery 2,
London, Saatchi Gallery

EMIN, T. (1997),
Always Glad to See You,
London, Jay Joplin

EMIN, T. (1995),
Exploration of the Soul,
London, Jay Joplin

MORGAN, S. and FLOOD, N. (1995),
Brilliant: New Art from London,
Minneapolis, Walker Art Centre

WILSON, S. (1999),
The Turner Prize 1999, London,
Tate Gallery Publishing

ZDENEK, F. (1998),
*Emotion: Young British and American Art
from the Goetz Collection,*
Ostfildern-Ruit, Cantz

Kiki Smith

BROWN, E. (1995),
Kiki Smith: Sojourn in Santa Barbara,
Santa Barbara, Calif.,
University of California

HAENLEIN, C.A. (1999),
Kiki Smith: All Creatures Great and Small,
Zurich, Scalo

LAHS-GONZALES, O. (1999),
My Nature: Works with Paper by Kiki Smith,
Saint Louis, The Saint Louis Art Museum

POSNER, H. (1998),
Kiki Smith, Boston, Mass.,
London, Bulfinch Press

SMITH, K. (1997),
Kiki Smith: Convergence,
Dublin, Irish Museum of Modern Art

SMITH, K. (1997),
*Kiki Smith: The Fourth Day:
The Destruction of the Birds,*
New York, Pace Wildenstein

Ping Qiu

HAUS DER KULTUREN DER WELT (2000),
Heimat—Kunst, Berlin,
Haus der Kulturen der Welt

MEY, K. (1999),
Bodies of Substance, in: *n.paradoxa,
international feminist art journal,* Vol. 4

QIU, P. (2000),
Ping Shui Xiang Feng, Berlin, Goldrausch
Künstlerinnen Projekt

WERNER, C. et al. (1998),
*Die Hälfte des Himmels; Chinesische
Künstlerinnen,* Bonn, Frauenmuseum

Azade Köker

KÖKER, A. (2000),
Azade Köker: Special Reports,
Berlin, Constanze Pressehaus

KÖKER, A. (1998),
Installationen Intensitäten Kulturausflüge,
Darmstadt, Kunstverein

MEY, K. (1999),
Bodies of Substance, in: *n.paradoxa,
international feminist art journal,* Vol. 4

PFÜTZE, H. (2000),
Azade Köker, Special Reports, in:
Kunstforum, Vol. 151, July–September

WEBER, E. (1988),
In zwei Welten, Frankfurt/Main,
Neue Kritik

Luc Wolff

BIANCHI, P. (1999),
Das Gartenarchiv, in: *Kunstforum,*
Vol. 146, October–December

HERBSTREUTH, P. (2001),
Grenzverschiebungen, in: *TransPlant—
Living
Vegetation in Contemporary Art,* Stuttgart,
Hatje Cantz

OBERTHÜR, J. (2001),
The Floodgate Between Space and Place,
Luxembourg, Edition Erna Hácey

OBERTHÜR, J. (1997),
Aufsetzen/Exposing Space, in: *Exposure,*
Luxembourg, Minstère de la Culture

QUAST, A. (1998),
Zur Arbeit von Luc Wolff, in: *Wachsen,*
Vol. 4, Weimar, Universitätsverlag

SCHROER, C.F. (1998),
Künstlergärten—Medium Vegetation, in:
Kunstforum, Vol. 140, March–May

WALLAS, A.A. (1997),
Von der Zukunft in die Vergangenheit, in:
Mnemosyne, Vol. 22, Klagenfurt

Stelarc

BECKMANN, J. (1998),
The Virtual Dimension, New York,
Princeton Architectural Press

BELL, D. and KENNEDY, B.M. (2000),
The Cybercultures Reader,
London, New York, Routledge

BENTHIEN, C. (1999),
*Skin—Images of the Body. Discourses on the
Boundary,* Hamburg, Rowohlt

BIRRINGER, J. (1998)
Media and Performance, Baltimore,
London, John Hopkins University Press

BROADHURST DIXON, J. and CASSIDY, E.J.
(1998), *Virtual Futures,*
London, Routledge

BROUWER, J. and HOEKENDIJK, C.,
Technomorphica, Rotterdam,
v2 Organization

CRAWFORD, A. and EDGAR, R. (1997),
Transit Lounge, Australia,
Craftsman House

KROKER, A. and KROKER M. (1997),
Digital Delirium, Montreal,
New World Perspectives

NOVAKOV, A. (1998),
Carnal Pleasures, San Francisco,
Clamor Editions

TAYLOR, M.C. (1997),
Hiding, Chicago,
University of Chicago Press

www.stelarc.va.com.au/biblio/index.html